SEMIOTEXT(E) ACTIVE AGENTS SERIES

Published by Semiotext(e)
PO BOX 629. South Pasadena, CA 91031
www.semiotexte.com

Cover Photograph: Lenbachhaus Museum, Munich. Photo by Victor Tupitsyn

Back Cover Photograph: Masha Tupitsyn
Design by Hedi El Kholti

ISBN: 978-1-63590-104-7
Distributed by The MIT Press, Cambridge, Mass. and London, England
Printed in the United States of America

Masha Tupitsyn
Picture Cycle

Essays

Introduction by Kevin Killian

"It seems, as with dreams, we are revealed by what we screen."
— Freud

"Pictures came and broke your heart."
— "Video Killed the Radio Star"

CONTENTS

For my mother

Kevin Killian

Introduction

The remembering child we meet in the opening essay of Masha Tupitsyn's *Picture Cycle* is one of the most captivating New York children I can ever remember reading about. Maybe since Kay Thompson's *Eloise*? Perhaps since Eloise's own forebears, the hotel kids in Edith Wharton's *The Children* (1928), or any of the younger and younger protagonists created by Henry James in the 1890s—in *The Anxious Age*, say, or *What Maisie Knew*. (James himself was in part a "hotel child.") In some of the more autobiographical essays, cineastes will spy behind Tupitsyn the spectacle of tweenage Tippy Walker stalking grown musician Peter Sellers through the streets of New York in George Roy Hill's charming 1964 comedy *The World of Henry Orient*. Everlastingly inventive and valiant as Tippy Walker, Tupitsyn sees things in her crushes no one else can see, not her parents, nor her dimmer contemporaries. And it is partly this fidelity to her own taste, and her faith in her earliest selves, that allow the now grown film critic to maintain an electric current; one that connects to the deepest currents of girlhood, lust, ambition, desire, and which Pauline Kael once spoke of as "reeling."

As the Ralph Macchio fanzine Masha "publishes" as a child in "I Touch Myself" illustrates, *Picture Cycle* often elaborates on the ways in which the pleasures of the cinema and the pleasures of writing need employ no object; each of these pleasures are

just as valid when experienced by oneself. The whole book delights in the daring of working it out outside of social discourse, approval, reinforcement. Whenever I hear Robyn—the fortyish Swedish wunderkind—singing "Dancing on My Own," I think of Masha Tupitsyn's rich underglaze.

In the second section of the book, "Analog Days," we learn about a young fellow called Fred who stalks Tupitsyn one summer—sort of—through Provincetown's seascape, eerie as a Marsden Hartley wave painting. "He wore his gingham shirts buttoned all the way up. It was hard for me to imagine what his body was like behind all those boarded up windows of fabric." Fred is threatening in a weird way, a subdued way, like all the most dangerous men, one of Hartley's dangerous fishermen. We know that you can read the language of gingham (of practically all fabrics, gingham is the one that most suggests "boarded-up windows" in old New England towns.). I think of both late Dreyer and late Ozu, as masters of what you might call fabric reveal—or wow, Karin Dor's evening gown exploding like a rose in Hitchcock's *Topaz*. Tupitsyn has read and written all the signals many times, and she has enough interest in men that their shirts puzzle her also.

Let me make it plain: Masha Tupitsyn is a wonderful cultural critic and writer. But most of all, first and foremost, she's an incomparable stylist. I know my own writing well enough to know to project that saying she's incomparable will lead me down the pathways of comparing her to dozens of other artists with recognizable styles. Let me see: Of her youth in a stylish Manhattan, she's something like late period Dawn Powell. On the other hand, she's more of a sensualist. Like Mina Loy, she writes about the personal in imagist ways, as a poet might. When I told a friend that I was writing the introduction to a book of memoirs and film criticism, written by one woman in a variety of styles but linked by sharp poetic incision, my friend, who's no slouch, without a beat, said, "You must be writing

about Masha Tupitsyn, then. Gary used to call her … Oh what did he say?, 'If Emily Dickinson wrote for *Variety*,' I think is how he put it." In part two of *Picture Cycle*, Tupitsyn writes an impassioned second person sonata called, "Mourning and Melancholia," a modern-day romance inspired by not only Freud, but Joe Brainard's "I Remember" poems. But also, the whole French playbook from Duras to Ophuls to Varda. They are the most luscious writers and filmmakers in the world, and yet Tupitsyn keeps up with them. It takes a tough tweak of the beak to think of Dickinson as any kind of urban Annie, and yet there's something of the girl-alone in Tupitsyn. No matter where we think of her standing, and watching, the question arises: What screen feeds her secret knowledge and yearning?

Working on a chat about what haunts us in the art works of the late LA-based artist Mike Kelley, Dodie Bellamy and I returned again and again to the poet Ed Smith's 1987 interview with Kelley in the art/poetry magazine *Shiny International*. I think of *Picture Cycle* as embodying much of Kelley's darkness and dread. For childhood—as Kelley told Smith—is the "most interesting time of sex because you're totally mystified. You don't know the full difference between the sexes, so your idea of sex is really outlandish and fanciful. You spend all your time just trying to figure out what things did and as you get older it just becomes thinking about not what things do but what roles are. It gets narrower and narrower and narrower. But when you're a kid it's actually about physicality and body and stuff and you're really hooked into that because you have a body and you think about it; horror films are always so sexual; they're all about body mutations. Everything's turning into fantastic sex organs." In Tupitsyn's book, 80s childhood is evoked as an era, less as memoir. Mike Kelley himself owned at least one copy of Debra Winger's 1984 film, *Mike's Murder*, and re-taped it every couple of years.

My one complaint—and, as I hope to make clear, it's not really a complaint at all. But yes, right now in this sentence I will

use the word "complaint"; my kvetch about the ecstasies of Tupitsyn's style—is in her definition of an anagram. She claims, for example, in her epic John Cusack essay, "All an Act," that "Roy Dillon" in *The Grifters* is an anagram for "Lloyd Dobler." An anagram should use once only every letter of the original word. Similarly, she anagramatizes "Daniel" from *The Karate Kid* as "denial"—that *is* a fit actually—but she also poses "Daniel" as an anagram of "lead"—no way! Charmingly, she claims, in a brilliant comparison of *The Social Network* and *The Man Who Fell to Earth*, "Part of the anagram for Mark Zucker-berg is *Czar*." I don't call these appearances anagrams—let's call them runes instead. In "The Devil Entendre," she writes about the devilish men in the *The Usual Suspects*: "One of the ana-grammed words the name Keyser Soze produces is Zero." Well, you get the picture—the *picture cycle*, you might say.

As the book moves into ever more vatic areas in the third section, you will begin to summon the knowledge you are being led to—the Hegelian rule of three, but from a remarkable viewpoint, that of a feminist rethinking of Hegelian thinking— a poetic translation, like those Maya Deren went working through in her own films (some left unfinished). Tupitsyn, who studied philosophy, is, after all, a filmmaker herself, while Hegel missed out on the incantatory and poetic form of cinema.

Besides the book's three-part structure—"Famous Tombs," "Analog Days," and "Picture Cycle"—we find references to trilogy in the same essay about Zuckerberg vs Bowie, "David Bowie & Mark Zuckerberg Play with Time," from which we have already mined such disruptive ideas on the anagram. "Bowie's Thin White Duke is addicted to cocaine; jumpy, famous, polished, superior, icy, polymorphous. He is also dressed like a character from *The Damned*, the first film in Luchino Visconti's *German Trilogy*... Like Visconti, Bowie made his own *German Trilogy*, the famous Berlin Trilogy—*Low*,

Heroes, and *Lodger*—with Brian Eno." In Tupitsyn's essay, we learn about Fassbinder's BRD trilogy, which culminates in the 1981 *Lola*, "loosely based on Josef Von Sternberg's *Blue Angel*, starring Marlene Dietrich." Because Tupitsyn lodges this info in a footnote—"lodges" indeed, an echo in the third LP of Bowie's Berlin trilogy—even the hungry among us may miss this reference and annotative gesture. But we need its teeth and we need its breath.

Similarly, in the book's titular essay, "Picture Cycle," we learn about "Michelangelo Antonioni's color trilogy (*Blow-Up*, *The Passenger*, and *Zabriskie Point*)," and notice in passing how Tupitsyn bypasses chronological ordering in this case, insofar as in real time, *The Passenger* came years after *Zabriskie Point*. But here the emphasis is on the alphabetical. In "Devil Entendre," she alludes to bell hooks's canny complaint that, in order to make Darth Vader evil, James Earl Jones was cast for his "villainous" (read "black") voice, not only evil but inhuman. This was in Lucas's '80s *Star Wars* trilogy, of course. The material about trilogy mounts up in Tupitsyn's book and comes to a troubling coda, as she refers to the sunny comic days of Pasolini's so-called "trilogy of life," and ends on *Salo*, which she alleges was part one of a trilogy of death, and which also introduces her first book, *Beauty Talk & Monsters* (2007).

Trilogies are much on Tupitsyn's mind in *Picture Cycle*, and elsewhere. Her own celebrated 24-hour film, *Love Sounds* (2015), ended an Immaterial Trilogy. In the context of modernist writing in which Tupitsyn operates, John Hughes's now controversial Molly Ringwald trilogy—*Sixteen Candles* (1984), *The Breakfast Club* (1985) and *Pretty in Pink* (1986), goes unmentioned as a trilogy, even though *Pretty in Pink* is integral to Tupitsyn's book—more fabric reveal, as Tupitsyn tries to describe what to make of Andie's own slash and grab poor girl's prom dress. Hegel describes a model by which all conceptual and ontological development takes form—beginning with a moment of abstract

or ontic fixity that reveals its inherent instability in every reflexive attempt to justify that fixity.

This instability yields the second moment of the dialectic, which Hegel terms the "aufheben," the crucial innovation of Hegel's dialectical method—often translated as "sublation." Hegel frequently attempts description of a dual moment of confrontation that both negates and preserves at once, allowing for a model of contradiction which is nonetheless progressing, usually (if not always) in movement towards the unknown of an ever-widening vision of the world, and the place of conscious- ness within it. Hegel poses this against—and as a solution to the problems of—what he claims the character of both Socratic and Kantian dialectical forms (although it is interesting to note that the Marxian criticism of Hegel's logic of progression sees the same problem in Hegel that Hegel identifies in the Platonic model). In part two of her own collection, "Analog Days," Tupitsyn is working furiously both with and against Hegelian ideas of reversal and traditional opposition. In Hegel, the third and final moment of the dialectic presents a synthesis of abstract and its negation, portending a kind of sequence of dialectical processes, always moving closer to an absolute synthesis that is never reached. In the *Wissenschaft der Logik*, dialectical move- ment reveals itself at the very basis of the speculative act—Being (abstract) is revealed as conceptually without content, indistin- guishable from its negation Nothingness, and the unity of the contradiction (which preserves the crucial predications of each) is Becoming, which serves as the basis of all further ontological investigation in turn.

Thus, in *Picture Cycle*, Masha Tupitsyn alludes to, plays with, and interrogates many of the films she admires most. The book is a trilogy of collections that assumes new meaning when read within the consecution that sets them off—contextualized, that is, by the other essays within each section, and by each section taken in the context of the collection as a whole. The

parallels are subtle, but satisfying. They allow the reader to approach this volume as a kind of cultural *Bildungsroman*, with the work itself functioning as both an intellectual biography and a developmental understanding of Tupitsyn's general approaches. We smile at the reader's exposure to a fully realized critical vision because it lands with something of the gravitas of Hegelian synthesis—but with a twist. And beyond this: we are charmed—in the old sense, in the Stevie Nicks sense—into both the oneiric and the senseless; the authentic today.

— *Kevin Killian, May 2019*

I. FAMOUS TOMBS

"When I met Johnny, I was pure virgin. He changed that. He was my first everything. My first real kiss. My first real boyfriend. My first fiancé. The first guy I had sex with. So he'll always be in my heart. Forever. Kind of funny that word." — Winona Ryder

"I'd die for her. I love her so much. I don't know what I would do without her. She's going through a lot right now. I wish I could just kiss away the pain, make it go away, stop it, kill it! If she, you know, I don't know what I would do. I'd kill myself. I love that girl. I love her. I love her almost more than I love myself." — Johnny Depp

1

Famous Tombs: Love in the '90s

"The skin is faster than the word."
— Brian Massumi

"What is there to indicate that we are no
longer haunted by the one we've lost?"
— Darian Leader

I. BEGINNING

I was a pre-teen when Winona Ryder and Johnny Depp moved
into a loft across the street from me in TriBeca. An older neigh-
bor friend, the sister of a classmate, told me they were living in
her loft building, on the top floor. I went home and looked for
them that very same day. I saw him at my corner deli, and on the
street smoking, but never her. At night, I sometimes looked up
at their windows and saw their lights on. The older friend said
they had no furniture and seemed nice. Depp was not very
impressive in person. Cute, but no big deal. His jeans had paint
on them and his t-shirts had holes. You might not look at him
unless you knew you were supposed to, which is really the sin-
gular difference between people onscreen and people offscreen:
famous people are to be looked at.

The story is: Ryder didn't want to live in pre-gentrification
TriBeca because it was too isolated and scary to her, so they moved
out after only a few months. This is of course ridiculous. Who
could be afraid of TriBeca, already considerably gentrified by the

early '90s, unless they were supremely bougie? Ryder was supposed to be a bohemian girl, a down-to-earth hippie who had grown up on a Northern California commune. But it turned out that the Lower West Side of Manhattan in the early '90s, primarily still a white artist's enclave at that point, was just too wild for her.

I loved Winona Ryder then. I, a weird-girl, could not believe that a weird-girl like her was on screen when she appeared in *Beetlejuice* and *Heathers*. Her creaky voice, black eyes, and 1940s-style dark hair, which she chose over her allegedly natural blonde. I even forgave Ryder her bad acting in period films like *The Age of Innocence*, *Dracula*, and *The House of The Spirits* because of how much her counter-image meant to me. Her look, her clothes, her early movies. Her boyish, impish, scruffy taxi driver in Jim Jarmusch's *Night on Earth*, before I even knew who Gena Rowlands was.

II. MIDDLE

Some actors are only made to play certain parts, revealing something about an age through their own age. Personal chronology becomes cultural chronology, and vice versa. Like John Cusack, another black-haired/pale-skinned '80s/'90s idol as well as a youth actor whose great and perhaps singular gift was to enact a different kind of youth—a counter-youth and counter-masculinity. Winona Ryder was never *timeless*, she was *of the time*. Most especially that brief time in *her* life: her teenage years and early twenties. Perhaps this is why Jake Gyllenhaal's light brown hair was dyed jet-black for the retroactive—'80s—*Donnie Darko*, and Christian Slater's jet-black for *Heathers*. Something about dark hair showing up in the late '80s and early '90s as a form of retribution for an aesthetically fascistic and representationally narrow decade. These are people who were not kissed by the sun, who were not California Dreamin.' Or, as the German writer

Heinrich Laube put it, "These pale youths are uncanny, concocting God knows what mischief."

If, as the teenage pirate radio DJ, "Hard Harry" puts it in *Pump Up The Volume* (1990), the '80s were a totally "exhausted decade, where there's nothing to look forward to and no one to look up to," Winona Ryder rose up from the bleached-blonde ashes of the 1980s. Playing the '90s was Ryder's part, for once the '90s ended, her specificity did not carry over into another time. She was characteristic, not character. Nor did she manage to recoup her cultural relevance, whose finish culminated dramatically with an arrest and public trial for shoplifting in 2001. And how could she when we no longer cared about the same things and she didn't either? If culture speaks through bodies, faces, and colors, as well as events, Ryder is a temporal archive rather than an Actor: a famous tomb, which all actors are to varying degrees, transporting us through time with their bodies and faces, which we visit and revisit. Ryder was employed not to play a range of characters well—the way actors are traditionally expected to, and the way we knew Ryder wasn't especially good at doing—but to reflect something about a particular time and mood.

III. THE END

In 1989, Winona Ryder and Johnny Depp, a couple, both made public declarations about each other in the press:

> **Winona Ryder:** "When I met Johnny, I was pure virgin. He changed that. He was my first everything. My first real kiss. My first real boyfriend. My first fiancé. The first guy I had sex with. So he'll always be in my heart. Forever. Kind of funny that word."
> **Johnny Depp:** "I'd die for her. I love her so much. I don't know what I would do without her. She's going through a lot

right now. I wish I could just kiss away the pain, make it go away, stop it, kill it! If she, you know, I don't know what I would do. I'd kill myself. I love that girl. I love her. I love her almost more than I love myself."

Two years later, Ryder and Depp broke up. Even though it didn't last, and they didn't die (or who knows, maybe they did—Ryder certainly died in some ways, and Depp did too), here they are: two Hollywood stars at the top of their game, saying this about each other in print. Talking about dying when, according to Hollywood, which considers itself reason enough to live, these two have everything—not just each other—to live for. Today public relations would nuke a statement like that. Today no one ever takes old words lost to lost worlds like "die" and "forever" seriously. Nor would anyone even think to publicly state this about someone else: someone they love, let alone another actor in print. Today public relations would tell—or worse, would no longer have to—Ryder and Depp not to talk like that in public because talking like that is morose and alienating for fans, especially when the lovers in question are young, famous sex symbols we want to project ourselves onto. Can we even imagine two actors declaring this today? Two actors killing their burgeoning careers with melodramatic words like "die" and "forever," when most celebrity couples today won't even discuss their love lives, let alone admit to "dying" over a breakup? For a while, Gwyneth Paltrow, formerly good friends with Ryder, talked about her first big love, Brad Pitt, this way. But after they broke up, and she became a seasoned actor both on and off the screen, Paltrow, like Depp and Ryder, stopped talking like that. Stopped talking about love, period, which means that maybe a part of Paltrow stopped being able to feel that way. After all, how one talks is also how one lives.

By the end of Depp's public declaration of love for Ryder, the promise of forever is mostly shattered. Depp admits that he loves

Ryder "almost more" than he loves himself. This melancholic and narcissistic admission is a red flag: a glitch in the love story, despite his "Winona Forever" tattoo, which he later edited to "Wino Forever." On the surface (his tattooed skin), Depp is literally able to drop his lost object of desire and replace it with something else. In this case, the insignia of purported addiction. This is hardly surprising given the preemptive mourning Depp does in his account of Ryder, anticipating and engraving loss into his relationship at the very pinnacle of their love. If, as Freud argues in "Mourning and Melancholia," melancholia is mourning in advance, the tattoo amendment itself is an affect of grief. Melancholia foreshadows and anticipates mourning. Inscription and encryption, addiction and dependency are close relatives and stand-ins for one another. Even before Depp actually lost Winona, he was *expecting* to lose her. Maybe even trying to. In the case of his tattoo, forever endures as the only constant. Forever *lasts* by describing, tracing, and encrypting what has been lost. What doesn't—*hasn't*—last(ed). It is what comes before and after forever that changes, and it is the addict who gets away with breaking his word.

In "Wino Forever," inscription and encryption are updated and reframed more broadly as *addiction forever*. In *Crack Wars*, Avital Ronell writes that "drugs resist conceptual arrest… Precisely because they are everywhere and can be made to do, or undo, or promise anything. They participate in the analysis of the broken word." The adverb "forever" works in a similar way here—it is everywhere, haunts everything, lingers, "and can be made to do, or undo, or promise, anything." In the case of drugs, or more generally, addiction, in order to break the promise of love—of "forever"—the addict steps in as the figure of unreliability: Wino replaces Winona. Just as melancholia is mourning in advance, drugs forecast and track an unravelling. The addict is the person you were never meant to depend on or trust. Whose promise is broken in advance.

While Depp had to remove traces of his lost love object (all addicts cover things up with their addiction) in order to make room for new love objects that would undoubtedly disapprove of the tattooed remnant, the Winona/Wino alteration chronicles the continuous loop of mourning and melancholia. While Depp chose the word Wino precisely because of its playful, lexical proximity to Winona, the two words are also a record of their split (breakup)— WINO-NA. By dropping the last two letters from Winona's name, Wino was conveniently piecemealed. Yet, Depp could have erased the tattoo completely, replacing it with an altogether new engraving. Instead, Depp enacts only a partial (token, nominal) erasure, so that something that did not last forever could nevertheless forever remain as a melancholic record of what has been lost. It is the dialectic between what is preserved and what has been (unsuccessfully) rubbed out that is crucial here. What the corrective Wino masks, or pretends to, is the exteriority of mourning. "The stomach *became* the tomb," Ronell writes in *Crack Wars*. "At one point [Charles] Baudelaire seems to ask: whom are you preserving in alcohol? This logic called for a resurrectionist memory, the supreme lucidity of intoxication, which arises when you have something in you that must be encrypted." Later, in *Loser Sons*, Ronell elaborates on this trajectory of addiction and dependency further: "As with the plight of addiction elaborated by Thomas de Quincey, one can move only from one addiction to another, even if the second term is that of a cure; the oppression of a dependency, the demand of adherence to the addiction or to that which opposes it, is structurally the same."

In the case of Depp's tattoo revision, the transfer from Winona to Wino, from addiction to cure, and back to addiction, Wino is a hypercathection, which screams, rather than silences. "Winona was here!" Wino wallows—swims—in what is left of Winona. A cheeky ode to alcoholism, Wino is Depp's recovery from Winona. It is Winona, not alcohol, that is the drug. One addiction, as

Ronell points out, serves as a decoy for another. Rather than erasing her, Wino pushes Winona deeper inside (Derrida: "*The cinder is not what is. It remains from what is not.*").

Is love simply a manic episode for the melancholic? Something that always ends in disaster, the way it does for Justine in Lars Von Trier's *Melancholia*? The word apocalypse means, "lifting of the veil" or "revelation." Justine, a manic-depressive Cassandra, is *Melancholia*'s final bride but also its final melancholic. In the film, Justine's wedding day anticipates not only the demise of her short-lived marriage, which lasts all but one day, but the end of the world. Justine is the embodiment of this depressive finality, what Slavoj Žižek refers to as "the melancholy of extinction." Justine's melancholia does not only foresee the end of the world for all of us, but the end of the world is a planet called—cathected as—Melancholia. Freud writes that mania shares its content with melancholia. Addiction, a substitute for the love-relation, as Ronell notes, is often one of the forms that mania takes. Mania brings out the dead, the buried, the repressed, by preserving it. By giving it a tomb. In an interview, Von Trier relayed that a therapist once told him that melancholics tend to act more calm under actual pressure because they expect bad things to happen. In *Melancholia*, the eerily calm Justine comforts her terrified sister, "Melancholia is just going to pass right in front of us." But if that is in fact the case, if melancholia is "a planet that has been hiding behind the sun, and is now passing by us," doesn't that mean that the melancholic has it all wrong? The end is in sight but the sighting is not the end.

Freud:
In melancholia, accordingly, countless are carried on over the object, in which hate and love contend with each other; the one seeks to detach the libido from the object, the other the other to maintain this position of the libido against the

assault. The location of these separate struggles cannot be assigned to any system but the unconscious the region of the memory-traces of *things* (as contrasted with *word*-cathexes).

Both the body and words, which are co-intricated in Depp and Ryder's oral love letters, require editing and rephrasing when things—"*Winona Forever*"—don't go as planned, and death does not part. In both the press quotes and Depp's tattoo, words—*forever, first, virgin*—literally get played out on the body. An inscription appears. An inscription is erased, rewritten, and turned into encryption. What disappears from view—Winona—goes into a vault under the skin. Equally, words go with the body, go where the body goes, go on with and without other bodies: taking the body out of the world and sinking deeper into one's own. Words stitch bodies and lives together; bind them and break binds. The answer to what Depp would do without Winona is provided by the tattoo amendment. Depp finds a way to live with melancholia and the consequent symptoms of mania—addiction (Wino)—not Winona (mourning)—forever, for while mourning is unsustainable (it tells us what we are missing in no uncertain terms), melancholia is (it allows us to live with what we are missing because we don't know *what* we're missing).

Before Johnny, Winona tells us, she was "pure virgin"—unmarked, unsigned. A self-proclaimed clean slate, "nothing," she says, was in her yet. But there is a masculine-feminine polarity to Depp and Ryder's amorous declarations. Winona's testimony of love is more buoyant than Depp's. It has a levity that Depp's melancholy and weighted declaration doesn't. Yes, Ryder is younger and self-admittedly inexperienced. And yes, she is a woman—a girl then—so her "forever" is feminized and thus expected to take a more innocent and receptive form. She thinks forever is "kind of a funny" word because it is her "first" forever. The hierarchal construction to Depp and Ryder's relation is

Pygmalionesque: he fills—encrypts—her with experience (first kiss, first sexual partner, first marriage engagement—"first everything." *Ovid*: "The living likeness of my ivory girl."). He is teacher, and she is student. But how does a woman, even a modern woman like Ryder, gain experience without being ruined? How does an actor of one age survive the failure to endure in another? In the 1938 film *Pygmalion*, based on George Bernard Shaw's play of the same title, Eliza Doolittle's repeated insistence, "I'm a good girl, I am" echoes Ryder's archetypally 19th Century appeal to sexual and empirical innocence. The '90s can be considered Ryder's age of innocence (a movie in which she starred in 1993), for after her shoplifting arrest and public trial a decade later, Ryder, the virgin, became Ryder, the fallen woman. Like Emma Bovary, no experience turned into too much experience.

ADDENDUM

Unlike Winona's seemingly death-free testimony of love, which focuses on Depp's Pygmalion role in *bringing her to life*, death figures prominently in Depp's hyperbolic pronouncement of love: dying for, dying with, dying because of, dying for the one who dies—who wants to, as Depp suggests Ryder sometimes wanted to—which causes the lover to die *with/for* the beloved. As the end of endings—endings as events and absolutes—could be said to define the 1990s, death contains the life of these two '90s lovers and holds it in precarious balance. Life tips the scale of death, and vice versa. Life depends on someone else, and when people are very young, they are still willing to admit to this. Adulthood requires one to learn to live without; to get both used to and good at, splitting up and moving on. Whereas childhood is marked by profound dependence and need. The dependency of childhood gets shaken off and uprooted by trauma and a lifetime of losses. So that what one discovers as one gets older is that

being able to live without people *is* the requirement of life: living without the people you said you would not and could not live without; living without the people who said they would not and could not live without you. And like true melancholics, living with, while all along expecting to live without.

Von Trier's melancholic—inside/outside—construction of the disaster film plays on this Freudian difference. It demonstrates that even if we no longer feel like dying (mourning), something final (melancholia) lives in us terminally. There is no "work of mourning" in melancholia. For the melancholic, identification with and attachment to the lost object is total. "Either we take traits from the one we have lost," Darian Leader writes in *The New Black: Mourning, Melancholia and Depression*, "or, as in the melancholic case, we take everything." In *Melancholia*, "everything" is Earth itself. It is fitting, then, that Justine's severe depression "takes everything" with it. Takes the whole world.

For most of us, life goes on in spite of death; in spite of lost objects and lost worlds and the things (the relationships) that die; in spite of our pledges to die for/with the death of our others; and in spite of wanting to prove our *in*-ability to live. Worst of all, over time, we learn to live without even wanting to prove that we would stop living *with-out* someone. Belief in this world and belief in someone break up like lovers. And as time goes on, we live without admitting to the possibility that dying is even on the table. In the end, this isn't a 19th Century novel, it is late 20th Century Hollywood, and Depp is—or was—a modern bad-boy and an expensive commodity who, at least professionally, out-lived Ryder (he has the tattoo to prove it), and that means some people can't afford to die. They can only pretend to. Can only adjust their idea of what and who is worth living for.

— 2014

2

Ever Since This World Began

"Even when the mouth lies, the way it looks still tells the truth."
— Friedrich Nietzsche

In an interview in *Index Magazine*, Kathleen Hanna of the fourth-wave feminist band Le Tigre talks to the writer Laurie Weeks about the female face(s) of music. Specifically, the facade of the female face when it sings. The face a voice has to put on to sing in the world.

Kathleen Hanna:
I'm also really interested in women's voices on old records, like Leslie Gore, or the Shirelles or whatever. They're singing all

these songs about following men to the depths of the earth, like, "You can drag me down a flight of stairs and I'll still love you," but the quality of the voice always says something totally different. It reminds me of this Judy Garland special where she was doing the most fucked-up things—probably because she was on so many drugs. But every time she sang a happy song, she looked like she was going to cry and when she sang a sad song, she looked really elated. It was really bizarre to have her facial expressions contradicting what she was singing. And Connie Frances got raped and couldn't even talk for several years. So I got really into what it would be like to be a woman with way more constraints than we have now, singing these really fucked-up insipid heterosexual love songs. How do you get your actual voice through that? It's through the quality and the tone. Like, there's sneaky stuff going on in the way they're singing the lyrics.

Like Hanna, I am fascinated by the image of the voice—not just the image of the image—and what's behind Judy Garland's. What is the song (story) of the female face and what does it have to sing through? Live through? What does a song cover-up and what does it expose?

In my first book, *Beauty Talk & Monsters*, I wrote a story called "Kleptomania" that blended real and imagined Hollywood. Partly a ghost story, "Kleptomania" summons the Hollywood repressed: a battleground of misogyny. In the first section, "Judy," three intergenerational female movie icons meet for cocktails at a bar. As actors, as characters—it's all mixed up.

I wrote about Judy Garland and Marnie while living in California. I moved there in 2004 to live with my boyfriend. It was in California, as an adult, that I read biographies on Garland and watched all of her movies and concerts back to back. It was as a child, in New York, that I became obsessed with Dorothy's "Somewhere Over the Rainbow" and the double lyric of the song.

In a deleted take from *The Wizard of Oz* posted on YouTube, Judy/Dorothy breaks down during her iconic song. She doesn't sing "Somewhere Over the Rainbow," she weeps it. Did they want her to cry like this? Did they push her too hard, for too many years? Or did her crying overtake her and "ruin" the take? The director's response, at least on camera, is positive. In the YouTube clip, a wide-eyed, sepia-colored static shot of Garland from *The Wizard of Oz* conceals the animate face that sings the scene when the stakes are highest. In the unused take, we can't see Garland cry when she is singing, and when we do see her sing this song in the movie, she isn't crying. The crying is left out of the scene. Either the face is hidden, as in the case of the outtake, or the face masks, as in the case of the visible performance.

What did Judy look like in this outtake? What we can hear is precisely what we can't see and aren't shown. My feeling is that Judy/Dorothy was supposed to cry during this scene, only not like this. Not this much and not this hard. Dorothy is finally going home, after all. She is sad about leaving Oz, but what is calling her back is supposed to be stronger than the intimate bonds she has forged on her dream odyssey. Yet the line between emotion and real pain—between the emotion you are asked to tread, to supply and bring to a scene, and the real pain that shows up instead, intervening; causing a breach in the fiction and a break in the breach (all the breaches that are enacted and received in a lifetime)—are devastatingly blurred. It's too much for Judy, not Dorothy. It was often too much for her. These are Judy's tears, not Dorothy's, and they are not the result of the fiction of movies, but of the reality of having lived them and made them.

In "Kleptomania" I describe Garland's voice as "a blue bird hitting the windshield of a car."

During the edits for *Beauty Talk*, my publisher asked me to rewrite the sentence from passive voice to active voice, as if it were merely a simple case (and to their mind, error) of grammar.

But where in the active is devastation and toil reflected, and how would it express what had happened to Judy? What was happening to her voice, as well as all the happenings that her voice had always imbibed and thrown up during her singing. That showed up in her face, which aged in a way that had nothing to do with straight chronology. It wouldn't. So in the end I decided not to make the change.

It's not just the act that's an act. It's the voice and the face, and the face of the voice. It's the song, leaving us with so much to wade through, especially in an era of extra-features and culture as tell-all. An era where everything resurfaces, returns, doubles—comes back. Language, along with the face, is a cover-up. It shows and it doesn't show. It doesn't show what it shows or it shows what isn't really there. The face doing something at the moment it isn't supposed to do it. The active covering up what's passive. What's vulnerable, at risk, at stake. What receives blows and cuts. If I'd adopted my publisher's edit, I would have been just another male producer / director / biographer, enforcing the active when the passive (the patient, not just the performer) is the truth. As if being a star automatically makes one a winner and an active agent, setting up a voice's relation to voice that is exclusively active and in control.

A voice in this case—in Garland's case—is grammatical, literal, and figurative. The English passive is periphrastic and derived from the Ancient Greek *periphrasis* ("roundabout speech"), which comes from *peri* ("around") and *phrásis* ("expression"). Unlike the active, the passive tells us how *long* it takes to get *somewhere* ("over the rainbow"). It stammers, slips up. Vacillates. The way isn't straight. The voice cracks. The active voice is the official story. The take that is used as opposed to discarded. Unlike the passive, which takes the long and hard way, and which doesn't grammatically edit, Photoshop, or sidestep, using the active voice in my story about Garland would have resulted in yet another cover-up and evasion. More makeup, more Star.

There is a lot of face in our culture today. Now more than ever. There is a lot a face is expected to do. But I can never keep a straight face when I watch Judy Garland sing. I'm not a singer or an actress, so it's not my job to do that. Yet regardless of vocation, a woman is still expected to perform, and is a natural performer—dissimulator—according to Nietzsche, and others. If it's not her official job, it's her role. Yet, as a heterosexual, seemingly femme woman, I break and queer some of the codes when it comes to physiognomy, which according to most men defies convention based on the facial expressions I either make or refuse to make. In graduate school in the summer of 2011, the filmmaker Elia Sulieman, my professor, referred to me as the "girl who frowns in class." When really, I was simply listening, which includes thinking, to what he was saying. The seams of my thinking and feeling showed on my face.

"Why couldn't the world *that concerns us*—be a fiction?", asks Nietzsche, for whom truth also takes the form of the "apparent world." The world here is not only the world we see, but the world that is shown to us ("shown" is passive. We receive it). Assembled for display. While the fiction consists of whatever we do not see, and are not permitted to, it is also what we are given in *place* of truth, for fiction is organized and mediated by the truth that is not only concealed or falsified, but tampered with and embellished. Of course Nietzsche is right in the sense that appearances cannot be taken at face value. Mere surfaces, as Hanna notes in her interview, never display just mere surfaces, but rather all kinds of concealed, fashioned, and prescribed depths. What is hidden is shown. Or, what is *not* shown is hidden and inscribed in what is. Active standing for passive. Simply showing oneself is not bearing a truth, just as "Talking much about oneself can also be a means to conceal oneself" (Nietzsche, *Beyond Good and Evil*).

Truth, like fiction, is a question of style and invention. Nietzsche inverts the relation between fiction and authorship as

well, so it is not only the fiction that belongs to the author who writes it, but the author who belongs to the fiction that writes them (*being* a writer is a fictional production). Moreover, the *belonging* is a link—a fictional device; the fiction of the fiction—that weaves truth and fiction into dialectic, rather than binary. However, it is not the concern with fiction and artifice—"mere appearance"—that becomes, or has become, the problem, as Nietzsche claims. It is making fiction and mere appearance the solution to all problems, the look of all reality, and the source of every truth.

What truth are our faces allowed to show today? If the digital mediasphere is any indication, nothing is faked and enacted more these days than a face, especially a woman's. A woman's face is something she has to fake all of the time—from the wearing of make-up to the surgical enhancement and modification of facial features, to the lightening of eyes and skin, to the concealment of age, to the facial expressions we make or don't make, to the way we sound. Faking is not only the modality par excellence of late modernity, the fake/r is the thing to imitate and strive for. Based on the 21st century fiction and artifice of celebrity consumer culture, there is no greater truth than a successful lie. Than a lie that functions and succeeds in public, even if and especially when, it inevitably performs its disclosure-as-lie and breakdown-of-truth as just another act (Reality TV; the public apology). The lie, or the secret of ideology, is no longer something to conceal. In the era of cynicism and instant commodification, dissemblance is the only truth worth telling (living). Truth, along with reality, is a performance, performance is reality.

Before we believed that a lie was the truth, we believed that what we were seeing was real, which means we believed what we were told. The fiction was not meant to be interpreted purely as fantasy or pure-fantasy, but as the ultimate-real. Now that we know that the fiction is a lie, that the truth is a lie, we have learned to approach it as such. We live in the name of truth, even

though—and precisely because we know—the name of truth is fiction. We tell ourselves that it's not that we have a more dishonest or corrupt relationship to truth. It is that we have a different kind of relationship with the lie—that is, with the *staging* of truth.

When I watched Garland's performance of "The Man That Got Away" from *A Star Is Born* for this essay, I broke down in tears almost immediately. Garland's heartbreak is my heartbreak. A heartbreak of women watching women. Women being women. It is my invisible (off-camera) face coming undone as it bears witness to the brave face another woman puts on for the whole world. Garland is giving us her heartbreak so that we can survive and better understand our own. Songs and movies are records of the breakdowns that have already happened and that we can now, in the era of deleted scenes, outtakes, and DVD commentaries, watch over and over—both to our benefit and detriment. The heartbreaks we've survived, as well as the ones we haven't, are inscribed and looped in the breakdown of notes that are sung for all of us to hear. And by being sung, shore up and keep at bay just enough to make it tolerable for the rest of us to show and not-show. Maybe it is because I can see and hear how much Garland tried to keep it together for the movies. In order to make movies. How she could do it and how she couldn't. How much fell and falls apart as she performs. And how her voice splits and spites and faced all those cameras for all those years.

— 2014

Behind the Scenes

"For one to whom the real world becomes real images,
mere images are transformed into real beings."
— Guy Debord, *The Society of the Spectacle*

"I don't dream about anyone, except myself."
— The Smiths

I spent the summer afternoons of 1988 pretending to be Olivia
Newton John singing "Physical" up in a barn loft in Maine
because I liked how bossy Olivia sounded. In the music video,
Olivia threatens to fuck not just those fat losers in the gym, but

if I wasn't careful me too. Olivia's blondeness makes men put up with her aerobicized commands as she tries to act heartless. I'd only ever seen Olivia in *Grease*, so it was hard to reconcile the tough-love gym instructor of "Physical" with the cheerleading high school pushover. The only way to understand Olivia's behavior in "Physical" is to view it as an extension of her transformation from goody-goody "Sandy 1" to spandex-clad "Sandy 2" at the end of *Grease*. "Physical" picks up where "Sandy 2" left off. Exhausted on the treadmill, men run to and from Olivia. In the song's chorus, Olivia sings, "Let me hear your body talk." Yet, stranded in the song's call for a female sexual initiative, the true lyric of "Physical" reflects the loss of a strong male alliance—a fear that plagued the 1980s. The body was shoved into fitness centers around the country and dealt with accordingly.

In the video, Olivia stands in front of a room full of frazzled, overweight men and comically harasses them into shape like circus animals with her voice and body, with her act; her image is reflected six different times in the gym mirror. Her pseudo-aggression is reinforced through multiplicity and repetition. Six Olivias are better, hotter, sexier, and stronger than one. Each man gets a copy of her. Each one has something to look at. In the afternoons, in between the beach and the girls at the cottage, I'd wear my mother's clothes and gold headband and hop around the hayloft to get in the mood. Like any decade, the '80s had a tone of voice. A color and an emphasis. Whenever I think about my mother's clothes, I remember the stars I pretended to be when I was inside them. Anything gold or metallic—fairy-dusted and shimmering—allowed me to morph into women like Olivia and Jamie Lee Curtis. Women arranged like chess pieces in a maze of locker rooms, dance clubs, and LA dramas. As a child, I imagined accepting the Oscar dressed in something from my mother's closet because it never occurred to me that I'd have my own money, my own clothes, or that time might make my mother's enviable wardrobe less desirable to me.

By proxy, I'd also long for John Travolta, who was dark like me, and whose name is mixed into Olivia's (Olivia Newton *John*) like a final ingredient. John had cut songs on 1983's *Two of a Kind* with Olivia after they'd made *Grease* together. Neither of them believed they could pull the album off on their own, so they combined, using the recipe of two to get down to the power of one. Inside the album's fold-out cover, which I'd peeled open and tacked to my wall, their heads are twinned, fused together like flowers knotted on a single vine. Siamese twins. One blonde, one dark.

Olivia and John had starred together, shared screen-time, sang duets, danced, vouched for one another. Fucked, or acted like they did. Unlike in *Grease*, on *Two of a Kind*, Olivia and John are modern adults. They are present-tense ('80s), instead of vintage ('50s), so things aren't just suggested, they are stated and contrived. The entire album is a clue. Only I wasn't interested in the pair's singing, or the songs themselves, which they sang but didn't write, but in what the songs revealed about their relationship and its market-mythology. What were Olivia and John doing in the recording studio that I couldn't see? And what could I see by listening to them sing? Instead of watching desire play onscreen, I went backstage, behind the curtain to listen for signs. Seeing things offscreen allowed me to assemble an onscreen story for what was happening. The body is a melody that often makes a lyric irrelevant.

* * *

In *Blow Out*, John as Jack Terry, takes the denotation of sound and turns it into a forensic science as a special effects soundman that discovers a crime by listening to it. Out catching noise for a film one night, Terry accidentally records, and therefore witnesses, a murder. In the movie, Terry spends most of his time alone, aurally stalking his surroundings. Trees and birds swish and

brush against his atomic tape recorder, a sponge that sucks up both the tiniest and biggest of historical forces and happenstance: Kennedy at Chappaquiddick, Watergate, the JFK assassination. In Jack Terry's bag of sound effects harvested for horror movies, car crashes fall like trees in a forest that no one hears and testimonial sound becomes a stand-in for vigilante justice. Unlike the male vigilante films of the 1970s, the 1980s hard-body films, explains the film scholar Susan Jeffords, suggest a different social order. Heroes like Jack Terry don't defy society, they inadvertently defy governments and institutional bureaucracies "who are standing in the way of social improvement" by being at the right place at the wrong time. The vigilante hero is thrown like a football past the threshold of society and is alone, a primary theme of Reaganism.

Blow Out (1981) is a reimagining of Michelangelo Antonioni's 1966 film *Blow-Up*, a title that refers to the photographic process of enlargement. In *Blow-Up*, a series of prints are repeatedly reproduced, blown up, viewed and reviewed, in order to increase perception. *Blow Out* refers to the reverse: a surfeit of sound that requires distillation in order to pick out the almost inaudible tone of certainty. Both films are preoccupied with repetition and return as the mechanism for recouping social relevance and new technologies allow for unexpected reencounters with history and historical trauma. In her book, *Death 24x a Second: Stillness and the Moving Image*, Laura Mulvey points out that "a return to the cinema's past constitutes a gesture towards a truncated history... Such a return to the past through cinema is paradoxically facilitated by the kind of spectatorship that has developed with the use of new technologies, with the possibility of returning to and repeating a specific film fragment." In both films, narratives move around the stasis of death in order to unearth a previously undetected detail, and the delay in time—between the sequence of events, the murders in question, and their register (sound and

photographic print) through mechanical witness—reveals a truth that has lain dormant.

The title *Blow Out* refers to breakdown, while *Blow-Up* connotes climax and embellishment—the irresolvable problem of constructing history and framing the past. Recording a more recent historical trauma (Watergate), *Blow Out* is anchored in real government corruption and conjures power outages, black-outs, power failures, breakdowns in communication, failed narratives: scenes of history. In light of the Watergate scandal, sound acts as the more substantive and historically relevant evidence, forcing Thomas from *Blow Up* and Jack from *Blow Out* to cobble their narratives of verisimilitude on their own.

When John Travolta was signed for the role of Jack Terry, studio executives at MGM wanted to cast Olivia for the part of Sally to cash-in on an onscreen rapport jump-started by *Grease*. But Brian De Palma vetoed the request, instead casting his real wife Nancy Allen in the role, who had acted with John in *Carrie*.

* * *

After dancing to "Physical," I'd pretend John was one of Olivia's dance pupils and had stayed after class to talk to me. He wasn't like other boys, I told myself. He was a male anomaly, though signs of difference are never coherent in his films. The movies tell me I want him. I was dressed in the clothes Olivia wears on the album cover: red-hot tank-top peeled back over her shoulders, white head band keeping her moist hair from her face. Her California visage—a mini-sunset—in profile and tilted back, mouth unfastened like a seatbelt. She is blissfully fatigued after a workout, sex, or sex with herself. You can't see the rest of the picture.

Upstairs in the barn, I'd sit on a block of hay in the dark and let John feel me as Olivia, which I did by feeling myself, or imagining a movie scene I could crack open and scramble. Walk into by splicing myself in. I longed for John because Olivia did.

I wanted what she wanted. Or I wanted what she acted like she wanted because it's often easier to act on an established desire. Easier to borrow and reuse from images than to build and test in your own life from scratch. I could work off an already existing script, material, cast of characters, set of scenes, and then I could recycle and edit. I could alter. I would switch.

I assigned roles and personalities to parts of my body so that they could act the parts or the body of some other body. My body played multiple roles. My eyes would end up being my mouth because they were what I was actually using to kiss with. I was looking at myself kiss and seeing the whole thing play on the screen in my head, or at least I'd see what I could remember seeing. I'd drag in a scene I wanted to work with, like an animal dragging a smaller, dead animal into its cave to devour it in peace. I'd walk into a movie's pivotal scene, into the point I wanted to start from, and hijack it. I'd sneak in through the back without paying. I'd climb in through the window and try to seduce the sleeping boy. I'd mull over a part in a movie that I liked, wanted to grasp, be in. A movie that I'd circled and returned to for some unknown reason, a magnetic field pulling me, and then I'd draw that part back like a curtain.

Sometimes I thought about the way film boys kissed film girls and wondered if film girls and film boys did things differently—kissed differently—offscreen. Does one act a kiss the way one acts everything else in a movie? Kisses are always vèritè. Kisses are how actors blur the line. How much of a person is in an actor and how much of a person isn't? The body is at a fictional disadvantage because it can never fully shed traces of itself. It can only change by shrinking or enlarging in weight. Otherwise, a body is locked into place. You can change the person you want to play, but you cannot trade the body for another body. In *The Karate Kid*, which I also saw as a child, Ralph Macchio's real walk—all in the toes, pulling off from the Achilles tendon, so that the heel is always suspended—is never Daniel, it's always Ralph. Daniel

and Ralph are both Italian, working-class. Ralph gives full-bodied embraces, sloppy kisses—mouth open too wide for acting. Did both actor and character desire the WASPy Elizabeth Shue, who put Harvard on hold to make the movie?

When it comes to the onscreen kiss, who does it belong to? The character or the actor? Is it Daniel's or Ralph's? Does the kiss belong to the fiction of a film or to an actor's real life? Is desire diegetic or non-diegetic? In movies, kisses are rarely forged, and neither are birthdays and height, which are almost always non-diegetic because they're outside the given story. The body isn't required to act. It's along for the ride—the ultimate prop. It's a vessel that chauffeurs a person around from place to place, scene to scene, feeling to feeling, part to part, movie to movie. Maybe that's the only kind of life an actor ever really has.

* * *

In DVD commentaries, actors turn into viewers and become their own identificatory site (image). Actors often admit they hate watching themselves. Is this because watching something they did while being inside, from the outside, snaps open the lock of dualism? Onscreen and offscreen? Front and back? Here and there? Is it like being in two places at once? Actors often claim that watching their own performances makes them feel self-conscious—fatal for an actor, like looking into the eyes of a camera, which are really our eyes. Actors have to stay *in* the picture. Or is it because as viewers—more specifically, viewers of *themselves*—actors would be forced into our real shoes instead of fictitious ones? Is it too much to juggle the inside and the out-side, the onscreen and the offscreen, when pretending? In DVD commentaries, offscreen eyes inform and review the onscreen body disrupting the flow of contrivance, so that the offscreen exposes and reveals what's happening onscreen, and the inside comes from the outside. Actors take shape through representation,

by physically materializing, so the absence of face and body requires a re-imagining of the viewership role.

On the 2005 *Karate Kid* DVD commentary, director John G. Avildsen mocks Ralph's noticeable gait, his perfect 50/50 boy/girl face, and Ralph says, "Yeah, I always walk from my Achilles heel. My Achilles heel has always been my problem." This private admission—revealed not through promotional text or onscreen body, but through a supplemental (non-diegetic) voiceover that wasn't there initially, but affixed later on—reinforces his character Daniel's cinematic struggle with physical vulnerability, linking onscreen and offscreen via a shared weak spot in the body. In the commentary, I can hear Ralph's discomfort the way I can see Daniel's shame acting out in the movie.

In *The Karate Kid*, the individual male, ethnic, and working class body itself is the Achilles heel of the larger national, masculine body, and in order to understand it, Daniel's is deconstructed and slowly reassembled like an old car. His is a body that garners strength through the deliberate, menial, and symbolic: sanding floors, waxing cars, painting houses and fences. It learns, trains, and becomes (emotionally, not necessarily technically) "skilled" via general tasks (labor) whose spiritual significance is slowly unveiled. This, the film points out, is the one thing the rich blonde villains in the movie have never had to do. For them, the body is a playground, a joyride, like every other machine they cruise around in. Through labor, Daniel discovers the "divine" (karate) and it is intention that leads to the rescue, rather than the triumph, of the body. As in *Rocky* (also directed by Avildsen), the "fight" is won via (immigrant) manual toil, thereby situating the body within a caste system. Bodies at the top and bodies at the bottom. "The more you watch him move, at night, working out, pushing the body against darkness and winter cold," Lidia Yuknavitch writes in *Real to Reel*, "the more it is true, it is the film of a man and not the man, or it is the man caught on film repeating himself."

Daniel, the name of a real-life boy I loved, and who I met in the same town I saw *Karate Kid* in, has what Dorothy in *The Wizard of Oz* has, has what every hero/heroine in popular American cinema has, an inner compass that cannot be shoved or knocked out the way teeth can. In the Hollywood movie, what is beaten, tested, and deplored is the very thing that cannot be terminally destroyed; the thing we know will heal by the end of a film. Cuts and bruises are merely illustration in the Hollywood movie; Post-It notes that allow the viewer to track the fiction and determine how much farther the hero/heroine has left to go in it. The worst injuries come right before the end, and the face, a sacred movie paragon that never (except perhaps in the horror genre) risks defilement, is routinely spared visible massacre. Pain is something a movie viewer has to imagine or take with a grain of salt, thereby, in some sense, avoiding it altogether. "Because the characters often live against all odds," writes Claudia Rankine in *Don't Let Me Be Lonely*, "It is the actors whose mortality concerns me."

The shiner that Daniel Larusso hides behind his sunglasses the morning after his first beating marks him as the film's body-with-a-heart. Daniel is trained to face not the adversity of his body, but the adversity of his eye/I. Meanwhile, the militia of blonde boys fights like soldiers at their SoCal dojo.

The offscreen Daniel came into my life after the onscreen one did, and when he appeared, I felt I was finally being given the chance to exit the cinematic frame. Rather than fight for a body's survival, like Daniel, a boy, I wrestled for the chance for my desire to see the light of day. My thoughts leaving the confines of a dark ship. If I could accomplish this, my body would catch up and be fine. In *The Karate Kid*, Ralph walks, from scene to scene—a nomad made up of scripted moves—in Daniel's shoes. When I came out of the movie theater, after years inside, my eyes ached from the patina of the real world.

* * *

In 1985 Jamie Lee Curtis made *Perfect*. In it, she, like Olivia Newton John in the "Physical" music video, plays an LA aerobics instructor whose body is the point. It's the point of her character's life in the movie, of the movie's plot, and of Jamie's onscreen and offscreen livelihood. In *The Karate Kid*, the body is also required to triumph, but unlike Daniel, who has to reestablish his prowess with each new *Karate Kid* sequel like a bad dream, re-entering the costume of the body in order to activate its pendulous strengths, Jamie achieved her victory a decade beforehand, earning her right to flaunt and shed her accumulative armor in future roles. By the mid-1980s, Jamie was after body maintenance, not a brand-new car. Although the body is a character in *Perfect*, or the role belongs to the body, the body, unlike the role, belongs to Jamie, not Jessie, who wears it like a costume for the part. Two equally similar androgynous monikers (Jamie/Jessie) allude to the diegetic aspect of the body, which struggles to be in two different places at once, as do the names themselves (Jamie's name and body have both been famously mythologized for their gender ambiguity off-screen; an opportunistic utilization that crossed over into film). While actors are routinely asked what it is like to play a certain character or part, they are rarely asked what it is like to play another body. Unless that body has been theatrically reconfigured through special effects, costume, or makeup. Unless the *point* is to change the body, making the body subject rather than object.

Perfect came out after Jamie spent an entire decade in the horror genre, which due to her mother's own horror movie past—death in the shower in Hitchcock's *Psycho*—she became heir to. Their abject mother-daughter paths crossed in 1980 when they co-starred in John Carpenter's *The Fog*. Jamie often referred to her famous absentee father, Tony Curtis, as "a ghost." By taking a name from both her mother and her father, Jamie makes use of her real and imagined ties with the spectral.

While a lack of explicit, or unspoken body (the body being a kind of elephant in the room in the horror genre) in *Halloween* (1978) saves Jamie from being murdered by her incensed, one-track minded, psychopathic brother Michael, it is her explicitly articulated body, disrobed in *Trading Places* (1983) and *Perfect*, that gave Jamie's acting career a second (after) life. Having managed to save her horror-bound existence on a diet of sexual modesty and repression that immunizes the female in horror, and allows her to become indestructible and indeterminate in the form of the Final Girl, Jamie got to celebrate her 1970s bodily endurance in the 1980s. For years, Jamie was called "The Body." The body that survived? The body that wasn't destroyed? Throughout the eighties and nineties, Jamie was asked about her body. She often told the press, "While they're up and firm [her breasts], why not shoot them once or twice." *Perfect* provides the diegetic link between the female body and horror.

Sometime in the early 1980s, John Travolta claimed Olivia broke his heart in real life the way he broke hers in *Grease*. Given his trauma—diegetic pain overlapping with non-diegetic pain— and the baggage he was hauling around because of it, I tried to be extra understanding, to put aside my jealousy and suspicion, to make it up to him. As a way to meet John and get him to make it up to me, I interjected myself into a movie at a pivotal moment. It was similar to slipping into a disguise (the drag of acting) in order to assume someone else's identity in a Shake-speare play; tricking them into reciting their lines to you instead of the person assigned to play the part. Sometimes, as the movie *Shakespeare in Love* demonstrates, you have to enter the body of the beloved to become the beloved. I was John and I was me. I was John and I was Sandy up to a point. In the dark I asked John all the questions Sandy hadn't asked in *Grease*, that she should have, that I wanted her to; that should have been in the script, that should have been her character, that I screamed at the TV set whenever John was acting like an asshole and a group song

just wouldn't cut it. Questions that had Sandy asked would have made the film cease to exist. Things have to go wrong in order for there to be a story.

In *Grease*, John never listens to Sandy. He's too busy pretending he doesn't love her or asking her to change so that he won't have to let his guard down in front of all his guy friends. I imagined John looking at me. Hard, then soft. It was the hardness that made it feel good. It was the hardness that finally made his gaze go soft. Underneath a sky of stars, I finally had one for myself. We'd switched places and John switched without objection, sliding right off the screen and into my seat. "I can't keep my eyes off you," he said. I closed mine and mouthed the words to myself until I could feel them, like any good actor trying to get their lines right. From the outside of that dark loft in the barn in Maine, lost in a maze of hay, I must have glowed and flickered like a little screen.

I wanted to respond to John's touch. To climb right into it as though it were a car and drive off with it. To fly as though John's touch was the caged Lovebirds that Tippi Hedren drives to Bodega Bay in *The Birds*. But those Lovebirds are more than just birds. They're part of a continuum between the kinds of brightly-colored acting birds that live in cages and the liminal black birds that fly off the screen, wildly pecking at our shared fantasies. I wanted a person somewhere between character and actor, between story and life. But I didn't kiss John or succumb to the new script. This is where people always get lazy in a movie. Instead of pushing through into some kind of understanding, they look for quick exits or slip into predictable patterns: kissing, silence, omission, happy ending, *The End*.

I wanted to be Sandy and not Sandy. Sandy for a minute, me for the long-run. In *Grease*, we never get to really see John squirm. His friends make him uncomfortable, or he makes himself uncomfortable, but Sandy's too busy trying to give John what he wants. I'd use Sandy to get in, wear her costume to get John's

attention, building on the intimacy between them, but I'd go further than her. I'd move past the mimicry and song. I wouldn't just dress myself up to please him. I'd get to the bottom of it. I'd be Sandy to get into the club, but once I was in the club, I'd dance like me.

I felt like Whoopi Goldberg in *Ghost*. The part where Patrick Swayze has to temporarily break into Goldberg's body at the end of the movie in order to have one final encounter with Demi, who in the film's possessive denouément, is actually having a lesbian experience with Whoopi, who is not psychic at all, just symbolically permeable. Whoopi is the restorative conduit for Patrick and Demi's prematurely terminated white romance. Like John, Patrick can't talk either, could not say what he wanted to say ("I love you") when he was alive. Just: *ditto, ditto, ditto*. Swayze is the return of the repressed who comes back from the grave—via Whoopi—to say all the right things to the woman he loves the second time around. As corporeal prime real estate, Whoopi's racial otherness is invaded as affective geography to resolve Patrick and Demi's marital problems. What they do requires a third person. A third person is often in the picture.

* * *

I remembered the first time I saw John. He was on TV helping Nancy Allen—who gives him blowjobs in the movie—dump a bucket of pig's blood all over Carrie, who had never sucked John's—or anyone else's—dick. I bet she could have torn it off and flung it across a room just by looking at it. I bet that was the problem. The power to freely do things with your thoughts that you cannot do with your body. In the 1981 movie *Scanners*, thoughts also kill. Though, in this case, the impulse to kill is entirely masochistic and scanning involves a psychic identification and empathy that results in pain—nosebleeds, nausea, stomachaches, earaches. Being "plugged in" (Carrie gets assaulted

with a similar phrase while showering in a locker room and getting her first period in the opening scene of the movie. A gang of sadistic high school girls throw tampons at her, while chanting, "plug it up!") leads to intense psychic pain, but is also an antidote to narcissism. Non-scanners force scanners to identify with them until their heads break off their bodies, which sounds a lot like love. Telepathy is heterogeneous, a kind of pluralism because it allows you to hear and feel more than one thing, for more than just yourself. At the prom, coated in blood like a bird pinned down by an oil spill, Carrie can hear everyone's voices and has to cover her ears.

Perhaps the rehearsal for the blowjob scene consisted of John getting his actual dick sucked by Nancy's actual mouth. Isn't he method? Aren't men usually method? Movie John could cum in movie Nancy's mouth, but not in real life, because from 1979–1983, she was both filmically and sexually contracted to Brian De Palma, who as the director, watched his wife fake things. It was Nancy who was originally supposed to play the Carrie role, while Sissy Spacek read for the part of Chris Hargensen, the movie's incorrigible female "monster." De Palma made them swap parts. A few years later, Debra Winger was recast as the female lead in *Urban Cowboy* because, according to Winger, Sissy Spacek and John Travolta had a falling out.

The night I saw *Carrie*, I was in some old man's TV den in Yonkers, NY, where Nancy was born, while my parents ate dinner with him and his guests. The old man was an art collector. After I finished eating, I asked my mother if I could watch TV. I sat in front of his television, kneeling by it like the little girl in *Poltergeist*, who died in real life but lived in the movie. Like her, I used my body to imbibe the horror the way a thick curtain sucks up too much sun. Having missed almost all of the movie, I had no idea what Carrie had been through before detonating the high school gymnasium. Under her spell, I was afraid to leave the room as Carrie made the cars flip over and crash. Maybe if I

moved, I'd flip and break too. Carrie was already outside in the parking lot, after having escaped the fire she started. She walked through the fire unscathed like a magician, arms stretched out like a zombie, in a sexy white slip that wasn't sexy on her at all, that should have gone underneath something, but that she wore like a heart on a sleeve, immune to the flames and to the heat, which was finally rising out from inside her. No more shame.

After *Grease* it was reported that John liked Olivia, or loved her, or wanted to have sex with her, or did, or talked about how he never got to. In real life, Paul, an older gay friend from Provincetown, told me that he used to "hang out with John" at the *Paradise Garage* in New York in the '70s, and that they got "physical" too. Or John did. Paul said John was "a regular" in a sea where only men were regulars. I was seventeen.

"Put two and two together," Paul said and rolled his eyes when I probed him. Using the look on his face to expose the secret.

He said, "You do the math," like we were solving a crime and he needed my help.

Paul took orders and waited on tables at *Bubalas*, the restaurant we both worked at in Provincetown. I refilled glasses with water, replenished people's breadbaskets, and cleared the tables. I carried bins of dirty dishes back and forth all day, building the muscles in my forearms. Paul smiled at the customers, acting through his long shifts. He was in front of the curtain, I was behind it. He was the actor, I was the editor who came in afterwards to clean everything up. It was why I took the job.

During my shifts, I'd fold my long hair up in a bun and throw on my required *Bubalas* t-shirt. After my shifts, I'd let my hair unfurl again, like a roll of film. The day went back and forth, a panorama of waves surrounded us. Our skin was always covered in salt and the dream of seawater. I'd put on new clothes, a dress, and the cooks would ask me out, acting on the worn-out cliché of women who switch from cinematic outcasts to sex pots

simply by letting their hair down or taking their glasses off (Jean Rhys: "The looks on their faces when she goes from being the frump to the fox."). From blurry to in-focus, cinematic makeovers concern an erotics of *re*-seeing. Like a mirage in the desert of desire, what the male lead imagines and wants to see, magically appears before him. The change is supposed to signify a heightening of consciousness on his part, but in actuality, is aided by the female lead morphing into the very thing he wants to see. By submitting to a cultural standard, it makes it easy for a man to finally love her. How he sees does not change. Rather she changes into the thing he wants to look at. Sandy does the same thing at the end of *Grease* and John gets all the credit. He finally admits to loving her, but why does he love her? Is it the body? Is it the clothes? She becomes him in order to be with him.

When the restaurant was quiet, Paul would give me cigarettes and serve up more Hollywood dish. It was before the internet, so he'd spent years reading tell-alls—authorized and unauthorized. He had dirt on people we only ever saw in an indirect way. People we saw but never talked to. We'd sit on industrial-size buckets of mayonnaise in the parking lot and look at the bay. We'd see: The sun drop. The first night star. The moon on the water. Long Point. Low tide. High tide. Our thoughts would swim around the same subject in different ways until we'd come up for air.

Paul said, "I never saw Olivia Newton John at *Paradise*." Olivia was in Australia with her family most of the time, or on tour promoting her albums. In 1982, John and Olivia declined to star in *Grease 2* because what more was there to say and do? They'd graduated from the ultimate caste system and floated up into the clouds to die—so intense was the euphoria of everybody getting what they wanted. For no apparent reason, the high school gang had somehow died and gone to heaven in a flying car. All this made it easier to go their separate ways and for us to do the same. The end of a Hollywood movie is often equivalent to Nirvana. "It is when a movie is full-square on the wall," Fanny

Howe writes, "that there is nothing more in life to chase after. There is no future. You have reached bliss."

Before putting his cigarette out, Paul told me that John used to hang out in the back of *Paradise* by the payphones and red bathrooms. He said it reminded him of De Palma's menstrual interiors—"all that red"—the pig's blood in *Carrie*, the Siamese twins in *Sisters* who are violently split apart, never to recover. John would stand there talking, not signing autographs. "Everyone was giving or getting head."

"An autograph would have somehow been proof, evidence," Paul said.

I pictured Paul's mouth all over John's five o'clock shadow. I remembered pretending to kiss John in the barn in Maine as a child. During the *Blow Out* shoot, John was pale and suffered from insomnia. Paul would leave *Paradise* at 6 am.

"A lack of sleep helped him create a moody performance, and it's why his character is so convincingly paranoid in the movie," Paul explained.

"I find his exhaustion very sexy. It's like he's sleepwalking, at the end of his wick. Melting like a candle. And the mystery is solved just before the candle blows out. The point is what's on the other side of that sound? Just like in *Blow-Up*, what's not in the image? People are like that, too. Actors especially. Actors are people up close. Actors are people we pay attention to. The image doesn't actually tell us anything. Only arrangement does that. Putting two and two together."

I nodded.

"Because John and Jack are so weary in *Blow Out*, they're able to hear things. They're open. Towards the end, Jack doesn't even need a sound 'detector' because he's like a dog. He can hear everything. His ear is the technology. His body doesn't fight back anymore. And he believes what he hears because he's no longer naïve about America."

"But he's not an insomniac in the movie," I said.

"No, but offscreen he is, and offscreen tells a story that ends up on film. Like an x-ray. It changes how he acts. What he can play. It changes the image that develops on film. That's why *Blow Out* is an elaboration on *Blow-Up*."

Then Paul changed the subject. "John tried to fuck me in the *Paradise* bathroom once."

"Did you let him?" I asked, excited.

"What do you think?" It wasn't a straight answer, but no story is.

In the end, I don't know what John really wanted, had, or got. Some wants, needs—stories—sound better out loud than others. But for years, John kept going backwards and forwards like he was dancing.

"He's such a liar," Paul said.

"Who?"

"John."

* * *

"Have you ever noticed how everyone gets well by the end of a movie?" John asked while reaching for places I shouldn't have let him go. Not off the bat like that. Not with our huge age difference and not with all the bullshit I put up with all year at school after traveling thousands of miles, hours on a plane, from Australia to Rydell High. Not after one vague, half-assed apology in the dark, where no one could see or hear us. Where it didn't really count. No camera to prove it.

While unzipping his black jeans. While slipping off my sweaty, red workout T-shirt, turning me around. I liked it better when I couldn't see him, when I could only hear him whispering to me in the dark like a movie. Television with the volume turned low. It was the way I watched it sometimes: in bed, rolled onto my side, my back to the screen, just listening, like Jack Terry. Trying to fall asleep without shutting the TV off. Afraid of the

room without it, afraid of myself without it, afraid of the gap in between. I'd lie there hoping not to plummet down the black rabbit hole wedged between my life and the movie. I'd lie there with just the voice of the movie next to me, like a nightlight left on for children who need a compass for the dark. A lighthouse waving circular beams across the water. Only the TV light was on. From my bed, I watched it on the wall in the shape of a cloud, flitting. A black shape encroaching upon everything, darkening the theater. A shadow over the forced-entry light. I wanted to stay in character. I could project anything on to that screen. I could play whomever I wanted. There was nothing else to do.

— 2009

4

All an Act

It's not me.

"You don't so much have a face. You slide into one."
— Deleuze & Guattari

I was almost twelve when I saw John Cusack on the street and thought he was Lloyd Dobler. I was with my best friend Lena. We were waiting to cross the street in New York City. We saw a black trench coat. A tall man waving his arm impatiently on 8th and Broadway. We saw a short, nervous woman with long brown hair beside him, and we thought she was Diane Court from *Say Anything*. We couldn't believe our eyes, but we wanted to believe them. *Say Anything* had come out the year before, and Lena, older than me, loved it more than I did. Quoted from it. Played the song that defined the movie. Had a poster of *Say Anything* on her bedroom door, with Lloyd holding his boom box above his head outside Diane's window. His sonic heart blasting into song.

Like Lloyd, Cusack had black hair and moon-colored skin. Like Lloyd, he was wearing a trench, baggy cargo pants, and Nike high tops. What came first, the clothes or the movie? The character or the actor? Cusack himself once admitted, "Usually I do everything in reverse. I practice something in movies and then I try it in real life."

Lena and I could tell immediately that something was wrong because Lloyd was yelling at the woman, something Lloyd would never do. It was cold and he was pacing, like Lloyd. But he was belligerent and petulant, not like Lloyd. From only a few feet away, we watched Lloyd yell at the woman.

"Get in the *fucking* car," he ordered when the cab finally came. "*Now!*"

The woman got into the car. Then Lloyd climbed in after her, slammed the door, and was gone. Until that moment it had never occurred to either one of us that the man we loved onscreen wouldn't be exactly the same man offscreen. Or that the man was actually two men, two separate things, and that the screen and the real world were two separate things too. Until that night, the screen was real. Lena and I asked ourselves how Cusack could play Lloyd if he wasn't Lloyd? That is, if you could become something in and for a fiction; if a fiction could make you someone or something else, why couldn't or wouldn't you be it for real? Who and what were we looking at? Who and what had we seen? Who and what is a man?

Shortly after *Say Anything*'s release, a female fan approached Cusack at a bar and asked him, "Are you Lloyd?" His answer, "On a good day." Cusack himself had once told an interviewer that he "felt close to Lloyd" in *Say Anything*. Adding, "Only I'm not as good as him. Whatever part of me is romantic and opti-mistic, I reached into that to play Lloyd. Of course, now it's all gone. Now I'm just bitter." I would later learn, it wasn't about one or the other: real versus fake, onscreen versus offscreen. Lloyd Dobler versus John Cusack. It was about doubling. Using

one person to be another person, so that you could be more and less of yourself. A hybrid. An ideal. A fiction.

In Ingmar Bergman's *Persona* (1966), Alma tells the stage actress Elisabet Vogler, whom she's been hired to nurse, "Nobody asks if it's real or not, if you're honest or a liar. That's only important at the theater, perhaps not even there." In *Persona*, two women—two images—consolidate to make one. Two different faces are not two separate people. Rather, they are an amalgam of who you are and what you are not. What you wish you could be and what you pretend to be. Bergman wanted the two women, the two characters, the two actresses—Ullmann and Andersson, who had both been his lovers at one time; whom he had worked with and lived with; whose faces he had tracked and studied on camera; who were characters in his films as well as real people in his life; and in whom he saw himself, having been gravely ill and depressed like Elisabet—to fuse the way they had for him. The way they did for us. The way things do onscreen. But also, so that two different faces could become one face. One person. One woman. And then you wouldn't have to ask yourself what and where you were seeing what you were seeing. When and where you were being yourself.

* * *

For thirty years John Cusack has been profiting from his iconic double by exploiting the cultural and romantic agitprop of *Say Anything*'s Lloyd Dobler, who has become Cusack's idealized cinematic male alias; informing every movie role he's done since, and "draw[ing] the spectator into a specific path of intertextuality," to quote film historian Richard DeCordova, "that extends outside of the text as formal system." On the blog *Rap Sheet*, writer Chris Knopf offers a description of Roy Dillon's disaffected yet charming con-man in Jim Thompson's 1963 novel *The Grifters* that could just as easily be a description of

Cusack (who plays Dillon in the movie version), specifically, Cusack as Lloyd Dobler: "The protagonist, Roy Dillon," Knopf writes, "is a natural at this game. Beguilingly ordinary and unassuming on the outside, the kind of guy everyone likes to talk to, everyone immediately trusts. He's highly intelligent, resourceful, courteous, and responsible—a paragon of respectability." *Say Anything*'s director Cameron Crowe has similarly described Lloyd, calling him a "warrior for optimism." And journalist Sarah D. Bunting observed that with *Say Anything*, "Lloyd, the character, became conflated, in the minds of many girls of a certain age bracket, with Cusack, the actor."

Years later, when Harold Ramis, the director of *The Ice Harvest* (2005), another neo-noir, was asked what made Cusack right for the part of Charlie, he answered, "I think people perceive John as a good person. I think that because they perceive him as a good person, as long as he's alive [as a character], there's the smallest glimmer of possibility for redemption." For one viewer, this perceived goodness and possibility of redemption was so overpowering, it resulted in wishful thinking in the form of revisionism. On the commentary track for *The Grifters* (1990), Donald Westlake, the movie's screenwriter, recalls meeting a young woman at a party in 1991, a year after the *The Grifters* was released. According to the woman, Roy Dillon was still alive. "But that's impossible," Westlake protested, "Roy gets killed." Yet despite the bloody equivocality of Roy's death, the woman continued to insist that Roy was not dead. The very last thing we see, as Lilly (Roy's mother) drives off with Roy's money, the woman informed Westlake, is Roy running across the street.

Since Hollywood is known for keeping people alive onscreen, often at the expense of realism (a tradition Robert Altman mocks in *The Player*, a study of the movie industry, and in which John Cusack and *Grifters* co-star, Angelica Huston both cameo), daring filmmaking is often equated with a willingness to eradicate primary characters. The female viewer's recovery of Roy that

Westlake relays, then, is not only symptomatic of Hollywood indoctrination, but the resonant and indispensable subjectivity Lloyd Dobler has endowed Cusack with, and vice versa—what Ramis refers to as Cusack's "perceived goodness." So that even when Cusack has tried to forsake his participation in the sanctity of mainstream narrative by playing killers (*Grosse Pointe Blank*, *War, Inc.*), or staging his death onscreen (*The Grifters*, *Max*), fans can't resist the urge to recuperate or resuscitate him. For without Roy, they believe, Cusack can still exist, but without Cusack, Lloyd cannot. "The actor cannot be said to exist simply at the level of film form," writes DeCordova in his book *Picture Personalities: The Emergence of the Star System*, and Westlake's anecdote testifies to this. In the case of Roy, the female viewer that Westlake describes looks beyond the film form (the non-diegetic)—the movie's ruthless fictional terms—to remedy what she sees as an unbearable conclusion.

As viewers, we often have one foot in a film and one foot in reality, so when it comes to the stars we love, we look to the fiction or we look for a way out of it, depending on which outcome is better. This adds a new layer to the cinematic fold. "We can note a number of levels at which the actor-subject is constituted as an instance exterior to its appearance in form," DeCordova writes, and "each is predicated on the knowledge... that the people whose image appears on film have an existence outside of that image." Perhaps Stephen Frears, *Grifters'* director, was less sure about the dual tenancy of the actor because (at least at the time of shooting) he believed that once an actor plays dead they shouldn't continue to appear in the film in which they've died. Frears waited until the very end to shoot Cusack's bloody death scene in *The Grifters*, concerned that once dead, Cusack might fail to come alive again as an actor. It's possible that Frears superstitiously believed that death, however staged, wasn't something one could rise above even in fiction. But what does it mean to *play* dead, and what exactly was Frears afraid it would lead to or

inhibit? Was it Cusack's acting ability that worried Frears (who said that Cusack always got good by "the end of the day") or simply the danger of acting something as irreversible and final as death? Perhaps it was the conceptual quandary of imagining the unimaginable; of feigning death while living.

Even Cusack took Roy's death literally. Lingering onset afterwards, Westlake claims that Cusack told him, "I always just saw this script as this cool guy who goes around conning everyone, and I never really paid attention to the ending of it. And in the end, I find myself lying dead on a pile of money, after having just been kissed and killed by my own mother. And I thought, 'Whadda'ya know? The joke's on me.'" An interesting noir rejoin to the *The Grifters'* elliptical tagline, "Who's conning who?", is also a double-entendre on an actor's life. Roy, so afraid of being conned that he takes conning into his own hands, ends up tricking Cusack, who not only played, but learned to play, a conman under the tutelage of rehabilitated professional swindlers ("Mechanics") like Ricky J., who taught Cusack nickel and dime cons, or what Cusack refers to as tutorials on "lying and deception" on Terry Gross's *Fresh Air* in 2001. "It was a great way to spend a September," Cusack told Gross. "Grifters are non-persons and grifts are about having information the other person doesn't have."

Yet just as all noir is fundamentally about characters who grift, conning and concocting for a living is something all actors and human beings do. Cusack, 23 and terrified of being typecast and duped by Hollywood, took the role of Roy Dillon in 1989 just after *Say Anything* as an act of mutiny against previous roles (perhaps even his entire '80s filmography. See *Hot Tub Time Machine*, 2010) and as a way into future ones. Desperate for the role (he'd even tried to option Jim Thompson's novel in high school), Cusack wanted to slay his loveable image—specifically Lloyd Dobler—with Roy Dillon (an anagram of Lloyd Dobler).

After a short-con goes wrong in *The Grifters*, Roy ends up in the hospital. Myra Langtry (Annette Bening), Roy's long-con girlfriend, comes to visit Roy, who's been posing as a matchbook salesman. Eventually Myra asks Roy what he really sells for a living. Maimed and bound to a wheelchair, Roy still manages to muster up enough swagger to answer "self-confidence." A euphemism, "confidence" (con-man) or "confidence trickster," meaning to fool a person by gaining their confidence, is the original definition of grifter. In order to hoodwink people and maintain their anonymity, grifters, also called drifters, never stay in one place, in the same way that "good" actors drift through the identities of others. For both actors and grifters, identity is a swindle; a temporary role you wander through and occupy quixotically without ever settling down into anyone. Perhaps this definition of acting is also the antithesis of Method acting, where one "lives" in a role fully in order to become someone else.

But while great screen performances and actors are meant to be remembered, grifters and grifts are not: "You couldn't disguise yourself, naturally," writes Jim Thompson in *The Grifters*. "It was more a matter of not doing anything. Or avoiding any mannerism, any expression, any tone or pattern of speech, any posture or gesture or walk—anything that might be remembered." Thompson's conspectus of grifters can be likened to a naturalistic style of acting. The kind of acting you don't see. The kind that doesn't leave a lasting impression. That passes for real. That tricks you into believing. In her book *Choking on Marlon Brando*, film critic Antonia Quirke echoes Thompson's description of grifters, "Actors always like to think that acting is about giving. But a great actor knows that it's about concealing. Great actors are people with something to conceal."

In Robert Altman's *The Player* (1992), acting is treated intertextually and the diegetic and non-diegetic merge seamlessly. Cinematic references, allusions, and stars litter the film as distinct Hollywood types and interrelated parts that comprise

the "identity-producing apparatus" of Hollywood. *The Player* features over sixty cameo appearances by Hollywood actors, producers, and directors, who appear extraneously as actors/directors/producers playing "themselves," or principally, as fictional characters embedded in *The Player's* diegetic fiction. Stars do not appear gratuitously to simply boost the celebrity count of the film. Rather, they depict an intricate system of representation in order to illustrate how that system operates as an increasingly complex nexus of onstage and offstage life. DeCordova points out that the "star's identity does not exist within the individual star (the way we might, however naively, believe our identities exist within us), but rather in the connections between and associations among a wide variety of texts—films, interviews, publicity photos, etc." These connections and associations are *The Player's* subject and mise en scène.

In the film, stars not only play "themselves" by appearing as "themselves," as in the case of post-*Grifters* Angelica Huston and John Cusack, who in the film are having a business lunch, but by playing their public personas. Altman evokes a return to a primitive form of cinema (newsreels) while employing the current discourse on acting. Further, *The Player's* theatrical schema salutes DeCordova's historical template for the star system, which began with the discourse on acting and led to the picture personality, the star, and finally, star scandals. In *The Player*, Hollywood producers scheme to do away with the existing system of production by eliminating star salaries, reverting back to factual versus fictional narratives, and returning to the early model of moving pictures as a mechanical form of reproduction.

But just as we never know what to believe when it comes to the actor—what is real and what isn't; or more importantly, whether real comes from fiction or fiction comes from real—actors never really have to defend the source of their reality, or the reality of their sources, and therefore can often traverse reality and identity in a variety of ways. "It [is] more than just the power

of having other people look at [you], or the power of being another person," writes Quirke, "it [is] the utter freedom and violence and irresponsibility available." In his films, Cusack eschews the pretense of realism of an earlier generation of less reflexive Method actors, instead fashioning a style of portrayal that is less immersive and more annotative of the nature of acting and persona—the way that acting is a condition that belongs to all of us, not just the actor.

In a 2008 episode of *Talk Theatre in Chicago*, Joyce Piven, co-founder and Artistic Director Emeritus of The Piven Theatre Workshop, discussed the school's philosophy. Cusack, along with lifelong friend, Jeremy Piven, Joyce Piven's son, had studied at The Piven Theatre. Joyce Piven explains that The Piven Theatre teaches actors to inhabit a text using one's own voice—not an "actor's" voice. The only way to do that, Piven explains, is to bring oneself into the story. Both the Viola Spolin Method (Spolin influenced the first generation of improvisational actors at Second City in Chicago in the late 1950s through her son, Paul Sills, one of Second City's co-founders), and the Piven Method, emphasize individuality and transformation. One has to master the former in order to achieve the latter. While Lee Strasberg's Method acting uses an objective and depersonalizing approach, in some sense making the mastery of method achievement itself, the Piven school emphasizes a conscious dualism: the relationship between interpretative subjectivity and fiction, the subjective experience of creating a fiction, and most importantly, the fiction of subjectivity (identity). That is, the way a fiction (role) changes according to who plays (fictionalizes) it. As Cusack put it to Gross, "The individuality of the actor is the actor's goldmine."

Both audience and filmmakers alike seem to have Cusack's screen mythology in mind, even when they claim, like Frears, to not know anything about it. In *The Grifters'* commentary track, Donald Westlake explains that Roy was a breakout role for

Cusack because he wasn't playing somebody who was just a "nice guy." Cusack was "getting to use all those winsome, cute things," says Westlake, "but he was taking it in an opposite direction." Frears, on the other hand, claims he was unfamiliar with his lead actor's cinematic past as a "lovable teenager." Unlike the movie's two female leads, Angelica Huston and Annette Bening, Cusack didn't technically even audition for *The Grifters*. Frears, who had never seem any of Cusack's films, said he "chose" him for his "quality" (the choice was reportedly between Cusack and Robert Downey Jr.). "On meeting John, I could believe in the character." Cusack met the director in a hotel room and sat on a couch while Frears "circled" him, he says. "It was the strangest meeting I can remember," Cusack recalls, who claims he didn't officially do any acting to land the part.

As Harold Ramis and Donald Westlake have rightly observed, viewers can't help but salvage the sainted Cusack as a powerful identificatory symbol and ideal love object, which partly explains why he is often airbrushed in roles, and why the sub-plot of Carol Roberg, a Holocaust survivor and Roy's private nurse in *The Grifters*, was omitted from the film. While the movie does retain Carol as a character, her backstory and Jewish identity were scrapped. Westlake claims that the movie's contemporary setting didn't permit for the inclusion of the story. Yet both Angelica Huston and Frears point out that time doesn't really exist in *The Grifters*. If the film is composed of all-time and no-time—"ambiguous time"—a lacuna specific to America, and Los Angeles in particular; and if time is "everlasting," or as Cusack pointed out, "each face has a hundred years in it," then why wasn't there space in the movie's symbolically blended chronology to include Carol? As a film, *The Grifters*, a color noir, gorges on American history by expressing it synchronically, and therefore not at all. History is medley, pastiche: "You had the women in forties dresses," says Cusack on the movie's commentary track, "and we were driving cars from the seventies, and I

was in eighties suits doing my grift at a Bennigan's." Even the movie's DVD image—now almost 30 years old—with the unspecified date surrounding Roger Ebert's emphatic assertion that *The Grifters* is "One Of The Year's Top 10 Movies!—" invokes a strange mix of anachronism, simultaneity, and atemporality. Frears' and Westlake's omission of Roberg's story, along with Roy's treatment of her, is an attempt to save-face—primarily Roy's (a victim of a shocking Oedipal dénouement, which complicates the film and saves it from being mere pastiche) and Cusack's—a beloved romantic icon. Roy's anti-Semitism and nihilistic interiority in the novel showcases a far more unpardonable and unsavory cruelty:

> He wanted to shake her, to beat her…He was furious with her. Subjectively, his thoughts were not a too-distant parallel of the current popular philosophizing. The things you heard and read and saw everywhere… After all, the one-time friends, poor fellows, were now our friends and it was bad taste to show gas-stoves on television. After all, you couldn't condemn a people, could you? And what if they had done exactly that themselves? Should you make the same regrettable error? After all, they hated the Reds as much as we did, they were as eager as we were to blow every stinking red in the world to hell and gone. And after all, those people, the allegedly sinned-against, had brought of the trouble on themselves. It was their own fault. It was *her* own fault.

As a novel, *The Grifters* does what the movie won't do: it displays Roy's bleak worldview outside of the suggestive but ultimately ambiguous narrative of conning and victimhood. The above passage by Thompson reveals that Roy is not simply the casualty of a biological con—a boyhood duped and allegorically stolen by "corrupt" motherhood—but an antisemitic and misogynist victimizer as well, which moves his conning beyond monetary survival.

However, due to film noir's open-ended history, any finale is possible, even the ones that come from outside a film. Westlake himself caved, admitting on the movie's commentary track that Roy Dillon may in fact still be alive: "For all I know, she's right." But it's also not surprising, then, that this sadistic and violent side of Roy, this bloody and true-history thread in Thompson's novel, is absent from the film's disparate mix of eras and styles.

So what is Cusack selling? If God is in the details, so is Cusack, who is accused of playing himself onscreen. But who came up with the idea that the onscreen Cusack is the real Cusack? How does an actor, who by definition plays people he isn't, get branded for playing himself (what critics and fans have dubbed "Cusackian," a correlative of "Doblerism"); a self viewers do not know and cannot verify. And how can Cusack be playing Cusack if the person he plays onscreen is, reportedly, nothing like him? Discussing his first movie, *Class* (1983), on *Fresh Air* with Gross, Cusack explains that acting, an ancillary to the self, ultimately "comes down to these very personal performances on this large scale… The first thing you do [as an actor], is play yourself, and if you can get comfortable as yourself in front of the camera, then you can start to play different aspects of yourself and different characters."

Unlike the taciturn romantic male icons of film noir, whose charm and sex appeal can be chalked up to their opacity, to what they conceal and withhold—a tension that has come to define heterosexual masculinity both on and off the screen, and to some degree, has rooted masculinity in the mechanics of conning, concealing, and withholding—Lloyd Dobler intercepts this gender paradigm by celebrating emotional transparency. In the opening scene of *Say Anything*, Lloyd, in the company of two female friends, not only proudly declares his unreciprocated interest in Diane Court, he emphatically asserts that he "wants to get hurt!" when his friends tell him he has no chance with her. Not only is Lloyd unafraid of getting hurt, he is unafraid to admit that he is unafraid.

In some ways, Cusack's performance as Lloyd has prohibited any other kind of act from him, for as William Hurt puts it to Viggo Mortensen in *A History of Violence*, "You been this other guy almost as long as you've been yourself." This shifts the question to not who Cusack really is, but rather, whether Cusack is anything like Lloyd, which is just another way of asking: do men like Lloyd exist outside of cinema? It also means that Cusack's popularity has less to do with acting bravura and more to do with the nature of identity and performance. As one IMDB blogger put it, "I like Morgan Freeman as an actor and John Cusack as a person," as if at the end of the day, Cusack weren't an actor at all, but simply a person onscreen. If the "real thing" is as fake as the fake, or if fake feels real, or real is so easy to fake, how will we ever know who's who and what's what?

If we return to what Cusack told Gross about playing oneself first, it might be useful to ask when Cusack transitioned into playing other people? But the better question might be: is the "subjective" screen-self that Cusack has invented his greatest dramaturgical contribution? In *Picture Personalities*, DeCordova argues that when a discourse on acting was established in the early 1900s, "the player's identity entered into the process of the film's production of meaning." In *Celebrity*, sociologist Chris Rojek notes that "celebrity status always implies a split between a private self and a public self, and that staging a presence through the media inevitably raises the question of authenticity… a perpetual dilemma for both the celebrity and the audience." Cusack's school of dramatics seems to validate both positions: that the self, however extrapolated, distorted and split, is really the only thing one has to work with, and is therefore the best invention to strive for. Therefore, why omit it from the creative process? Why not use it to drive the fiction?

In a 2005 review about *Must Love Dogs*, one critic scoffs, "Cusack is playing Cusack as he always does. You know what I'm talking about." Another blogger chimes in with a similar

complaint, "The problem with John Cusack is he has no range. He always plays one role: himself." While it's one thing to accuse someone of bad acting, it's another to equate what they do onscreen—however badly—with authenticity; that is, to assume that the flaw lies in an intrusive verisimilitude that doesn't belong in cinematic space, or in a fiction, and that the viewer can never actually authenticate when it comes to the star. Moreover, that a lack of range or acting ability is rooted in the failure to break with the "real" self. And yet it's because of Cusack's implicit and explicit utilization of subjectivity in his acting; his acknowledgement that the choice to act, to play someone, to compose a self, to create a continuum between the self onscreen and the self offscreen, is one of the reasons Cusack's screen presence has engendered such unique significance.

When *Total Film* asked Cusack, "Isn't there a speck of duality in there? If an actor's doing their job, shouldn't a bit of themselves poke through the performance?" Cusack answered, "Without question... Actors should embody someone who is real. Meaning their own qualities should come out. Good actors can access themselves—possibilities, possible versions of what they could become." In the *Guardian*'s "Being John Cusack," Suzie Mackenzie ponders the ethical repercussions of acting: "Actors, of course, play roles for a living. But all of us, and all the time, play roles in life and we have choices about how we play and what we play. Unthinkingly to play a part—to say this is not me, this is just what I do for a job, is morally irresponsible... (You could make the case that all [Cusack's] films since *Grosse Pointe Blank* are about this. Is this me or is this an alias? Who am I?)." Mackenzie, however, makes her most astute observation about Cusack's reflexive role-play at the beginning of the interview: "John Cusack is a man with a conscience, but as a film actor he specializes in morally ambiguous characters." But isn't it the other way around? Cusack plays men with a conscience; men with often uniquely intact hearts

and egos; men who lack guile. Who never con. In other words, men who do *not* act.

When it comes to John Cusack, viewers look as much at what's inside the frame as what's outside it. For we not only go to a John Cusack movie to see John Cusack (the incentive for many viewers when it comes to their favorite actors) we go to consider the nature of being and performance—of acting—through some-one who seems not to be acting at all. Instead of suspending belief, viewers want to build belief through someone who feels and acts believable. Someone who uses acting to show us what authenticity (or more precisely, a person being authentic) looks like. Even when Cusack plays bad men, we believe he's simply commenting on what and who is bad, which makes him *good*. That the fiction is always his—him—thus, making it, and whatever he's showing us about himself, real. That Lloyd is who Cusack *really* is, has always been, and every character that has come after Lloyd is all an act. It is this enduring conviction that allows us to keep Lloyd, and by extension, Cusack, in our hearts as a romantic icon. And it is also this conviction that makes us rewrite the script whenever Cusack falls out of it. Otherwise, we wonder, who will hold the redemptive boom box under our window? Who will make our dreams come true? Who will love us? As Jim Thompson writes in *The Killer Inside Me*, "… If you'll just love me… Just act like you love me."

— 2011

5

The Authentic Personality

In March 2013, Jennifer Lawrence, a 22-year old actress and star of *Silver Linings Playbook*, won her first Oscar for best actress. In addition to her work on the big screen, much attention has been paid to the refreshingly "authentic" way Lawrence handles the press, fame, and herself. In particular, her witty and down-to-earth Oscar speech, in which she poked fun at her fall on the stairs, and her droll backstage comments about winning her award. Yet despite her obvious appeal, it is possible that Lawrence, prized for her acting prowess as well as her refreshing candor, quick wit, and lack of guile offscreen, is simply very good at acting real; at not acting like other actors; at not hiding the things that actors are trained to hide, which is to say, Lawrence does not cover things up in the way that we are used to seeing them covered?[1] As a young star, Lawrence, who called acting and making movies "stupid" in a 2013 *Vanity Fair* profile, "Girl, Uninterruptible," does not pretend in the spaces in which we have grown accustomed to hearing and seeing pretense. Nor does she act "feminine" in the way that we have come to expect young female celebrities to act feminine—exhibitionistic, hypersexual, mollifying, ditsy.

I have long been interested in the difference between acting and authenticity, trying to determine whether there was ever a difference, and whether there still is. In addition to the acting we see an actor do on a movie screen, there is also the acting an actor

1. Instead of downplaying her spill on the stairs during the Oscar ceremony, Lawrence highlighted it.

does on all the screens that constitute celebrity culture in our post-digital world. Some actors handle the reality and fiction of their celebrity better than others. Some go to great lengths to hide what they can't handle, and some show it by acting out their struggles publicly. While we love some actors for their TV and movie roles, we dislike them as people, and vice versa.

What makes acting fascinating and mysterious is that while it is a talent for some, acting is first and foremost a human condition rather than a vocational ability. If acting is a condition of life, it is hard for any of us to know not only what is real and what is fake, but the relation between the two. In today's surround-sound media culture, the real question is: where and when does acting happen? And: is it ever not happening now?

Our first instinct is to interpret Lawrence's "raw" personality as a break from artifice and façade. But being that the nature of artifice is precisely the mystery of acting, we can never know for sure. We crave feeling the tension between acting and not-acting, honesty and dishonesty, real and fake, spontaneity and premeditation, because it makes us see the contrivance, and by extension, the authenticity. More importantly, it makes us believe—belief being the operative word here—that not everything is contrived.

Lawrence is almost the inversion of another actor, Kristen Stewart, who while not as gregarious or self-possessed as Lawrence, doesn't quite have a handle on the actor script either. By today's standards of public figures and sex symbols, Stewart is shy, self-conscious, and seemingly uncomfortable in her own body. She fidgets and averts her gaze during interviews. She mumbles wryly and has an introverted quality that we rarely see in young actresses today. With both Lawrence and Stewart, the seams show but in different ways.

In the case of her post-Oscar interview, are Lawrence's responses to the press too quick-witted and unpredictable to be contrived? Acting is partly about knowing how to mediate—filter,

calibrate, program—one's responses. And conversely, not-acting is about not filtering, premeditating, fashioning. We have become so used to rehearsed answers, red-carpet poses, air-brushed bodies, faces, and lives—that when something or someone is even slightly different, we are both excited and relieved. We like Lawrence because she does not appear to be faking it in "real life"—only for a living. She seems real as far as our current definitions of authenticity are concerned. But sometimes what one doesn't do is an equally self-conscious project—the flipside of straight artifice. As Paul Schrader stated about Robert Bresson's perversion of film technique: "Pretending not to manipulate is another form of manipulation."

On the most basic level, Lawrence perverts some of the key tenets of being a contemporary celebrity by going off-script and poking holes in some of the veils and mores of stardom. Yet, while any industry breach is always refreshing, given our profoundly reflexive, self-conscious time, disclosure and confession can be equally perpetuating—yet another way of masking and maintaining the mask. The writer David Shields notes (in lines he appropriated from the poet Ben Lerner): "What is actual when our experiences are mediated by language, technology, medication, and the arts?" Actual and acting are analogous, for what is actual when acting is not just a condition of being human, but an increasingly daily requirement of being human? Fame is high-risk and fundamentally incompatible with artlessness. An actor's job is to calibrate the fiction and master the presentation of a public persona, and usually the longer one acts, the more one acts. An actor, said Bresson, who insisted on using non-actors ("models") in his films, "Can't go back. Can't be natural. They just can't." According to Bresson, only automatism allowed for truth. Models did not act, they were "automatic." Yet despite what Bresson chose to call it, the difference lies partly in the reformulation: humans acting rather than actors acting. Or humans acting for the benefit of art

versus humans acting for the reward of an industry that then creates a demand for them as actors. That is, to become famous for their ability to act. But whether an actor was natural pre-fame and unnatural after fame is not the question. The real issue is: fame changes us, and acting is about learning how to change ourselves. Actors fascinate us because we think that mutability is profitable when we see it rewarded.

People, both famous and un-famous, change for all kinds of reasons. We never know exactly how or why. But we do know that almost everyone is irreversibly altered—usually for the worse—by power and fame, especially when it comes fast. Fame today is simply too invasive a phenomenon to survive unscathed. So why do some actors handle certain aspects of stardom better than others? Why do some actors succeed at maintaining a gap between the public and the private, while others blur the line completely? Is fame different for different people? If so, why? And is that difference something you can control? If so, how? Some celebrities insist that fame becomes invasive and destructive only when one participates in a certain kind of paparazzi-courting lifestyle: the kind in which the camera rules and where everything is arbitrated by the camera. Conversely, it can also backfire if a star resists their fame completely, à la Michael Jackson (post-sexual abuse scandal), Greta Garbo, and Marlon Brando (famous people who were also famous for not wanting to be famous anymore. Tellingly, I cannot think of a contemporary example). Most stars don't start off like Lawrence, let alone stay like her. When it comes to celebrities, being naïve and "real" is something you either pretend to be or pretend not to be. Now, more than ever, with aesthetics, fame, technology, and identity in such radical flux, who's really who, and what's really what, continues to be the great mystery.

Will it last? Will Lawrence stay this way? Down-to-earth, self-deprecating, unaffected? Attention comes with an expiration

date, so, in a sense, "Are you afraid you have peaked?" is the right question to ask a young Oscar winner.[2] It is celebrity, not just celebrities, that we revere. "The top" is a dangerous place to hit, both creatively and culturally, and one should think about what it means to hit it, especially when one does it so quickly and at such a young age. Where stardom is concerned, particularly female stars, shelf-life is an old parable. So while it might be a buzzkill to bring a star down to Earth with a question about peaking, it is more than fair to ask one—as well as ourselves— not just what success and fame might bring, but what it might take away.

— 2013

2. Lawrence was asked this question by the press after she won her Oscar. Many people were outraged by the question, claiming it was both sexist and disrespectful.

II. ANALOG DAYS

6

David Bowie & Mark Zuckerberg Play with Time

"Changing isn't free."
— David Bowie, "1984"

There are two incarnations of David Bowie's song "1984," which appears on Bowie's 1974 funk-soul album *Diamond Dogs*. The song is the interlink between Bowie's Ziggy Stardust period (1972–73) and his Thin White Duke phase (1974–76). In the 1973 performance of "1984" at the London Marquee Club, and the 1974 performance of "1984" on the *Dick Cavett Show*, Bowie performs the same song a year apart as two different characters. "*This* is David Bowie," Cavett announces in his TV introduction. "And on the other hand, *this* is David Bowie." Cavett continues his prologue:

> Rumors and questions have arisen about David. Such as: who is, what is he? Where did he come from? Is he a creature of a foreign power? Is he a creep, is he dangerous, is he smart, dumb, nice to his parents, real or put on, crazy, sane, man, woman, robot? What is this?… In this concert tour, he is, still another, David Bowie.

The alien, or as Cavett puts it, "the robot," can do this because the alien always plays with time—setting themselves ahead. Setting time ahead. Even though it is actually 1974, not 1984, Bowie, as the alien rock star Ziggy Stardust, doesn't have to be in present-time. That is, in time *now*. Regardless of where time

actually is, Bowie teleports time—the heart of all science fiction. For Bowie, time is drag, a keyhole (Bowie wears a black keyhole costume when "Ziggy" is uncloaked on stage in the Floor Show). Wikipedia describes Ziggy Stardust like this: "Ziggy is the human manifestation of an alien being who is attempting to present humanity with a message of hope in the last five years of its existence. He is the definitive rock star: sexually promiscuous, wild in drug intake and with a message, ultimately, of peace and love; but he is destroyed both by his own excesses of drugs and sex, and by the fans he inspired." This is also a classic story of corruption by fame.

As the Thin White Duke singing "1984," Bowie is the year 1984 even before the year came around. While the omniscient alien Ziggy at London's Marquee Club warns us that the year is coming, a year later, the Thin White Duke informs us that the year has landed and has taken residence in his new body.

It has been widely reported that between the years 1975–76, Bowie made pro-Fascist remarks, expressing his admiration for Adolf Hitler and his wish to rule the world. Whether or not Bowie was actually a fascist, he performed and aestheticized fascism with the Thin White Duke—making it an aesthetic identity and costume and affecting its authoritarian politics.

In Hollywood movies, aliens are almost always accused of wanting world domination. Their interest in Earth is imagined as supremacy. Mark Zuckerberg, the inventor of Facebook, has been accused of the same thing in *The Social Network* (2010), which also imagines the future by going back to it.

If the Thin White Duke is Bowie shedding his mutable, androgynous alien status in order to enter the cynical hardness of the hypermasculine '80s, Facebook is Mark Zuckerberg's 21st century

antidote to social dominance. Zuckerberg can be read as the digital and corporate analog to Bowie's Thin White Duke.

Bowie's Duke has been derided as "A hollow man feeling nothing," as "Ice masquerading as fire." As the Duke, Bowie claimed to subsist on a diet of "Red peppers, cocaine, and milk." Ingredients that could easily be the recipe for fire and ice. He was also called an "immoral zombie," "mad aristocrat," and "an emotionless, Aryan Superman." Similar descriptors have been used to describe Zuckerberg. Bowie, who called his Duke an "ogre," is not unlike Zuckerberg's rogue brat in *The Social Network*.

While Zuckerberg, Jewish and middle-class, is not an Aryan Superman, money has enabled him to become a corporate Superman. In *The Social Network*, Napster founder Sean Parker, played by Justin Timberlake, informs Zuckerberg, "A million dollars isn't cool. You know what *is* cool? A *billion* dollars." Parker takes Gordon Gekko's '80s tenet, "Greed is good" in Oliver Stone's *Wall Street*, into the new millennium.

Bowie's Thin White Duke is addicted to cocaine; jumpy, famous, polished, superior, icy, polymorphous. He is also dressed like a character from *The Damned* (1969), the first film in Luchino Visconti's *German Trilogy*.

Like the Nazi character Martin von Essenbeck (Helmet Berger, Visconti's real-life lover), Bowie's Duke is masculine and powerful in a way that is symbolic—not physical (he is strung out; anorexic). Essenbeck's fascist polymorphism suggests that he can do anything to anyone (in the film, Essenbeck is secretly molesting his young cousin, a poor Jewish girl. He later sexually assaults his mother and joins the SS) and also, be anything and anyone because he possesses the right body at the right time. Essenbeck first appears onscreen in drag impersonating Dietrich in *The Blue*

Angel.[1] Made in 1930, it is considered to be the first major German silent film. In 1933, it was banned in Nazi Germany, although it is reported that Adolph Hitler viewed the film secretly on a number of occasions. Essenbeck as Marlene Dietrich suggests the permission to perform anything, no matter how scandalous or salacious.

In *Hard Bodies: Hollywood Masculinity in the Reagan Era*, Susan Jeffords argues that the masculinist, right-wing politics of the 1980s were developed into a hard male body equivalent. In *The Male Body*, Susan Bordo points out that "'hardness' alone is not sufficient to make a phallus, and well-defined muscles are not enough to make a master of the universe. The master body must signify an alliance with the gods rather than the masses, the heavens rather than the earth." This is where Ziggy Stardust— the otherworldly alien—meets the fascistic, Aryan God: the Thin White Duke. Translated from Italian, *The Damned*, "La caduta degli dei," literally means, "The Fall of the Gods."

Both Bowie and Essenbeck exemplify phallic symbolism. They are not literal hard bodies, they are symbolic ones. "Increasingly, masculine power and authority," explains Bordo, "were seen to derive not from nature, but from God—not a god of procreation like Osiris, but the God of Immortal Forms, Disembodied Spirit, Pure Reason."[2] The actual penis became less significant and in some sense was even believed to be an obstruction to male rationality. Potency had to do with will. Hardness was less about the hardness of an actual penis and more about having the right kind of "upward-pointing" body. "The penis's potential for

1. Rainer Fassbinder's 1981 film, *Lola*—the third in his *BRD Trilogy*—also approaches questions about fascism and performance. Lola is loosely based on Josef Von Sternberg's *Blue Angel*, starring Marlene Dietrich.
2. The following anagrams can be made from David Bowie: *Via Web Id Do. Bad Void We I*. Part of the anagram for Mark Zuckerberg is *Czar*.

'hardness," writes Bordo, "and all that it suggests, has been displaced onto the whole male body, where it can function more unambiguously as a symbol of strength, power, and upward aspiration. Where it suggests Prometheus, not Priapus." Because they possess the right kind of culturally-signifying bodies, it hardly matters that Bowie and Essenbeck flirt with androgyny and sexual ambiguity, or that they look like or play women. Their culturally "superior" bodies permit them to be other bodies and exploit other bodies, both literally and aesthetically.

With his Jewish body, Zuckerberg is not endowed with the same cultural privileges. However, if we think of Facebook as the ultimate exercise in the Disembodied Spirit, his male superiority falls under the paradigm of male intellect and rationality. It is this paradigm of masculinity that allows Zuckerberg to "rule the earth."

In "1984," Bowie sings, "I'm looking for a vehicle." In 1992, Radiohead released their debut single "Creep," an anthem of alienation (covered by the Belgian choir group Scala & Kolacny Brothers) that *The Social Network* exploits in its trailer. As the Duke, Bowie was also largely derided as a creep, Cavett tells us. Using "Creep's" famous lyric: "I'm a freak/I'm a weirdo/What the hell am I doing here?/I don't belong here" as its mantra, *The Social Network* encapsulates Zuckerberg's alien invention as the move from material to immaterial exile. Not belonging (in *The Social Network*, the seeds of Facebook are sown after Zuckerberg's girlfriend breaks up with him) leads to dispossession, as his culturally representative anomie evaporates—or *liquidates*, to use Zygmunt Bauman's term—into Facebook, a vehicle of disembodiment that enables us not to be anyone or anywhere. And, conversely, everyone and everywhere.

Facebook also represents Zuckerberg's sexual, ethnic, and class anxieties about not belonging at the elite and exclusive Harvard

University, where in turn, Zuckerberg crafts his own elite proxy to electronically treat his disaffection. Likewise, British export, Ziggy Stardust, "comes to earth," both vulnerable and alien. An alienation alleviated by his Thin White Duke.

As the Thin White Duke, Bowie—the man—was on the brink of total disintegration. His recovery, both creatively and mentally, is reported to have taken place in Berlin, where Bowie lived (some say hid) for a time. Like Visconti, Bowie made his own *German Trilogy*, the famous Berlin Trilogy—*Low*, *Heroes*, and *Lodger*—with Brian Eno. Bowie's song, "A New Career in A New Town" from the album *Low*, documents some of the themes in Bowie's life at the time. As does the song "Move On" from *Lodger*. Respectively, Zuckerberg sought refuge from his discontent on the internet, not simply by using it, but by designing it in his likeness (God) and bending it to his will (Superman).

According to *The Social Network*, Zuckerberg mixed loneliness, avarice, resentment, and digital time, making him simultaneously alien (everyone hated him) and Duke (he ruled the world), and turning Facebook into the new egoistic poetry of disaffection. To quote Zygmunt Bauman: "And so we seek rescue in 'networks,' whose advantage over hard-and-fast bonds is that they make connecting and disconnecting equally easy."

Bowie's humanoid alien in Nicolas Roeg's 1976 film *The Man Who Fell to Earth* is another amalgamation of Ziggy Stardust and The Thin White Duke. Thomas Jerome Newton, Bowie's alias in the film, has both the red hair (fire) of Ziggy and the short slicked back white hair (ice) of the Thin White Duke. Newton's planet, Anthea, is sick and starving for water, like in 1974's *Chinatown*. *The Man Who Fell to Earth* can be interpreted as Bowie's creative and personal trajectory, for what is Bowie but the ultimate humanoid, simultaneously corrupted and corruptor? In

one scene, Newton tells his earthly red-haired lover, Mary-Lou (Candy Clark), "If I stay here, I will die," which really means, if *we* stay here—in this corrupted human state—we will die. The alien is always warning us about ourselves.

In the Thin White Duke performance of "1984," Bowie looks vaguely like Christian Bale playing Patrick Bateman in *American Psycho* (2000), if Bateman were emaciated and played by the Christian Bale of *The Machinist* (2004), and if Bateman weren't the classic American '80s hard-hard body. No longer merely symbolic, the '80s hard body was the ideological armor that housed masculinity and stood for the indefatigability of national identity. In the Thin White Duke's rendition of "1984," it is the '80s *soul* that is on display. In the case of *American Psycho*, it is the '80s imagination. And, like *The Social Network*—a "vehicle" for the 21st—the Duke's performance of "1984" is affecting and chilling because it is Bowie commenting on the '80s (singing about them) while embodying them through cocaine, the decade's drug of choice. It is the world *in* a body, just as *American Psycho* is about the ethos of the male body ruling the world. In the film adaptation of *American Psycho*, Patrick Bateman literally revels and luxuriates in the supremacy of body. Thinks and feels from its hardened and inflated point of view. This is also what the alien narrative dramatizes. The alien uses its body to comment on and host the world.

In *The Social Network*, Zuckerberg uses the technology of Facebook to express what it means to live in a Facebook world. It is about using *while* using, as well as being the kind of disembodied body you need to be in order to live a Facebook existence. Facebook is about us being us right *now*. *The Social Network* is thus perhaps the closest reflexive example we have of being thoroughly reflexive. To being, metaphorically speaking, instantaneous. That is, the moment of watching the moment we live in as we live it.

After all, what better account could we find of becoming electronic, of filling up on nothing—of the sentiment, "I don't belong here," moving from a material world and relocating to an immaterial one—than "1984's" line: "They'll split your pretty cranium/And fill it full of air?" Radiohead's idealistic, yet still in-your-body, "Creep," on the other hand, is still betting on a real place to really belong to.

When the petulant and disassociated Zuckerberg is asked at one of *The Social Network*'s deposition hearings, if they have his "full attention," it is a question posed to us. Not "us," the spectators, but "us" Facebook users. What or who has our full attention now? Zuckerberg, distracted by the "rain" outside the window, turns to face the attorney—us—and answers, "No." When the attorney follows up with, "Do you think I deserve your full attention?" Zuckerberg, both seething and bored, grudgingly turns to face the room. He elaborates: "You have *part* of my attention. You have the *minimal* amount."

What could describe Facebook, or the internet age for that matter, more succinctly? On the internet, and because of the internet, we all give and get *part* of each other's attention—but only part. Only the minimal amount. Jesse Eisenberg as Zuckerberg concludes his now celebrated and quintessentially antisocial, egoistic speech by falling silent, once again. Shooting his competitors a homicidal look, he wryly cocks his head to the side. This gesture is eerily malevolent, reminiscent of Michael Myers' famous head tilt in John Carpenter's *Halloween* (1978) after he nails a dead teenager to a bedroom door. Both gestures are almost parodies. Homicidal spoofs on human behavior. While Myers' head tilt takes comic form as he reacts to something horrific with a surprisingly human gesture—curiosity—Zuckerberg's authoritarian scowl takes almost horrific form because it comes across as utterly contemptuous and callous.

In an interview with John Carpenter, film critic Mark Kermode describes Michael Myers' masked face as "the blankest of anti-heroes." Carpenter provides a definition for Myers' monstrous apathy: "It's almost like the comedy-drama mask. It's just blank. You read into it, as opposed to there being anything there. It's not a personality. It's a force of nature." A description that befits Zuckerberg and Facebook alike.

In his first television interview in seventeen years, the singer Morrissey launched a scathing attack on David Bowie in 2004, stating that his beloved Bowie had become "showie," a "business."" Morrissey argued that the public only fell in love with Ziggy Stardust, while "the visuals for Ziggy were dreamt up by someone else." Similarly, Facebook, a social networking phenomenon, feels like it's ours. We have claimed it as an alternate for ourselves, but its visuals (algorithms, codes of conduct, profit) have been dreamt up by someone else—Mark Zuckerberg, who went from being the creator of Facebook to building an empire out of his own alienation, and by proxy, ours. If Bowie's musical career is a cautionary tale against becoming all business, Facebook is a cautionary tale against being all social network. "(He is) not the person he was," Morrissey goes on to say: "He is no longer David Bowie at all. Now he gives people what he thinks will make them happy." This switch charts Bowie's course from Ziggy Stardust (heaven) to the Thin White Duke ("an ogre" on the brink of disintegration). It also charts our own arc from being not *who* we were, nor *how* we were—not happiness per say—but a prototype for happiness we can all assert as our own. Simply put, Facebook isn't significant because everyone uses it. It's significant because we *are* it. Perhaps like Bowie we are aliens, allowing our analog bodies to be invaded by the digital.

If 2012 is the speculative number of the foretold end, the end of the end—as in no more ends at all—"1984" was the end of one

way of living in the world and the beginning of a new way of living. It's why the number still counts. It's also why Bowie—as if he were beaming the year out into the world with his voice; carving it into the earth—chants it eight times as Ziggy. For when it comes to late modernity, "1984," like *The Social Network*, is a year that tells time. That tells us where time went.

As "1984's lyric informs: "Times are a-telling/And changing isn't free." The '80s. The '80s talking to the '60s and '70s. It is the '80s taking charge of all the years before it. Of everything that was and never will be again. This isn't Bob Dylan's "The Times/They are a-changin,'" when things get better—maybe—and where, as Bordo notes, the earth, not the gods, matter. This is: Forget about what once was. Forget about existing for free. Forget about time. Forget about belonging or going back. Because, as Bowie tells us, "Tomorrow's never there."

— 2010

7

A Sentimental Education

For a long time it was about the camera. The truths it revealed and the truths it covered up. We knew the camera lied, but we also believed it told the truth. Now we know it only does the former, only we don't care anymore. As a little girl, I had a crush on the Watergate journalist Carl Bernstein because I saw *All the President's Men* on TV and thought he was Dustin Hoffman. I believed what I was seeing. I didn't know there was a difference between actor and person. When I grew up, I saw Nora Ephron's *Heartburn*, a film about Ephron's unhappy marriage to post-Watergate Bernstein, and changed my mind about Bernstein, which wasn't hard to do since Bernstein is played by Jack Nicholson, a man and actor I dislike. *Heartburn* was Bernstein at home and *All the President's Men* was Bernstein at work. In *All the President's Men*, there is no private Bernstein. There is only a public, which also functions as private since the public

in the film is composed of secrets and lies, and because both Bernstein and Bob Woodward spend all their time at work. It is a woman—Ephron—who has to change the meaning of public and private when it comes to a man's (who is also a husband, not just a reporter) life, reminding us that the two are not in fact separate, or one and the same.

In *All the President's Men*, the only couple we see onscreen is Woodward and Bernstein. Redford and Hoffman. In interviews, Hoffman claims that Redford suggested they memorize each other's lines for the movie so that they could both interrupt and finish each other's sentences whenever they wanted. "The two of us can be one person," Redford told Hoffman. This is what people in love do—they construct the truth together. In *In Praise of Love*, Alain Badiou states that love is a "truth procedure, that is, an experience whereby a certain kind of truth is constructed. This truth is quite simply the truth about Two: the truth that derives from difference as such... all love suggests a new experience of truth about what it is to be two and not one." If love, along with what constitutes public and private—the way one hides and contains the other—is also a truth procedure, then it is not too far-fetched to say that even

a political thriller like *All the President's Men* is a love story, if love is two people banding together not only to uncover the truth, but to re-construct a truth that is being concealed. In the process of determining which is which, a process that is always political, the lie and the truth, the public and the private, form a dialectical Two.

Does the camera unveil a truth, or does it create one that isn't there without it? When Mike Nichols called Dustin Hoffman to do a screen test for the lead in *The Graduate*, it was a disaster, Nichols jokes. The camera liked what no one could see in person, not even the director himself. No one had seen Hoffman, a 29-year old theater actor, on camera yet. No one saw the indefinable "it" factor until they looked at what they were seeing in front of them on camera. "It" wasn't there without it.

In his book, *Scenes from a Revolution: The Birth of the New Hollywood*, Mark Harris recounts Nichols' recollection of Hoffman's screen test for *The Graduate*:

> 'There was no Eureka!' says Nichols. That is, until they printed the screen test and watched Hoffman on film. 'He had that thrilling thing that I'd only seen in Elizabeth Taylor,' says the

director. 'That secret, where they do something while you're shooting, and you think it's *okay*, and then you see it on screen and it's five times better than when you shot it. That's what a great movie actor does. They don't know how they do it, and I don't know how they do it, but the difference is unimaginable, shocking. This feeling that they have such a connection with the camera that they can do what they want because they own the audience.'

Urban Cowboy director James Bridges was similarly unimpressed when Debra Winger did her first reading for the part of Sissy. "It wasn't until I saw her screen test that I recognized her magnetism," Bridges recalls. "Even when I was standing by the camera directing her, I didn't sense it. Jack Lemmon told me it was the same with Marilyn Monroe. She was not that striking in person, but something happened on film."

Actors materialize on camera in a way they don't in real life, and in a world where what the camera sees and materializes matters more than anything, camera presence counts for everything. It's not what you really feel or what you actually see. It's how you feel about what and who isn't really there in front of

you. We want a barrier between our objects of desire and ourselves. We want a screen. A film. This is where actors come in. The camera creates a necessary triangulation between actor and audience. In his reading of Freud and Lacan on melancholia, Slavoj Žižek states that with "Melancholia it is not that you lose the object; you have the object but you lose the desire for the object: you lose the *object cause of desire*. Everything is here, but you no longer desire it. This is the enigma of modernity." When it comes to the politics of representation, something like the reverse is at work: you create an object cause of desire for something or someone you would not have it for were it not for the mediation of the screen, which creates an object cause of desire that is not only not really there, but is also both the object of desire and the object cause of desire. It is not a coincidence that the rise of commodity culture has led to a decrease in tangible and lasting desire—you desire everyone without actually desiring anyone; without actually having an object cause of desire—or that melancholia runs parallel with consumer capitalism where the point is to consume transactionally and melancholically (status you will never have, commodities you will never own; objects lost in advance). In *Consumer Society*, Jean Baudrillard notes, "You have to try everything, for consumerist man is haunted by the fear of 'missing' something, some form of enjoyment or other. It is no longer desire, or even 'taste,' or a specific inclination that are at stake, but a generalized curiosity, driven by a vague sense of unease." As Žižek and Baudrillard note, we are living in an age where the majority of people are overmedicated, overanxious melancholics, who preemptively anticipate (expect) loss (of objects; of people; of jobs) before it even happens. Speaking about post-war German writer W.G. Sebald, psychoanalyst and essayist Adam Phillips, describes melancholia in Grant Gee's 2012 documentary *Patience, After Sebald*:

It's as though these people, people who feel this, are people who feel some inexplicable sense of loss. And they're people who try and locate this in history, as in, why am I feeling so fundamentally *at* a loss, and so unattached? And it's as though the history gives you some sort of story about this. The feeling is somehow that there's been some catastrophe that can't be located, and that one is living in the aftermath of that catastrophe.

In the media matrix of the postsexual techno-world, desire is everywhere and nowhere at all. For everyone to see but no one to actually have. You desire precisely because you don't have any real desire for the real world. Desire plays by the consumerist rules of desire, which is to want without having and to have without wanting. Desire and object causes of desire roam for signals: attaching and detaching, consuming and discarding with ever increasing speed. Desire may not last, but at least you get better—faster, more adept—at casually simulating desire. You keep up with the production and disposal of affective goods.

Days before Hoffman's *Graduate* screen test, and nearly ten years before *All the President's Men*, Redford, who actually looked like the Benjamin Braddock of Charles Webb's book—blonde, six feet tall, blue-eyed, a WASP—was turned down for the part of *The Graduate*, which went to Hoffman, who is short, dark-haired, and Jewish. In the movement from presentational to representational, profilmic to filmic, blonde to brunette, WASP to ethnic (a switch I suspect might not have happened had the lead been female), the camera "saw" what no one else could see, even redefining the requirements for seeing. The part represented one thing, yet looked like another.

Given that we are a culture that sees what we are shown, it is puzzling that actors are routinely asked to modify (perfect) their appearance for the camera. To make themselves look

"better" when we know, as Nichols tells us, that the camera can make an actor what they might not be in the first place—charismatic, attractive, interesting—desirable. It was seeing Hoffman on camera that made Buck Henry, co-writer of *The Graduate* screenplay, exclaim, "With that, in one fell swoop, we lost all the blondes we were thinking about [for Benjamin Braddock]." People agonize about conforming to the camera without considering the ways in which the camera, as we are told, invents the person in front of it. We are so concerned with what the camera records (shows us), we forget that the camera produces a discourse of vision.[1] Making us see what we otherwise would not see. Making us like what we would otherwise not like. Want what we might not otherwise want. The camera gives us a system of desiring and as well as an inventory of things to desire. A close-up, but not the whole picture. The whole picture is what we get in life. In an interview with Dick Cavett in 1981, Ian McKellen explained the difference between acting on stage and acting in the movies: "The trouble about the stage is that the audience sees the whole body. You take it all in... It's all to do

1. The rise of plastic surgery requests to make oneself look more like their filtered selfie has now replaced the request to look like one's favorite movie star.

with distance." McKellen is talking about the fiction of proximity that the camera—rather than the actor—invents.[2]

The camera is like the girl who gives the guy a chance when no one else will, which is why men—not women—always use a sexual analogy to explain their desire for fame. To be famous, actors and musicians confess, is a way to "get" women they would never otherwise get.[3] Women never say they became actors in order to seduce men. Is this because women are always already being surveyed, so when it comes to fame, they want to corroborate that implicit male gaze? Moving from a paradigm of private to public, the way men shift from a paradigm of public to private through fame. Is it because women want to make public use of what is so personal for them—to make the personal and the private matter? To exteriorize it, giving the personal and the private they've been confined and restricted to currency and value.

The philosopher Félix Guattari wrote that language must be written down otherwise it is nothing. Seeing is also a language that must constantly be recorded. What is said in private—in confidence—has become worthless. The private has always mattered to me more than the public, and privacy—what I withhold; or more precisely, the dialectic between showing and not showing; saying and not saying—is also part of the way I write. But this is not the world we live in. What *you* see is not as important as what *everyone* sees. Less is not more. In the age of social media everyone is fighting to get their private self to matter to everyone. And while there is still some

2. As many short male screen idols have proven, you don't have to be tall on camera because the camera creates the proportions and stature an actor lacks.
3. In an interview in the 1990s, infamous womanizer, John Mayer stated, "Playing music for me is as close to having super powers as you can have." Presumably one of those super powers is unlimited access to women. In a 2010 interview, Mayer reiterated: "If I had gotten dates in high school, I would have not played the guitar. That guitar would have been gathering dust."

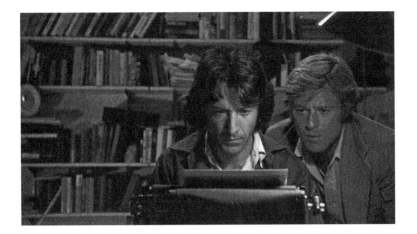

shame and dishonor in exposing the private, especially for women, in the digital mediasphere, the real disgrace is being invisible. From that, we think, no one can recover.

Traditionally, men have been able to get away with being and staying private in a way that women cannot because, as *All the President's Men* shows, a man's private is always inherently public. A woman's private, as Ephron's film counters, is her unseen and undocumented personal history with a very public man. This is the reason so many women are ghettoized not only as being too invisible (and thus pathological) to be appropriately public, but also as only being able to write from the inside-out, as opposed to the outside-in). This is still the case with much of what is considered transgressive women's writing. As if women don't deserve to keep anything inside. As if the only solution to the historical predicament of being marginalized, silenced, and invisible is to expose everything for public consumption.

As women writers and feminist scholars have pointed out, a white man's "I" is universal, therefore it can and has stood for both being alone *and* being with. Being together and being apart. Being at home and being at work. Would Redford have suggested the technique of memorizing his own and his co-star's

lines if his co-star had been a woman? When it comes to women, men like to "joke" about how unknowable, unreadable, and inscrutable women are. "*What do women want?*", they plead in exasperation. But what is especially knowable or readable about men except that we *want* to know them and have been given white masculinity to ponder existentially and identify with? No one actually wants the Pandora's Box answer to the question of what women want. The question is there precisely to replace understanding and thought. For the most part, we reject the answers women give (some of these answers internalize sexism, so having an answer is by no means a simple answer). Just as we seem to need the mediation of the screen in order to see and desire the actor, we are equivalently reliant upon the stamp and myth of inscrutability as a descriptor for women precisely to keep from knowing them. Not knowing while pretending to allows us to continue omitting.

In Luce Irigaray's "From the Multiple to the Two," Irigaray writes about a masculine and feminine difference in relation to speaking (both literal and phenomenological speech) that can be applied to the motivation of the acting subject:

Of course, speaking to many or speaking to only one person does not presuppose the same relation to speech. In the first case, it must convey a meaning in some way closed, in which the speaking subject converses above all with their own self and with speech. No doubt this kind of meaning is the one that the masculine subject has always privileged. The feminine subject, on the other hand, takes an interest in the relation between two, in communication between people. This subject is thus confronted with a new task as regards to the unfolding speech.

Men belong together. In almost every shot of *All the President's Men*, Bernstein and Woodward are always Two. In the duo of Redford and Hoffman as mise en scène, the two actors remembered each other's lines and finished each other's sentences. All four men—the two onscreen and the two offscreen—exemplify a cultural and emotional inside-ness (trust; Two) that only men have been allowed to have with one another when it comes to the dialogue between public and private. In the film, history is made up of men who make history together.

— 2013

I Touch Myself

California, here we come!

"There are forms of stuckness that are bodily."
— Lauren Berlant

Like a lot of children, I was obsessed with my fair share of stars. I was six when I saw *The Karate Kid* in Provincetown after a teenage girl coaxed me. She lived in the summer cottage next door, made necklaces, read teen magazines, and talked about *Karate Kid* non-stop for a week. She talked about Ralph Macchio. "I hate karate movies," I told her unimpressed. "It's not just about fighting," she lustily insisted, "Ralph Macchio is *gorrrr*geous." Persuaded, I asked my mom and dad to take me one night in July. The summer movie had been playing for weeks. We went to the two-screened theater wedged between Town Hall and what used to be Café Euro, a reggae-themed bar and restaurant in the center of town. *Bambi* was playing across the street in an old

theater behind a stained-glass shop. I dressed up for the occasion and we all walked down Commercial Street together. I had short hair and was into denim, plaid, and Converse that summer, because it seemed cool and boyish to me. But I also carried a little red purse that my mother picked up for me in Greece.

When Ralph Macchio first turns to face the camera in *The Karate Kid*, four minutes have flashed by and he is sitting in a run-down station wagon after a grueling cross-country drive with his mother that begins in Newark, NJ, and ends in Reseda, California. Until then, Daniel is only a petulant acoustic; all "M*aaa-s*"—an accented, offscreen teenage voice pitched against high vistas of American land-scape. Arizona desert, Canyon. The kind in movies and postcards.

This is the end of the line.

In the 1980s, American movies often portrayed the struggle to be American, which is the struggle to stay in the picture, specifically *Daniel's* struggle to stay in *this* picture. At seventeen, he is world-weary and literally the movie's sore subject, a soreness that is later reconfigured as physical suffering. While *The Karate Kid* isn't technically about the quest for fame, it is, among other things, a frontier story and an acquisition story. A dream factory fable ("This is the garden of Eden," Daniel's mother rejoices) that comes directly from

the way in which movies portray dreams (dreams we wouldn't have, were it not for the movies telling us what to dream) and the way those dreams are located in the representation—not the experience—of place. But in the usual mix-up over real life and fiction, Daniel's mother confuses proximity with access. It's *where* you are, not *who* you are. The problem of course lies in the fact that representation, unlike actual places, is uninhabitable and thus inhospitable. Daniel understands this instinctively. One cannot live in a picture or the places that pictures make. This is why when Daniel's mother sings "California, here we come!" during the film's opening travel montage and then asks, "What's the matter, you don't like my singing?" Daniel moans, "I don't like the *song, Ma.*"

After the film screening, I was hooked. Ralph Macchio looked fourteen, but to everyone's surprise, even the film crews', he was twenty-two. Since our bodies were the same—slight and prepubescent (he was girlish, I was boyish)—it was easy to pretend he was ten. Ralph had no body hair and the waist of a twelve-year old. For his Scorpio birthday, I cooked lasagna (reportedly his favorite food) and drank lemonade (reportedly his favorite beverage). I tried to sit through a hockey game on TV because I'd read that he loved the sport. I knew what town he lived in in Long Island. I even knew he was engaged. I wrote to Ralph and about Ralph in a fanzine that I "published" on a weekly basis and read to my parents (my sole audience), manufacturing my own form of press in which I was simultaneously journalist and reader. I played both sides of the fence and covered all bases. I acted like an intimate and I acted like a fan. I treated him like an actor and a real person. I did what any good girlfriend does: I took an active interest in the things my "boyfriend" cared about. I sang Ralph's praises and watched every single one of Ralph's movies over and over again; aping his walk and mannerisms, and even memorizing his lines, so that I could talk like him, and in the process become not just an actor myself—part of the fiction—but, by doing what Ralph did, I became Ralph.

At a young age, I understood the power and theater of clothing. The way in which it helped me have what I didn't have. Be who I couldn't be. Years later, as I watched the somnambulistic Donnie Darko ride the Carpathian Ridge on his ten-speed in the titular 2001 film, I remembered my own solitary rides around Province-town during the summer. Whenever I rode my bike up and down Commercial Street as a kid, I was dressed in tomboy wardrobe and makeup: short hair, plaid shirt, jean jacket, jeans, Stan Smith Adidas, Walkman—a gender-bending, outsider ensemble I had self-consciously assembled based on the movie boys I'd seen. Movies like *The Outsiders*, in which Ralph had starred as Johnny Cade.

I added a soundtrack to much of what I did, building a mood around my excursions, cruising around a town full of flamboyant adults (teenagers, drag queens, writers and artists), and was aware, even then, that I was enacting a dramatized—cinematic—image of aloneness and autonomy; the unseen story of girl-solitude, which I thought I could only play as a boy, or which I had only seen boys play ("The emotions of youth" that *The Outsiders* purports to capture, is really "The emotions of boys"). Whenever I wasn't watching a movie, I was screening an image of aloneness for other people's benefit, which was my benefit. I imagined it as revenge. I was both in and outside the theater of myself. When I was alone, I was Ralph being alone. I was acting alone. Because movie stars offer such powerful affirmations of belonging, when it came to Ralph, I could belong to his not-belonging because even as an outsider, he belonged to a commonality of representation. He belonged to the screen.

Did I think it would be easier to have Ralph Macchio if I were him or if he were me? If I were an actor and a character at the same time? Was I looking to fit by looking alike? By looking like the one I wanted to love me? If so, was looking alike the desire to mend deeper schisms? Macchio's short-lived iconic status was rooted in his ability to endure disapproval and rejection through the very

source of his chastisement—his body. A body that was not like the bodies of that time—big, strong, dominant. As a centrist movie about binaries—inclusion and exclusion; inside and outside—*The Karate Kid* portrayed all the discordant socio-cultural elements that plagued my own childhood. I could relate to watching Daniel, Ralph's iconic character, get the shit kicked out of him; his mouth packed with beach sand by a gang of rich blonde villains on his very first day in perfect-Southern California, followed by a black eye two days later after he is pushed off a cliff.

The '80s were live or die when it came to cultural archetypes, and *The Karate Kid*'s blonde villains wanted to annihilate Daniel. During the movie's decisive Halloween beating before the karate tournament finale, Daniel is almost gang-bashed (or, as Macchio put it years later in the DVD commentary, "This is where I got my ass kicked by the skeletons") to death. The hawkish quintet sport skeleton costumes and chase Daniel home through the urban forest. Daniel's weary body begins to fail him as he runs out of breath. He's already injured from other beatings, so he won't be able to climb over the fence to safety after running for blocks. The skeletons surround him. He is one, they are five. One skeleton begins to feel pity and says, "Enough." Another skeleton, the one who feels no pity, says, "No, more. No, all the way." Not only does the troupe plainly signify death in their costumes, but as symbolic cadavers, the blonde gang also signifies the dead body of Daniel. Death as wishful thinking. Death as ideology. Death as masculinity. What happens to Daniel is not bullying, it is torture. And the only thing that saves him—a delicate, feminine, working-class boy—from death in this '80s-fable is magic. And does that even exist? In the 1980s, salvation is almost always a fairytale. Realism jump cuts to fantasy.

In a 1984 *Washington Post* article titled, "Blond and Bad: The Advent of the Preppie as Screen Villain," Rita Kempley writes, "Inevitably, blondes became the establishment villains. The trend

represents more than the ancient rope-tug between haves and have-nots." "It's the reemergence of the American dream," adds Richard Stephens, a sociologist at George Washington University. "We've had such bad world press on our divisiveness. It's a calculated thing on the part of the producers to show the other faces of America." Daniel LaRusso may be one of the other faces of America, but it's this other face that gets bashed the entire time it's onscreen. That pays the price for being shown.

When Daniel and his mother pull up to their new home in Southern California, a voice tells Daniel to "Wake up." Then, through the camera, we crawl into the car to watch him sulk. For Daniel, the dream, which is a nightmare, begins. To Daniel's mother, the dream is a fairytale, and is launched the moment they step onto California soil. "Welcome to Paradise," she tells Daniel, introduced by a triptych of sky-high palm trees. But California Dreamin' isn't for slight, working-class, ethnic boys raised by single mothers, especially not in the 1980s—the decade of the hard body and the rich blonde villain. Like a movie role, the best parts are only doled out to certain kinds of people. "Those are the breaks," Daniel says later when he doesn't make the rigged soccer try outs. To Daniel, "Wake up" is a command that unleashes class-based dread. Just as he suspects, paradise is a run-down, motel-style dump in Reseda, and the luxurious pool in the brochure that his mother lured him with is all dried-up. A saggy rubber swan lies shipwrecked at the bottom of it. The aspirant dream is deflated in a matter of minutes. After that, things only get worse.

Possessing and being possessed by Ralph reminds me of what another Masha, played by Sandra Bernhard, does to Jerry Lewis' talk show host, Jerry Langford, in Martin Scorsese's media satire *King of Comedy* (1982). Film scholar Robin Wood argues that obsession with celebrity is Oedipal due to the celebrity's "prestige and authority." Wood calls this the desire to be in "Father's

shoes," for Father, in the symbolic sense, signifies ultimate acclaim and approval. Held hostage by Robert De Niro's fame/father hungry, Rupert Pupkin (a name that has the longing for *kin*-ship built into it), and Masha, Bernhard serenades the hostage Langford with: "Come Rain or Come Shine." "You're gonna love me/like nobody's loved me," she croons. In my case, by being Ralph because I couldn't have Ralph, I was gonna love me/like nobody loved me. And, like nobody loved Daniel.

In my six-year-old mind, Ralph and I weren't strangers. But when it came to the exact nature of my relationship with him, I didn't know what to call it. Was I just a fan? In *Celebrity*, sociologist Chris Rojek points out that the physical remoteness of the star is "compensated for by the glut of media (fanzines, press stories, TV documentaries, interviews, newsletters and biographies), which personalize the celebrity, turning a distant figure from a stranger into a significant other." Given that I was generating some of the media myself by reshaping what I'd seen and read into my own yarn, and in the process concocting the self ("I") I wanted Ralph to possess, I was acting as one of the cultural intermediaries in charge of Ralph Macchio's personality, for I literally wrote him into my life.

The Karate Kid is an Oedipal drama too. Mr. Miyagi, Daniel's Karate sensei and savior, is the superego Daniel's never had and desperately needs in order to survive. The film makes clear either that Daniel has no use for his mother, or that mothers are of no use in America. Daniel cannot acquire approval or social status if he remains fatherless (both "denial" and "lead"—which without a father Daniel cannot do—are anagrams of Daniel). Miyagi doesn't just teach Daniel karate, he teaches him everything. He both hides Daniel (the Halloween shower costume that Miyagi makes for Daniel is a disguise so that he can attend the high school costume party without his bullies knowing) and thrusts him into the world of male initiation and dominance (the karate tournament).

But what happens when California cannot be the dream for certain faces and bodies? What happens when your color is wrong? When all you've got is a mother? When your body is weak? What happens when you're too poor for the California we've invented for the screen? The post-feminist 1980s was obsessed with boys—a nation—raised without fathers. Even though Mr. Miyagi is a Japanese immigrant who speaks broken English, some father, the film insists, is better than no father, because Father is always better than Mother. The film punishes Daniel for having only a mother. It says you will die without a father. *Stars Wars* says you will die without a father. *E. T.* says you will die of loneliness without a father. Then, years later, *Fight Club* came along to tell us that manhood died without the Father around to keep it alive. "We're a generation of men raised by women," alpha-male, Tyler Durden, tells *Fight Club*'s narrator in 1999—the final year of the 20th century. In *The Karate Kid*, the beatings cease only when Daniel finds a father who can exploit both Daniel and his failed masculinity by putting them to work. In the film, karate is working class labor: a body is something this body has to earn. But Daniel's body will never work—it's too late, he's too soft. It's an inside problem, not an outside one.

Years later, while traveling through Mexico one summer after a bad breakup, I ended up in a video store in San Miguel de Allende with a group of people. Half-drunk, we were a motley crew who spoke different languages and barely knew each other, so no one could agree on what to rent. As I split off and walked through a sea of banged-up VHS cases, I came across *The Karate Kid*, a movie I hadn't watched or thought about in over a decade. I studied Ralph Macchio's baby face suspended and disembodied—a day-time moon hanging over the Southern California coastline—and started laughing. Sarah, my best friend, walked up and asked what was so funny. "I look *just* like I him," I told her. "We're identical and I never noticed that before."

When I was eight I found out that Ralph Macchio was making his theatrical debut in *Cuba & His Teddy Bear* at the Joseph Papp Public Theater in New York City. Written by Reinaldo Povod, a 26-year old Hispanic playwright raised on the Lower East Side, the play starred *Rocky*'s Burt Young and Robert De Niro in his first stage production since 1970's *One Night Stands of a Noisy Passenger*. When the off-Broadway run sold out in three hours, the Public Theater started selling closed-circuit tickets of *Cuba*. The play became "filmed theater. That ideal point," writes film historian Richard DeCordova, "at which the theater and the cinema… seamlessly merge." Watching Macchio on a surveillance camera in another room added a layer of voyeurism I was familiar with, and rivaled the secret feeling I'd always had of wanting to catch an actor in the act. There was no editing room to alter anything Ralph did. No cuts. No body doubles. No special effects. I was watching raw footage. Unlike a movie, the play, even in closed-circuit, would take place in real time. This meant Ralph and I would finally be in the same building together while it was happening.

My mother and I watched the live TV play upstairs while the actors performed onstage below us. An old hardwood floor replaced the barrier of the screen. I was getting closer and closer to him. During intermission, I ran downstairs to see if I could find Ralph. After the show was over, I figured out that I could wait for him in the lobby if I wanted an autograph. I was the only kid in the theater. I was also the only audience member left in the building after the play ended. No one had even stuck around to meet De Niro, who at that point, I knew only as the Devil with the trick name—Louis Cyphre; aka *Lucifer*—from *Angel Heart* (1987). The play finished at midnight. I asked my mother to wait outside while I sat on a long wooden pew-style bench with the playbill in my hand, along with the pen she had given me. I had a Louise Brooks-style bob and was wearing my mother's non-matching silk blouse and skirt.

When Ralph finally came out, he was—amazingly—alone. No entourage or bodyguards. Just Ralph. Just me. His hair was wet, and he had a white towel around his neck like he'd been swimming. I handed him the playbill and he asked me my name. I said, "Maria" because it was easier to pronounce than "Masha," but also because it sounded Italian. Like him, not like me. I'd switched over to Maria, my full name, in the second grade because it sounded culturally neutral, no one made fun of it. Like Daniel, I was beaten for both my body and my name.

Ralph was quiet and sweet. It was just the two of us. On my playbill, he wrote, "Maria, all my love. Ralph Macchio." Later I drew a heart around his face and the messy inscription below it. In 2008, while digging through some boxes in my parents' basement after a flood, I found the moldy playbill still intact despite all the water floating around it. In it, Ralph's black and white face is disembodied, just like on the *The Karate Kid* movie poster. Today the playbill is in a zip lock bag in my apartment, stiff as a board. I look at it for laughs. Of course, it locates me more than him. I'd found a way to condense and autograph my own essence. To serenade myself. To give myself what I couldn't get. I might as well have written across my own face, "Maria, all my love." More specifically, "I'm gonna love me/like nobody loves me."

The following year I managed to get actual Broadway tickets to *Cuba & His Teddy Bear*. Before the play my mother made lasagna and lemonade, which I ate and drank in Ralph's honor. It was November, sometime around Ralph's birthday. I brought a teenage friend along to see the show. A girl I'd coaxed into loving Ralph just like I had been coaxed into loving him.

— 2010

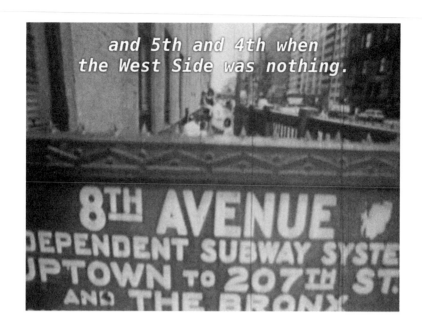

and 5th and 4th when
the West Side was nothing.

[male interviewer]
In those days, it was not.

Mixed Signals

> "In a society of consumers, no one can be a subject without first turning into a commodity, and no one can keep his or her subjectness without perpetually resuscitating, resurrecting, and replenishing the capacities expected and required of a sellable commodity... The most prominent feature of the society of consumers is... their dissolution into the sea of commodities... In a society of consumers, turning into a desirable and desired commodity is the stuff of which dreams, and fairytales, are made."
> — Zygmunt Bauman, *Consuming Life*

Sometime in the late '80s I watched the TV show *Miami Vice*. I was a kid and I watched it with my friend Nora, who could be mean and cold, and whose actions could be inscrutable. Like a boy's. Who sometimes wouldn't talk to me for weeks, for no reason, like we were in some romantic relationship that had suddenly and inexplicably ended. After a wave of ecstatic bonding, Nora would cut me off, and I would wander the school halls alone, watching Nora flirt with her other friends. Watching Nora seduce new people. For Nora, people were clothes.

I watched *Miami Vice* with Nora, who used to spend every other weekend at her divorced father's loft in Soho. She had a TV in her bedroom. I discovered a lot of things with Nora, like sex hotlines, all the rage at the time, Tears for Fears, Channel J, and the first boy I ever loved.

Nora's father was an artist and took us with him to modern dance recitals, the theater, and parties in Soho. One party was in a warehouse building that overlooked the West Side Highway. Nora and I threw paper airplanes out the window, which landed in the Hudson River, which we could barely see because it was so dark, and called sex hotline numbers from the host's bedroom.

For one party, Nora and I dressed up like Don Johnson and Philip Michael Thomas, the two lead cops in *Miami Vice*. We had been trying to look like them for a long time. I don't know where we got the clothes, or why we chose to be those men in particular. I think we already had the clothes and the clothes just dovetailed with the images of the two men. We both had a pair of boat shoes that could pass for loafers. We wore them without socks. We had linen jackets and pants. Bright pink t-shirts. We rolled our sleeves up. I had short, dark hair, like Philip Michael Thomas.

All of this was before I discovered Blane and Steff in *Pretty in Pink*. Blane and Steff are emotional opposites. Yet both are rich and dress the same. So how can you tell the two men apart? The movie is about that. Even Blane doesn't know the answer until the end of the movie.[1] But Andie, who is different, sees the difference.

Like Blane, Steff is attracted to Andie's difference, but only because he can't assimilate it. Andie isn't able to appreciate her best friend Duckie's difference (his love for her) because Duckie's difference doesn't require recuperation. Difference, the movie says, has to be rescued. Difference is a damsel in distress. Andie

1. In *Pretty in Pink*'s original ending, reshot six months after production wrapped due to audience disapproval, the melancholic Blane didn't know how he felt about Andie by the end of the film either.

believes that Blane is different—"not like the others." Blane's interest in Andie signifies non-conformity. Blane is attracted to Andie's difference—both respects and fears it—and yet, he tries to insinuate Andie into the very things she is different from because he has nothing different to offer himself. Blane wants to be different, but does not want to do anything differently. Blane wants difference without the difference.

A lot of teen movies in the '80s were about exteriorizing one's socio-economic aspirations and formalizing them into adulthood in the form of mature clothing. Clothing that signified a kind of subjunctive adulthood and mainstream success. Even if you weren't an adult, you were in training to be one, and the clothes—the suits, jackets, and ties at school, which weren't uniforms in the strict sense—meant you could transition into adulthood because, really, there was nothing to transition from. Adult or formal clothing—"power dressing"—was a way of being part of the world, the status quo, which in the '80s was about identifying with the tropes of power, wealth, greed, and success. Women sported "power suits" as they entered the corporate sphere, parodied and dramatized to great effect by David Byrne in Jonathan Demme's *Stop Making Sense* (1984). Your life was your business, and business was your life. This was before we found cheap ways to look expensive or expensive ways to be cheap. This was before you could cheat at being rich.

Wearing grown-up clothes in the '80s (*Less Than Zero, Saint Elmo's Fire*, even *Ferris Bueller's Day Off*) was a way of being tied—primed—to the conventions of the world even before you were emotionally and chronologically prepared to be primed for them. Through your clothes, you could look like the authorized world. You could show the world you were part of it by dressing like and for it. The market, personified by the yuppie as the market in the flesh, became an identity. Brands became increasingly

important in the 1980s. Ralph Lauren and Calvin Klein were household names. In *Less Than Zero*, teenagers dress and fuck like adults.

In *Ferris Bueller's Day Off*, Ferris, a high school student, plays hooky like a child or adolescent, but spends his day off acting and dressing like an adult: dines at a five-star restaurant, drives around in a Ferrari 250, goes to an art museum, impersonates adult voices, and wines and dines his older-looking girlfriend in the manner of a middle aged, married man. Even the songs Ferris sings at the Von Steuben Day parade he crashes—"Twist and Shout" by the Beatles and "Danke Schoen" by Wayne Newton—are songs for and by an older generation.

Yet, as much as the '80s were about mainstreaming the alternative, and maturing and commercializing the juvenile (teen movies, slasher horror movies, The Brat Pack), it was also about the avant-gardization of the mainstream: a time when clothing signified identity but also when everything started getting mixed up. As conformist as the '80s were, it was also a decade that was refreshingly incorrigible about its fashion *faux pas*. We had nefarious teenage-adults like Steff—who wore job clothes, *power clothes*—but we also saw people like Andie, Duckie, and Iona, Andie's older, mother-figure friend (who, by the end of the movie, turns corporate and transitions into mainstream culture when she decides to date a yuppie and dress like one too), who were retro, romantic, anti-label—"mutants," as they're called in the movie. Whose clothes reflected their anti-conformist sensibilities and interests, signifying not just who they were, but who they weren't.

Andie's first date with the rich Blane—her "dream" man—is a disaster. Neither Blane nor Andie understands or fits into the other's world. When Blane brings Andie to Steff's party, Andie

demands to know why Blane has chosen to take her there, of all places. Andie refuses to temper her disgust or her mortification. At the party, Andie and Blane go upstairs to Steff's bedroom, where Blane insists they will be alone. Instead, they find Steff and his girlfriend Benny (another girl with a boy's name), who bullies and mocks Andie at school, running around drunk and half-naked.

Blane is embarrassed and unsure of himself. Steff is a mixture of conceit and self-contempt. But Steff also always knows what Andie's thinking better than Blane does. And what Andie's thinking is what Steff is secretly thinking about himself. In *Pretty in Pink*, a great deal of emphasis is placed on diagnosing what makes Andie different and what Andie's difference makes of her. When Andie refuses Steff's advances, Steff responds with: "I don't know what makes *you* so different." But of course this isn't true. Steff knows exactly what makes Andie different and part of that difference is her disavowal of him. Later, at Steff's party, Benny tells Andie, "You're an asshole. I don't want to know *what* you are." Steff is visibly disgusted by Benny. By the things he has. By what and who is like him. Andie and Blane are sitting on a loveseat in Steff's room watching the spectacle of Steff and Benny—which is the 1980s—like it's a movie inside a movie. A time inside a time. The '80s are turned into a primal scene and the room becomes a code.

In *Pretty in Pink*, difference—both its appeal and its threat—is attacked and neutralized. A misnomer, difference is repeatedly named and misnamed. Labeled and mislabeled. Recognized and denied. Pretending not to know her name, Steff asks Blane, "Where's... what's her name, *Eddie*?" By being given not one but two male names in the film, Andie's difference is emphasized over and over.

Through Andie, *Pretty in Pink* asks: How do we address, dress, and name our desire for what it is and isn't? For what we want and don't want from difference. For who we are and aren't. By stumbling over her name, by calling her a "piece of trash," by giving Andie a plain—double—moniker, Steff deflects Andie's difference, which not only fascinates him, rejects him.

In Jay McInerney's 1984 novel *Bright Lights, Big City*, there is a line about not crossing lines. Lines that don't exist anymore. About how yuppies wouldn't go below New York City's 14th Street in the 1980s. Now the yuppie wears the artist and the artist wears the yuppie. Made in 1985, Martin Scorsese's *After Hours* offers a parodic rendition of this topographical miscegenation, where the yuppie is literally encased in art/ist, and the avantgarde/alienation is Soho—a former art district of New York City, later moved above 14th Street to Chelsea—at night. Once Paul Hackett does go below 14th Street in *After Hours*, he literally can't get back Uptown for the rest of the movie. As a socioeconomic zone, the demarcation, "Below 14th Street," has long been dissolved by gentrification.

Like Paul and Steff, who both wear linen suits to school, Nora and I wanted to go to the Soho parties as boys, maybe even as grown men. We thought we could pick up boys that way. Attract them by being some version of boys ourselves. We thought we could know and access the world that way too. We knew that boys liked to talk to other boys. We knew that clothes were also about whose bodies they were on. We were power dressing too. But why dress like grown men on TV, in another city, in a hot climate, like we weren't two New York girls with alternative, bohemian parents who wore all-black, going to a party in the dead of winter in summer clothes? Why did we decide to ape two middle-aged men whose job it was to drive around and capture other men?

I have always been more interested in looking than being looked at. Before I knew that I could think what I wanted to think, and feel what I wanted to feel *as a girl*, I was a boy in my head. A boy in dress. As a little girl, I was obsessed with male beauty (still am), instead of being concerned with the potentials or logistics of my own. In a culture where to a large extent only women's beauty is meant to have real value, male beauty mattered to me because I felt that while I might never be a beautiful girl, if I fashioned my outside to match my inside, I might be able to pull off being a cute boy. Moreover, I could possibly be the kind of cute, thoughtful boy, cute, thoughtful boys sometimes liked girls to be. I believed I could only access the strength of girlhood and womanhood through boyhood.

Nora and I thought images belonged to men. We thought images were the road to adulthood, agency, and independence. We thought boys could be what they wanted to be. Images taught us—even if our parents didn't—that men, not women, were independent. Romantic. Creative. Passionate. We didn't see the girls we wanted to be onscreen, so we thought being some kind of boy was to be some kind of image of a man. But everything is an image now and the image is now everything. Not just part of who you are and where you came from, the image is now the thing you see, the thing you are, before you do anything. Think anything. Want anything. There is no *you* first, only a *me* that performs; that is a commodity, a notion that comes from a culture of images that are meant to act for and instead of us.

While some aspect of difference was clearly the motivation for my identification with gender bending and *Miami Vice*, because I was little I also misjudged what was similar. I did not yet understand that you can learn to experience the world on the basis of difference, not only in terms of identity. What I really wanted to be like, and conversely *not* like, was not a man with power, but a

girl who did not want to be divided or limited. I didn't know yet what power could turn a man, or the world, or me into if I tried to act like one. Nora and I thought about the sameness we were accessing in the form of difference, but we did not think about the difference we were erasing by performing an imitation. By trying to be the same when we wanted to be different.

As a decade, the '80s were obsessed with classifying and categorizing people. It divided and subdivided. *The Breakfast Club* gives us a list of social categories: The Jock, The Brain, The Princess, The Criminal—creating binaries within binaries. There was always a hierarchy. A delineation. A type. A rule.

In *Pretty in Pink*, Andie makes her own clothes; makes her famous pink prom dress by deconstructing the status quo generic mall gown that her father buys for her and splicing it with the vintage prom dress Iona gives her. Andie remakes the dress into something unique, something money can't buy, in order to transcend her class avarice and shame. Money is how the rich kids in the film get what they want. Andie conquers and subverts her desire to be the same, to have what everyone has, by re-establishing and reconfiguring her difference. By turning a dress that is for everyone into a dress that is just for her. A dress that money can buy, but difference can re-make. Through Blane, Andie also gets to the world of privilege through a mix of difference and conformity—blurring the line between the two.

I preferred it when only people like Steff could afford to wear Lacoste and Ralph Lauren. People with real money, wearing clothes that signified their actual socio-economic position in the world, because it allowed me to know my place in the world. It represented a dissonance. I knew who and what a Steff was—the world he came with and the world that came with him—the way Andie in *Pretty in Pink* knows who and what a Steff is, allowing

her to keep her distance from him. But how can you keep your distance from something or someone if you don't know who or what that thing is? If that thing looks like you and you look like that thing. If you can't tell anything apart. You can't, and since you can't, you don't, and when you don't, differences and distinctions are eroded. Yuppies go below 14th Street. Sometimes a book is a cover.

In *Ferris Bueller's Day Off*, instead of fashioning his rebellion against the white, middle-class bourgeois suburban adulthood in which he's been brought up, Ferris goes deeper into the fantasy. So that it's not rebellion at all, it's a sign of things to come. Of his life in the future. Of the gap closing. And Ferris' rivaling sister knows it.

— 2010

10

Analog Days

"As 'tis said of Epimenides, that he always prophesied backward."
— Montaigne

I knew this man. He didn't know me, but he talked to me like he did. It takes a while to know someone. But not always.

Looking for a woman who wasn't me, this man walked into my room at the tail end of one summer and accidentally found me reading on my bed.

He said: Oh, it's you.

It was August. It was raining. The ocean under my window was sliding back and forth as usual. Fred, this man, wearing a yellow raincoat, walked in with his head down, concerned. He was the coastguard, I was a boat in peril.

Fred slid off his hood and lifted his bowed head to me like a monk, a humility obscured by the fact that he'd hadn't bothered to knock before entering my house. His face was freckled, covered in beads of water. Looking at him was like driving down a road.

I put my book down and we stood in my room talking, trying to make sense of his sudden appearance.

What are you doing here? Fred asked me.

I live here. What are you doing here? I asked Fred.

Fred was happy because when he saw me, he knew exactly who I was. Whereas I was confused. My memory needed jogging.

After ten minutes bent over my desk, trying to scribble some words down for the woman—my roommate, Izzy—he'd originally intended to find, Fred kept looking up at me in disbelief. His visit now taking on an entirely different purpose.

Fred wondered whether he should keep writing a note that no longer mattered to a person he no longer wanted to find. He stopped and looked up again. Then, looking right into my eyes he said, "You are above and beyond bullshit," even though he couldn't have known that for sure.

I didn't hear Fred come in, but I knew it was raining. I was reading on my single mattress when he walked into my room. I listened to the words I was reading drum on the page, louder than the rain on the roof. Back then I could spend an entire day reading.

When I looked up, Fred was just standing there in his wet raincoat, an insect that had accidentally flown into the room. I wondered how he got in but also wanted him out in case he did something dangerous.

If we'd been in New York, I would have yelled for help or called the police. I would have tried to defend myself. But in New York, Fred would never have been able to get in like that. He would have had to break down a metal door that cannot be broken down. Appearing suddenly in my room in New York would have meant something completely different. There would have been a sound, a jolt, some obvious thunder. Glass might break. Or maybe nothing would break. But violence. Violence would surely be there.

In Provincetown, with its wood shingle houses, sandy interiors, and old screen doors that didn't close all the way, bloated by salt-air, people didn't lock their doors at night. They left their wooden gates open. The worn-out paths to their houses, half-grass, half-sand, were knotted with old bicycles.

Things slipped in. Sand dunes spilled onto the road. Asphalt unfastened into loose grain the closer you got to the water. The tide erased all strings over and over, and men showed up in rooms uninvited without trying to kill you.

Fred had spent years watching me and looking back on it, I'd seen him do it. Not just in my room, but all over—in Province-town and New York. It took me a few minutes to recall his miscellaneous gazes. The where and when of them. The scenes they came with. The years they happened.

Standing in my room, Fred waited for my reaction because time was ticking. Time is. But I guess I was speechless.

Later that night in my bed, I searched and found Fred's eyes in the back of my mind as though they were stars up in the sky I could look at. I followed Fred through the long, continuous maze of my fuzzy memory. In bed, I thought about all the times I'd missed what Fred's eyes had tried to tell me, and if hearing him then would have made any difference.

In Provincetown, things come up to the surface. Wash onto shore. Debris becomes memento. Sometimes you don't even have to wait or try. The tide is a sure thing.

In bed that night, I asked myself: wouldn't Fred need more time to come to a conclusion like that? What I was "above" or "beyond." Whether I had any bullshit in me. But, and what I

didn't know at the time, was that he'd actually had the time, independent of my knowledge of it. He'd come to this decision over a period of years he later told me. That day was not the first day, but it was the first time I'd ever heard about it.

I never thought I could be so oblivious, meeting Fred over and over again and it barely registering. Me not taking note. Like some dumb movie where the point is to be obtuse and negligent until it's time not to be. In the movies, you get multiple chances to discover how great someone is. You get chances and don't even know that that's what they are, and this is fun to watch but not fun to live.

I was lucky to have Fred say those words to me. I was feeling so low. It was my worst summer on record. It was like I wasn't even there. I remember someone telling me they'd barely noticed me all summer. That I was a ghost. Not like myself. Sometimes I think I shouldn't have been there at all, should have just gone home, not come to Provincetown after two months of roaming around Mexico with Sarah, after she was done with her sculpture and ceramics classes in San Miguel de Allende, and I was out of money, we both were, my stomach still battered from the parasite we got over Christmas in Oaxaca. We woke up at the exact same moment, in the middle of the night, to vomit out our guts in the concrete bathroom of Sarah's shared house. In Oaxaca, Sarah drank to make herself feel better, cooked big meals, and I read and disappeared for hours like a petulant male lover. I took naps on park benches, ate ice cream, read all day, and hung out with stray dogs that I named, sometimes fed, and the city caught and killed. At the town square, Sarah and I would take turns crying into each other's arms after fighting and not speaking. We'd make up like lovers. We couldn't even put words to things. We'd lost language in Mexico because we were both heartbroken. But once, even with the language barrier, our tears got across,

and two elderly Mexican women—also friends—sitting beside us at a town square in Oaxaca, took our hands, stroked our hair, and smiled. One night, Sarah and I watched *The Fifth Element* in Spanish in a deserted, industrial part of town because we'd already seen it in English twice. We needed to listen to people say things on screen. We put our sorrow into movies. The language of cinema replaced our native tongue.

Sarah and I had watched movies together for years. In college, in Provincetown. At Sarah's place in New York, at my place in New York. In theatres around the world. In our beds together. I'd always stay up until the end of a movie, Sarah would always fall asleep. Movies were our education. I used to yell at the screen when I realized something terrible about the way the world worked. But after we fought at her grandmother's house in Tuxedo, NY, a few weeks later, I had to get out of town, fleeing a comatose female friendship that would never wake up again. Sarah watched me from the top of the staircase, holding onto the banister, like a 1940s-femme fatale, screaming and pleading for me not to leave, but not coming down to stop me either. Back then I was such a good Glenn Ford to her Gilda. Such a withholding silent noir man. It took me years to become a woman. To scream and holler and come back for more.

"I'll drive you to the train station," Sarah offered at the last minute.

In the car, we talked to each other like it was the last time, and it was. I didn't want to look at her, and the leafy summer trees obscured what I could see out the car window. I needed to get some distance, but it was summer, the season of color and close-ups, so there was no distance. I wanted to do the opposite with Sid. Go back to him by zooming in. I knew Sid wouldn't be back in Provincetown, wouldn't do something as stupid as rub salt in the wound in a place that was all salt so soon after our breakup. That's what I did. I

knew how to lick old wounds. I was a pro. When I left for Provincetown, Sarah started taking drugs and forgot all about me.

On the phone, months before, Sid said he wouldn't be back to Provincetown and he meant it. But I said I would and I meant it.

After the summer ended and we broke up, Sid spent the winter in Provincetown while I went to college in New York.

I left and he stayed. Then I came back and he left.

I waited for Sid to show up all summer. I believed some residue of us would still be in town and I could rent a place and live in it for one more season. I could ride my bike around our old haunts, circling them a hundred times. I could swim in it. I could take pictures. I could look at the pictures I already had of us. I could revisit each and every day. I could remember him. I could try to understand. I went back the way a detective returns to a crime scene. I stuck around the way every ghost sticks around. I haunted. I was haunted. I had nothing to do with everything around me. I had too much to do with everything around me.

In the movies people say things. Words get across. Images depend on it. Otherwise we'd be lost in them, the way we're lost in our real lives. In real life, sometimes people don't say anything. They miss their chance to say something or they say a lot of other things they shouldn't instead. Words in place of other words. They waste time. They lose time. Time is lost and people get lost. Movies know that at some point you have to attend to the thing you want to ignore. It's a basic human requirement that cinema is plugged into. To fix whatever mess you've made with whomever you've made the mess with, either through the person you made the mess with or through another person who helps you clean up the mistakes you made with others.

When Fred told me that I was above and beyond bullshit, it jumpstarted my life again. It brought me back into the world. He'd said the right thing at the right time. Reminding me of my power, he'd finally succeeded in getting my full attention or there was finally nothing preventing me from giving it to him. No Sid blocking the way. Before that, I'd always ignored Fred. He'd said other things over the years, but I hadn't heard them.

Fred: We've actually met many times. You just don't remember.
Me: We have? I'm sorry.

The deleted scenes. The outtakes.

After Fred left, I went back and rewound. I realized that I had managed to catch some of the things he'd said to me over the years. I played our encounters back and watched those old silent movies of us.

I was nineteen when Fred walked into my house. But we'd also met when I was 16, 17, and 18.

In my room that day Fred and I said:
I thought you were 31.
Why 31? I'm only 19.
It has nothing to do with your skin. Your skin is perfect. It is everything but your skin.

There was no small talk after that day. Fred's random appearance and cryptic non-sequiturs instantly bonded us, even though we'd previously been disconnected. Or I spent years ignoring him, which is a kind of connection. Pretending that what's there isn't there.

When Fred said this, it was raining outside. Fred came in looking for another woman, Izzy, a painter and baker at Café Edwige, where I was a breakfast hostess. A friend of his, and a one-time sexual encounter, Izzy told me about Fred in the kitchen one night over tea, a few weeks before he showed up in my room. At the time, I didn't put two and two together. Fred didn't stand out, not even after a story. How many chances did I have with this man? I had so much patience, so much gall then.

Driving up from Brooklyn for the weekend, Fred thought maybe he could try again with Izzy. He'd check to see if she was home. If she wasn't, he'd leave her a note. Maybe they could have dinner or go to a movie. He wouldn't be pushy because he wasn't pushy.

Fred was soft-spoken and sensitive, yet his entire life was dedicated to cultural detritus. Six years older than me. A skateboarder, an insomniac, a former drug addict, a social worker. A TV and magazine junky, he seemed to only read fashion magazines, which he carried rolled up under his armpit. Yet he didn't even know how to dress. I was obsessed with clothes but never looked at fashion magazines. Fred talked about models like they were his friends. His shallowness was a defense mechanism the way my intelligence was sometimes my shield.

Back in the City our conversations drifted into triviality and gossip in a way they hadn't in Provincetown. We suddenly had to comment on the world around us and realized we had nothing in common. And yet I liked him.

Over the years, I'd met Fred at parties on the Cape and in New York.

Months later, right before the Twin Towers fell down, we danced to go-go music at Windows on the World on the 107th floor

with friends. On a few occasions, I found Fred on the dance floor and made sure our bodies didn't touch even by accident. Afraid of heights, I hated going up there. It took ten minutes for the elevator to take us to the top. When the planes crashed into the two towers, I imagined sliding off the black marble dance floor and falling down one the hundred-and-seven stories.

Fred had freckles and looked like Bobby Kennedy. He was preppy. He was plain. He was easy to miss. I remembered thinking that at a party one summer in Wellfleet when he walked up to me and just stood there looking at me without saying anything. His brown hair always perfectly straight and parted on the side. He wore his gingham shirts buttoned all the way up. It was hard for me to imagine what his body was like behind all those boarded up windows of fabric. There was no way I could ask him. Above all, I didn't want him to know I wanted to ask. One night, after a stint at the Hyannis Hospital for a ruptured ovarian cyst—my second—I fell into bed high on some codeine a nurse gave me. It was three days after Fred had walked into my room. I was so dizzy, I had to leave the drag bar I was in, the bar I shouldn't have been in so soon after, the hospital ID band still on my wrist. In bed, spinning, I imagined the lullaby of undoing each one of Fred's buttons slowly in my room as it twirled around me. In my mind, I discovered that Fred's chest had no hair on it, just more freckles. I imagined us standing in front of each other, the moon out the window, our faces an inch apart. I'd be able to feel him breathing. His breathing would speed up my breathing. I could hear his heart beating. "Look how close we are now," I'd say. "Isn't this what you've wanted all these years?" I'd make him hold that position for as long as he could stand it. Up close but still apart. I'd say, "Close your eyes. You don't have to look anymore. Things are different now." I'd touch him for a long time without letting him kiss me. I wanted to include a barrier in the intimacy because obstruction had always been between us. Timing,

memory, other people. It was what connected and disconnected us. Some thing always in the way, so why get rid of it? Why not use it? Minutes would go by and we'd still be standing there. I'd make Fred hold the pose until he was out of breath from trying to get near me. He'd say my name. He'd beg quietly. He'd move to express his pleasure. I'd see that the look in his eyes was never plain. I'd see that I'd been wrong. I'd say, "I remember you." He'd stand there without letting his posture shift. His shirt would be open, parted slightly like a curtain. I'd slip in and go behind it, like Jane Eyre discovering sex. I'd say, "I know it wasn't like this with Izzy." I'd say, "Only time can do this to people."

Weeks later, in September, we went swimming at Slough Pond in Truro. It was already getting cold. Fred wouldn't go in the water. Instead he sat on a fence post with a towel around his neck like some cowboy watching me from above, those freckles on his bare chest. It was the cockiest thing he'd ever done. Because timing is everything, I decided to swim across the pond with my ex, Josh, not to get closer to the past, but to get away from the future, which was now possibly Fred. Someone I wasn't ready for after Sid. As a thing of the past, Josh was already too far away from me and what I'd once wanted for there to be any chance of my getting caught up in him again. No matter how present he was. No matter how near. I used the past to escape the future.

Fred had a face that receded into the background. A face that was easy to lose sight of when other faces were around. If you were caught up in another face. Sid. The memory of Sid. When I first met him, it felt like a car was crashing into my body. His face shattering the glass of my face. He walked up to me that way on purpose, and I instantly hated it because some part of me liked it. Sid called my bluff. "Hi, I'm Sid. You're the girl I always watch biking around town. You always look like you think the world is fucked up." Fred's face left almost no impression over and over.

He had a face that needed to be seen at the right time in order to make sense, and it was never the right time. I had to look to find what was in Fred's face. I had to try to see what was there. It was my face to find.

I remembered all of Fred's awkward attempts to talk to me over the years. At a birthday party in Brooklyn one winter, Fred interrupted a conversation I was having to ask me how my arms had ended up being "so beautiful?" "Do you work out?" he asked, blushing. I laughed at his question, which I found ridiculous, and walked away. Then I looked around the room for Sid, who was rumored to be at the party. When I saw him, I went upstairs, locked myself in a room, and cried. But I also would have cried if Sid hadn't come to the party.

Three years earlier, I saw Fred for the first time. We were outside of Ben & Jerry's with a group of people in Provincetown. We were sitting on the ground with our ice cream cones, Sid by my side, his hand cupping my right thigh. At one point, I looked up and saw Fred staring at me. He wasn't just looking. He was in the middle of a long take. He'd been looking the whole time. When our looks attuned, I was only partly there, in the eyes, looking back. The look was strong enough to come across, to stop me from talking. I banned its meaning from fully registering, ignoring whatever thing Fred was trying to tell me. I let the look fall away. Fred looked scared, like I'd caught him going through my things. When everyone stood up to say goodbye, Fred walked up to me and introduced himself instead. "Bye," I said, to no one in particular. "I'm Fred. We've met a couple of times," he told me. With our arms around each other, Sid and I broke free from the crowd and went to the movies.

Sid said: That guy likes you.
I said: What guy?

Love is also the place where things happen.

Three years later, I rented a room at Izzy's because I'd always wanted to live at the beach house on 411 Commercial Street, which was owned by her mother. Crazy Mitch, a liar and a painter, had lived there in 1999, and we'd all piled around him, much younger, sprouting short-lived teenage friendships. I thought if I couldn't have that anymore, or ever again, I could at least live near it.

I wanted a house that people could spontaneously visit. At first I loved it and then it scared me. I started locking my door because I felt too ugly to be so impromptu with people. When Fred walked in unannounced, I was wearing overalls and a hideous acrylic orange sweater with gold buttons that I had found in a church charity shop the week before. The gold was chipping off like paint. Why did I buy this?, I asked myself when Fred walked in. I discovered how humiliating it was to be unprepared.

When he walked into my house, Fred said, "Oh, it's you," like he couldn't believe his eyes. I knew what he meant by that, the way I sort of always know what someone means when they say that kind of thing. When I heard it, it felt more like I was a viewer watching what was happening to me, to us. It's a prescience or reflexiveness all of us have now mostly due to romantic movies. I felt Fred realize it was me. I felt it matter to him. I felt him land in something important to him. The room was a form of serendipity.

Afterwards, we walked through town. Walked down Commercial Street in the pouring rain in our raincoats after talking in my room for an hour. Walked to the Governor Bradford, a bar. Walked to Spiritus Pizza for a slice. Ran into some people we knew on the way. A small promenade town, everyone raised their

eyebrows at the sight of us together. I was recovering from some unspeakable trauma I couldn't get across. Everyone around me knew what it was and never brought it up, like Sid had died instead of acted like an asshole who was still alive. In the rain, my orange sweater reeked of mothballs after a life in somebody else's closet. It was so bad people kept asking where the smell was coming from. The stench of my sweater wafted between Fred and me as we walked.

After nearly a year of occasionally emailing back and forth in New York, neither of us cared or called or emailed anymore, and when Fred and I did accidentally run into each other again at the Angelika Film Center, two years had passed, and we were so angry, or hurt, or disappointed, or just indifferent that we never spoke again. I know it mattered to both of us that we connected the way we did that summer. "I'm a good judge of character," Fred told me at a party in Provincetown, and I believed him since he chose to sit next to me all night when he could have kept moving. The most radical thing to do in a room full of 100 people you barely know is stay put with one person the whole night.

But time makes you stop doing what you once would have done. I wanted to send Fred things—words—things I'd say in my head to him, but I have always stopped myself. I saw a photo of Fred on Facebook a couple of years after that summer and it made me sad because he looked like he didn't need anyone anymore. He'd lost that quality of needing that I liked about him. Later he took the photo down because maybe he knew he looked like that, and it wasn't true. Images have different meanings for different people, often showing what isn't really there, what isn't really happening, and we've all been reduced to images. I know pictures lie, the way people lie to themselves and others. But I'd rather believe this picture of Fred because I am more afraid of lying to myself about what I see, about what I think I saw, than I am

about seeing through lies. But this is a new fear. One that I didn't always have. One I didn't have then. It's so thoroughly modern to see people you don't actually see anymore. To talk to people you don't actually talk to. To look at them all day long and think: *This is what it means to know people.* All these pictures are ghosts pretending to be people. All these people are acting like ghosts pretending to be real. It is so brutally modern that people are everywhere and nowhere in your life, which is a series of online accounts and screens now. We've gotten so good at not really showing up for anyone anymore. At stalling. At missing our chances. At wasting the chances we get. At not actually being anywhere with anyone at any time.

In the movies, more than anything, people want to be known. In real life, people are willing to remain inscrutable. I've always been good at seeing through things. Fred even said so after knowing me for only a few days. Fred made the observation at a bar that summer, after he walked into my room in Provincetown. He said it about me, not to me: *She sees through everyone.* Fred actually surprised me a lot. For a while I thought he was just a wallflower. A boring guy. I did stupid things like drunkenly cry in front of him about Sid, and he never said a mean thing. He let me do what I needed to do, and say what I needed to say, without saying much of anything himself. He looked at me with patience in his eyes. And the more time passes, the more I think these things, which just seemed like filler at the time, on the sidelines of the so-called big things and big people that were happening in my life—Sid—are unforgettable. But I might be wrong, as there's always the chance that I've been wrong about Fred all these years, thinking he had these rare qualities that people either never have in the first place or lose over time. Fred, who didn't necessarily have determination or purpose, but who had other precious qualities, like vulnerability and candidness; the desire to know someone—qualities he'd somehow managed to keep, even

though I could see that he was getting weary, and that's already a lot in this world. This ability to see through people, as Fred put it, really just meant that I knew some things that I couldn't have learned. It's the things that I have learned that have pushed away the things I was born knowing. I also have faith in things other people don't believe in and doubt in things other people don't question. And now, after believing that I knew some people deeply, I realize that I have actually never really known anyone. I think they only knew me, though I'm sure they think they didn't.

— 2016

11

2004

Underneath the huge tree in Lisbon. Not the one that is 250 years old. But same age bracket. Now that I no longer write in fits, I no longer think in them. I crushed the cedar again in my right hand and smelled it. Would José say I am sentimental? No, he says romantic. José is a friend, almost 70 years old, in whom I confide. All kinds of things I don't expect. I wasn't expecting to say what I said last night. But mostly drunk, the giving away was easy. It's the way I really am. Spent nearly three hours with Paul yesterday, up in the Prazerés (Pleasure) cemetery, and he drove me crazy. I would have had a place to put him. I hid behind the tombstones but he kept finding me. Later that night, Kane said he would check on something I said about a book we both read. I felt like he was giving me things when we spent the evening together. *This is my favorite bookstore.* I think he said that three times. The magic number. It was closed but we stood in front of it anyway. In the alley. He laughed over *The Street of Short Little English People* because I did when he pointed out the sign in the dark and translated its name from Portuguese. Laughed at my laugh. I looked up at the sign and he read it to me. He also smoked because I smoked. I said, *Go on, have another.* Tempting him. He did. Had many. Was this us flirting? Doing the same thing, together. Sharing not a mouth, but what touches it. I can't remember if we took turns sharing the cigarettes or if we each smoked our own. I could have sworn his footsteps every night, past my door, were for me. Not just him going up and down the stairs because he lived on the floor above me. Saw him walking up our hill with a grocery bag after work one evening.

His blue button-down shirt, high on the hill like sky. I couldn't speak. That's when I knew I had been waiting for him. I made a joke about how *hard* he'd been at his job. The word hard sounded sexual. I regretted using it. But he picked up the joke and gave it back to me, curbing it by repeating it. *Yeah, all that reading I do all day. Hard.* Changing the word but also letting it stay the same. More sharing? The only thing possible. He is married. He is a literary publisher, four years older than me. In this steep city of seven hills, which demands that you climb, like the stairs between our apartments. Sometimes he makes faces when I tell him something. The faces make me feel uncomfortable and stupid. The things I say to him are regrettable. Sometimes he frowns. Half the time he looks like he'd rather be doing something else. Like kissing me. His irritation feels intimate. Though in the moment I'm never sure. I swear I know what I'm talking about. Telling me the age of the cedar tree that night sealed the deal. *Two hundred-fifty,* he said. I thought maybe I'd known him, something, that long. The desire so sappy. Also his footsteps, always a little too slow around my door. Pausing. And now he's not even home for another three days. I don't even have the footsteps to listen to. Not even sound to grind into. When I knocked days later, he answered the door. Held it halfway shut, halfway open, and I handed him the laundry clips I'd borrowed. He looked embarrassed, sorry, like he was laughing at me or himself or the situation. But he also didn't want me to come in. I swear he watched me walk back down the stairs. I swear I felt it on my back. At the café, a day or two later, I had a fuchsia colored flower in my hair, for him. Small, pink, dying. It was wilting over my ear. I think I picked it off a tree on my way through the park because he'd told me he planted the same kind of flower in his garden. I wanted to be something he grew. I told you, José said romantic. Romantics are people who do things even when no one is looking. Even when there is nothing in return. I am wearing the flower for him even if he

doesn't see me. I think the nicest think about him is that he links things. Strings them together after you've said them. Remembers, reminds you. My cigarette half lit—*Someone's thinking of you*, he says. José, who translates books for Kane from Portuguese to English—Kane is both—said he thought he probably had a sweet tooth. *It's just a sneaking suspicion.* Why did José tell me that? Am I the sweet? I'm afraid to ask. I'm getting too drunk, so I probably will. It's both a reason to ask questions and a reason to stop drinking.

He gave me the name of streets in English, he gave me three glasses of wine, he gave me his thoughts on different things, he gave me laundry clips to dry my clothes, he gave me coffee. He gave me nothing. What's getting? He sat with his arms crossed, his legs crossed, in the blue shirt, smoking my cigarettes. He asked me about the book I'm writing. *Maybe we could publish it. Can I read it?* I try to say no without actually answering. I change the subject. But I've also told him more about the book than I've told anyone else. I had no phone, no landline, no cell. I had left my husband. I was using the city to hide. To mourn. How did anyone find me? How I did find them? When he got back from his summer house, the night before I was flying home, Kane knocked on my door and asked me to come with him. He said it just like that. *Come with me.* I responded too quickly. Days before, he tapped my shoulder. No, he didn't actually touch me, while I was at the café next door, reading. I had on red lipstick and my dark hair was sealed back, 1940s-style. He was happy when I looked up, his style. And surprised? About the red lipstick. An echo of the flower. His voice was private, generous. Not generous. He's uncomfortable, careful. So am I. I asked what his sign was, he answered. I did something like melt, felt predicable with my taste. Said something inappropriate. Again. He looked annoyed, closed shut. He's right. What do I think I'm doing? Don't say that. *Funny, you should*

knock. I'm not allowed. But you are? I just wait. Feel glad I know how. I am young. But in the future waiting will come in handy. *If I hadn't been home, would you have gone back up to your apartment?* Meaning, was I the destination, *Or what the hell* as you went down the stairs and your arm touched my door on the way out. I did my laundry at his house and didn't want to take my clothes out of my bag until he left the kitchen. My underwear felt sexual on the floor. Finally he left the room, then told me I could meet him and his wife and her brother at the cafe. They were all standing there, on their way out, and I had my dirt in my hands. I knew I shouldn't take him up on his offer. I waited, that's what I do, and wrote at home, downstairs, for a while until enough time passed. *You couldn't possibly know what I'm doing.* Then I went out and sat down with them at the cafe. He pulled a chair out for me, then we bashed London—where he's from; where I used to live—and the English, of which he is half. Just the two of us. *Fuck.* I said the word a lot. He grinned. I wondered if I was paying too much attention to him. If he was paying too much attention to me. If certain words, like *fuck*, were more attentive than others. Just between us. When I leave Lisbon I won't ever see him again. But he is someone who understands, so I will remember. The clues are everywhere. I can spot them a *mile away. He is one of them. 250. Would I have all these things if I had love?* The question makes me sick to my stomach as I board the plane to New York. The more I think about it the less I eat. When I'm back home, I tell my mother I've lost my appetite. She says, *You can eat again when you're in love again.*

— 2010

12

Mourning and Melancholia

(After Joe Brainard's *I Remember*)

I remember waking up all the time in the middle of the night: 2015, afraid.

I remember I was terrified that I was going to die someday. But I also felt more alive than I do now. Maybe that's why.

I remember texting you (my last love), "Let's meet" after we decided it wasn't a good idea. You had a girlfriend. I was with my German gallerist at a hotel bar on Kenmare Street, getting drunk.

I remember pretending to be sober in order to seem professional, but she kept ordering more wine.

I remember I hadn't eaten dinner.

I remember at one point, I said, "I need to use the bathroom. I'll be right back." In the bathroom, I threw up the moment I entered the stall, then returned to our table as though nothing had happened.

I remember her daughter showed up at the bar. She had just moved to New York to go to film school.

I remember her telling me and her mother that her first NYC apartment had been burgled because she had left all the windows open.

I remember her telling us about her first film shoot for school and how she left her $5,000 camera in a parking lot in New Jersey. She didn't sound sorry.

I remember her telling me she was living with her actor boyfriend and feeling jealous that she'd found someone so quickly even though he seemed stupid and had already cheated on her.

I remember thinking she was spoiled and wore too much make-up for someone so young.

I remember telling my gallerist about liking you.

I remember asking her how long she had been alone before meeting her fiancé, Karl. She was 52.

I remember she said 8 years.

I remember I had been alone for 2.

I remember that being that drunk gave me the courage to tell you that I wanted to see you again. I hadn't planned on ever doing that.

I remember being happy that you were happy to receive my text. You instantly wrote back, "Yes, when?" and we made a second date.

I remember how easy it is when both people want something at the same time.

I remember there was melting snow on the ground.

I remember going outside to smoke cigarettes with my gallerist's daughter.

I remember red light in the windows, on the pavement, all the heavy foundation on her skin.

I remember not being afraid the way I am afraid now.

I remember the splashing sound the cars made because the streets were wet.

I remember checking my phone under the table. Something I never do because it's rude.

I remember my gallerist made fun of me for it, and that's when I told her about you.

I remember I was out and you were home.

I remember you asking me where I was.

I remember you said there was a big bruise on the inside of your thigh. I had bitten you.

I remember not having any memory of doing that.

I remember we were texting each other about what we remembered: Slow dancing on the last night at school in the Swiss Alps three years prior, at a Eurotrash dive bar, the summer we met and were just friends. Suddenly I was in your arms because someone had pushed me into them. "Dance with each other," they ordered.

I remember you texted, "I remember I liked holding you."

I remember saying, "Do you remember we almost kissed?"

I remember you saying, "You remember that? Yes."

I remember how romantic and exciting it immediately felt to remember things with you. About you. To feel remembered.

I remember it was late February 2015, dead of winter. We had known each other for three years.

I remember 2015 was the last time I felt beautiful.

I remember we were clumsily, drunkenly, kissing in my bed the week before.

I remember I whispered something in your ear. I was on top.

I remember you said, "What is that voice? I've never heard you sound this way before."

I remember I said, "I know, it's *high*. Do you like it?"

I remember you said, "I love it."

I remember that we texted every day about how cold it was outside. Where to meet for our dates. What to wear. What we wanted to see each other in.

I remember choosing bars, movies, restaurants, bookstores to meet you at. Whether to stay home in bed together. "Do we want that?" you once asked in an email. You said "we," which I liked, but really you meant you.

I remember you texting that you missed me.

I remember texting that I missed you.

I remember having sex for hours as the weeks went by.

I remember being afraid in the beginning that the sex might not be very good because you were too shy at first.

I remember being surprised, and liking, when you talked during sex.

I remember being amazed at how pleasure arrives in one's life. Then leaves.

I remember trying to remember if I had ever wanted you all those years when we were just friends.

I remember rereading all our emails to try to figure it out. Were there clues in the words? The ones we said and the ones we didn't say. You always being in one place, me always being in another. Months would go by. You would ask me where I was. I would ask how you were, your favorite part you later told me, because "No one ever just asked like that." Were the letters

themselves a sign? In one email you wrote: "You, who are already so concentrated, are also a sign."

I remember liking (no, loving) watching you cum. You seemed so free.

I remember thinking nothing about you turned me off, which amazed me. There had always been something repulsive or strange about other lovers, their bodies, even when I loved someone.

I remember thinking that I knew you when we were in bed even though sexuality is the one thing we can never know about someone.

I remember you looking at my hands.

I remember you kissing my hand.

I remember that you made pained sounds when we kissed like you couldn't bear it.

I remember never pushing you away. Never avoiding you. Never thinking anything would go wrong.

I remember emojis.

I remember: crystal ball, fox, fire, green heart, red heart, red rose, the symbol for Pisces (your North Node), a star, a lock, a key.

I remember that every text you sent was: thoughtful, warm, romantic, immediate.

I remember that there were daily emails that always felt like letters.

I remember you writing about how "private and intimate" it felt to write to me.

I remember you writing, "I can't wait."

I remember me writing, "I can't wait."

I remember how when we misunderstood each other, you always offered to call. To let me hear your voice, which solved whatever problem we were having.

I remember you telling me that you saved the only voicemail I ever left for you and listened to it over and over. I was at a noisy bar with friends when I made the call.

I remember you telling me over the phone that having a recording of my voice was "precious."

I remember that we always felt better after talking on the phone. After seeing each other in person. As soon as we kissed, which always took time.

I remember the way you would look at me whenever I walked towards you. When we would meet on the street. When I would leave a room then come back into a room.

I remember you telling me that was your favorite part: me at a distance, then me up close. When we kissed, you would look at me—my nose, my profile, my neck. You thought of me—"my beauty"—as a filmmaker. In terms of angles and shots. Zooming in on me, then zooming out.

I remember you, a student at film school, asking me, a film professor, for a list of old movies to watch. You thought they were

boring but wanted to change your mind. I told you why they weren't boring. I gave you a list.

I remember getting up to sit on your lap at a bar in the East Village on our second date.

I remember when we left the bar, you reached for my hand to hold it.

I remember it was very cold outside.

I remember we saw a little dog that the owner had dressed as Edie Beale from *Grey Gardens*. I stopped to pet it.

I remember strangers always asking us if we were in love because we spent hours talking and kissing at bars.

I remember you sending me videos of yourself as a child.

I remember sending you photographs of myself as a child.

I remember you telling me what you saw in those photographs.

I remember we never took pictures of ourselves together on our phones.

I remember we only looked at each other in person, so there is no record.

I remember when you took your sweater off, right before we kissed for the first time. You were wearing a forest green button-down shirt and it was like I had never seen you before.

I remember talking about the weather getting warmer, "thawing," needing the sun.

I remember sitting in Washington Square Park with you in March because spring was coming.

I remember that what was happening outside of us was also happening inside of us.

I remember meeting you in Washington Square Park on my birthday and you telling me that I "stood out in a crowd."

I remember you said if you were on safari I'd be the first thing you would kill.

I remember telling you how romantic and sick that was.

I remember making out in a taxi in Brooklyn on my birthday.

I remember leaving my birthday party a few different times to kiss you in a stairwell where no one could see us.

I remember I didn't want anyone to know we were together at the party. I don't know why.

I remember you telling me that I was beautiful over and over.

I remember how flushed your skin would get when you were turned on. Your grave face. Your kind face.

I remember I was wearing a red satin 1940s Canadian high school jacket (you are Canadian) that you loved to see me in.

I remember you put your hand inside me in the stairwell.

I remember your cheeks went red. That whenever you were turned on it looked like you were concentrating or worried.

I remember thinking those were the best kisses I ever had. I still think that. And it is painful because we are not together.

I remember thinking you were in over your head.

I remember thinking I wasn't in over mine.

I remember always convincing you to come home with me at the end of every date.

I remember you always resisting. Then succumbing.

I remember I should have known that was a bad sign.

I remember I was 16. With another boy. The first one I ever loved.

I remember school was almost over, one more week. Memorial Day weekend.

I remember the last time we almost got back together. We had been walking around Soho in circles. Mulberry, Mott, Prince. My best friend Nona, who had always been our catalyst, was with us. In high school, we were the only two kids that lived Downtown. We went to Jazz clubs on weeknights—where you played, a teenage musical prodigy—hoping to run into each other. The Village Gate, now a rundown CVS, The Village Vanguard, Bradley's, now a sports bar. Sometimes I took long walks at night, knowing I would find you somewhere. Knowing you were looking for me too. When I'd find you, I'd pretend it was by accident. Or you would find me and pretend it was by accident. We pretended a lot because it was too much for both of us. This was before anyone had cell phones. This was when you had to really look for people.

I remember at one point we were sitting on the NYU faculty housing steps, across from the Silver Towers, facing LaGuardia Place the night we almost got back together, but then didn't.

I remember it was night.

I remember feeling sick with a stomachache. I had eaten a bad slice of pizza. You didn't eat anything.

I remember you were wearing your long tweed winter coat. But you probably weren't. Too warm?

I remember you asked me to take you back.

I remember you were on your knees. "Please don't mess with my heart," you said.

I remember you placed my hand on your heart like you were pledging allegiance.

I remember I was dating your best friend.

I remember I wasn't in love with him. I was in love with you.

I remember telling you I had to run across the street to use the bathroom to throw up.

I remember I went into one of those Italian bakeries that used to be there. The bakery is now a Viennese restaurant called Freud.[1]

1. As with everything else in New York City now, Freud closed down in March 2019.

I remember, last spring, that I saw that a restaurant called Freud was opening and thought, "When it opens, I have to go there because it is called Freud."

I remember wanting to go to Freud, which hadn't opened yet, because I was teaching a class on Freud's *Mourning and Melancholia*.

I remember later realizing that Freud is the bakery where I threw up at 16.

I remember I realized the steps where me and my first love sat together are directly opposite the old Italian bakery that is now Freud.

I remember that when I unexpectedly saw you (the last love) on the 5th floor of the NYU library in August 2016, after not speaking for a year and a half, you walked over to me and mustered up the courage to ask if I wanted to get a cup of coffee. It took you five minutes. You were shaking.

I remember I proposed a drink instead of coffee to our calm nerves.

I remember realizing later that it was only 12 o'clock in the afternoon.

I remember you suggested we go to "a bar called Freud."

I remember I didn't tell you the story behind it. How I had been wanting to go to the bar for months. How I didn't know you were its future.

I remember we sat in the back. In the corner. Me in a booth, you in a chair opposite me.

I remember no one else was there.

I remember the waitress felt nervous around us and was too cheerful.

I remember you almost cried. And paid for our wine.

I remember we both felt such pain.

I remember the way you looked at me, like it was hard for you.

I remember that you always looked at me that way. Even when we first met and there was no reason to.

I remember only days before, knowing, feeling, that I would see you again.

I remember I didn't remember that Freud was once an Italian bakery where I threw up over another boy.

I remember (months later) that I remembered that I told myself to go to Freud when it opened, but then never did.

I remember I didn't tell you that because I didn't remember that yet. In "Screen Memories," Freud writes that a screen memory describes any memory which hides or plagiarizes an original memory. Was the memory of the first love reappearing 20 years later a cover for the memory of the last? Or was it the other way around?

I remember how after 5 years, it wasn't okay (with the first love).

I remember how after 10 years, it wasn't okay (with the first love).

I remember how after a year and a half, it wasn't okay (with the last love).

I remember it was only okay (with the first love) after almost 20 years.

I remember how at Freud the last love told me, "Time didn't take care of it," even though Freud said it takes two years to mourn.

I remember that on the phone, early July 2017, the first love told me that time didn't take care of it after 20 years. All three of us had failed Freud's timeline, or he failed ours.

I remember how because 20 years had passed, the first love and I were finally able to talk to each other.

I remember, over the phone, the first love spent three days remembering me. Remembering what he lost. Remembering what he ruined.

I remember thinking: *There's no way this isn't fate* about the first love and the last love.

I remember being surprised when the first love told me things I didn't remember: that we talked on the phone for hours as teenagers. Something he's never done with anyone. Not even his wife.

I don't remember "talking for hours."

I remember not being able to talk to him. Too scared.

I remember telling him things that he didn't remember: that I loved him, which I never told him. That he got into a fist fight with his best friend, who was my boyfriend after him. That we were all thrown out of the bar we were at because of it.

I remember that we were on the phone again 20 years later. Finally able to talk.

I remember I wasn't afraid anymore.

I remember he said, "You were never afraid."

I remember his voice cracking when he said, "I squandered love." When he said, "I wasn't ready." When he said: "I'm still afraid of you."

I remember he prefaced every memory with, "I don't remember," as though he were ashamed for not forgetting.

I remember he told me that he never felt that kind of intimacy again. The intimacy of "those kisses. Like Romeo and Juliet."

I remember that the last love and I always remembered things about one another.

I remember that I don't remember everything I think I remember.

I remember things I forgot.

I remember things I never forget.

I remember exchanging memories with the last love about the brief time we spent together as lovers (2 months).

I remember thinking, "He remembers everything."

I remember that he remembered that after a year-and-a-half of not speaking: I always ordered "dry" wine, the color of my hair when we first met, the color of my hair when we dated, my gray

leopard coat, the blue glass pin I wore in it (my mother's), the red rose emoji I once texted him right before his plane landed in New York, the two horses—one white, one brown—that I used to pet in Switzerland, at school, where no one's cell phone worked so it always felt like the '90s, the night we made love four times in one night, my birthday party, the length of our "long" dates, "from 9–2am," how "warm" I am as a person. "The warmest, but I forget that," he said.

I remember he said, "Your memory is better than my memory."

— 2018

13

Time for Nothing

The world is now greatly threatened.

I.

I'm not in the world. I am the world. The world comes to me. I wreck it and it wrecks me. The world is a place where I watch things. Where I make things to watch. Where I become something to watch. I let the world make me.

What happens in the world is my family. What happens is my family. The world's problems are my family. Images are my family. I want to make sure everything keeps happening even when I'm upset about it. Especially when I'm upset about it.

You know me from TV. You know me on TV. What we're saying to each other used to be the movies, but now it is TV.

We put the TV on the computer so we could bring ourselves closer. So we could be ourselves better. The better to be ourselves with.

We pass the TV around. We pass ourselves around. Our selves get passed.

When I am upset it is TV. When actors are upset it is cinema. I can get to actors, I can get to my emotions, I can get to the script of emotion, by being like TV.

I want to watch myself be upset. I want to be watched when I am upset. I want to be upset without being upset. I want other people to watch me watch myself being upset. I want the disaster of emotions—my emotions—to glide off me like a duck in water. To be disasters I can enjoy and you can enjoy. I want people to deal with my emotions—me—and then forget about my emotions while still remembering to remember me.

The screen is me. The screen is first—so let the image come first. First I have to appear onscreen, then I have to watch myself appear, then after watching, after we all watch, I can say:

Those feelings are mine. That person is me.

And also:

Those feelings are not mine. That person is not me.

Because being someone and not being someone are not two different things anymore. They are both at the same time.

You are someone and you are not someone.
You were, now you're not.
You could be, but you won't be.

I let the TV and the computer do all the talking. I do all the talking. The only time I like feeling upset is when I watch actors being upset for me. When I get upset like an actor gets upsets or an actor gets upset like me. So I don't have to. When I become an actor in order to be myself, then the emotions come right out.

I like the way things feel in movies and on computers. The way I feel in movies and on computers. Like I am parts I cannot see. Like I played this person and I play this person.

I like the way I feel because of the movies. There are images coursing through my body.

We are watching and listening. We are not watching and we are not listening.

We're in it. We're not in it. We are watching the world. We are watching ourselves and hearing ourselves in the world. All the watching and listening is culture.

Me being made. You being made. You making it. And me making it.

It's in this liquid language that you go up in smoke. That you don't mean anything you do. That nothing you do means anything.

We are letting go of what was. We were, then we weren't, then it's like we never were. Then it's like you, me, never happened.

It's hard to stick together when there's no sticking together. When clean and perfect surfaces can't fasten or fix because they have nothing to fasten or fix to.

When there's only me looking at your blog and you looking at mine. When there is your thumbs-up and my thumbs-up. When there are your nature shots and my nature shots. My clip and your clip. Your now and my now.

When you were young and I was young. When we can't look each other in the eye. When we type. When we type everything. When we type all day long.

When we say nothing has changed. When we say everything has changed. When change and no change are the exact same thing and cancel each other out.

When I can't hear your tone of voice and you can't hear mine. When you can't see me and I can't see you, like everything wasn't hard enough without reducing everything to what's on screen.

When the lights are down, or there are no lights. When you're here and not here. When there is your comment and my comment. My feedback and your feedback. My picture and your picture.

When I look at you, but you don't know it. When you look at me, but I don't know it.

When you might be looking, when you say you're looking, when you type you're looking.

When I type back.

Given how it is now, how things are now, I have to assume that you always are and never are.

That you always will and you never did.

That you do and you don't.

That it can be, but only as any number of things can be.

II.

The world I'm in is a green screen. Is made-up, the way it's made up to be made and unmade in end-of-the-world movies. Where the world just simply pulls away from us or gets covered up in water. Goes away in one full sweep.

There is nothing in the way. The wall was engineered to collapse. There is nothing as fixed, steady, or solid as a wall. Nothing ever comes down like that. You don't come down like that. You have all the room you want.

I was built not to break, or the break was built in. This wall was built not to break, or the break was built in.

My emotions are like this too. Loose cannons. Rootless. Restless. I feel something, then I don't. I don't get hung up. My emotions come pouring in and out of nothing. They just sit on top. They come and go. They turn on. They switch on. They switch off. They are sucked back like footage on rewind. Watch me stop and change my mind right in the middle of what you're watching.

I hear things. I see things. I change my mind. My mind never changes. I pause and decide to do something else. Be someone else. People come and go. I come and go, and the green screen is

always there for this. Green for this. People function as an image and the image functions as people.

I play with this wall, zooming in, changing the place where things break, so I won't break. I move the wall around. I push it to the side. Dragging it into the trash. I can zoom in on the destruction, the wreck. I can make the death so small. So big. I can make it not at all.

I can not answer you. I can stop answering you. I can confuse the roles. Who is doing what to whom. What is doing what to what. I can play with it until it's arbitrary and obsessive. Until I never miss you or anyone else. Until it keeps me company. Until it's what I am, until it's mine, until it's me.

Until it's not me.

I can reduce it to niches. I can freeze it there and save it for later, stopping the world from stopping me.

There is a loop of meaning. Meaning that goes out at the very same moment that it comes in.

Is this why disaster movies often take the world out in a wave? Because a wave is synchronous? Clean. Because it goes out with the thing it came with. Comes back with the thing it pulled away. Swims with the things it swallows. Tosses and turns us. Follows up and follows up. Erases and erases. Evidence is lost.

Wreck, wrecker, wrecked—it's reciprocal. It's a loop.

I think about this instant reciprocity, this constant effect, this deficit of time and space, this lack of deferral and delay where we can think about what happens, where what happens is something we have

time to think about, before the next thing happens, before we forget about the space between the things that happen and the things that happened. The things that will and the things that won't, where everything ends up being the same thing at the same time—a wave.

III.

Here's the new emotional schematic:

I might need you, but I might not.

You could be the one. But maybe there is no one. Nothing will ever make me want to know for sure. Not even you.

I miss you, but I can stop. I miss you, but maybe I think I miss other people too.

This isn't a movie. My life doesn't come undone just because you came into it. Just because you're not in it.

I'm not going to turn back or go forward or come around for you.

I want you the way I want you, which is the same thing as: I want you when I want you.

You want to be on time because time is a screen and the screen is time. Onscreen you know what you're doing and you know what will happen to you.

Do you want the world to go on? Do you want to go on in the world? Does a world still exist to go on in?

Remember when the screen looked and sounded a lot quieter? Remember when the screen was a green forest and you were lost

in it. You were happy to get lost. You had no idea where you were going. Where anything would lead. You were some Lancelot and some Guinevere.

Remember when the screen sometimes took it easy on you? Took it easier. When there were breaths between the frames. Cuts. Horizon. Digital means no breath. Digital means seamless. Means the image never shows and the show never ends.

There used to be deep breaths between the frames. Your deep breaths between the frames. Lungs to the frames.

Before 24/7 broadcasting, TV used to come to a screeching halt. Would die and go into flat line. Would go to bed like the rest of us. Shut down at a certain point, for a certain number of hours, so you would too. Bright vertical bars of color—a test strip— would suddenly flash across the screen, accompanied by a high-pitched sound. A ring that was sometimes laced with crackle and static. The test pattern meant the image had reached its apex. Had run out. For hours every night, you couldn't find TV on TV.

When radio first came into the world, sound came on and off like that too. Radio did what TV did. Said goodnight. Radio had a time you couldn't just catch any time. Couldn't just hear again. Couldn't repeat. The radio would turn on. You would turn off.

The noun "broadcasting" came from an agricultural term— meaning "scattering seeds widely."

The '70s were both an end and a beginning.

Then the '80s came and got rid of things like endings and beginnings.

Something like before and after. A different tense for every stage.

What you were once and what you became. At least you knew. At least you could tell when things happened.

The '70s are like vinyl. They had a texture. They sputtered.

There was a silence that startled the music. The music had scratches. The circle got worn, in time. By time.

You'd wait for a song to catch. You'd focus your hand over the lines etched in an album, the orbit of songs, like the lines of a tree. You'd wait for the right moment to drop the needle. You had to be careful about how you dropped the needle. You had to be careful not to wear the needle or the record out, but you don't have to be careful anymore.

Pier Pasolini, who put the past on the screen to look at the present, the future in the past, said the world changed in the '70s. That it stopped being The World and became something else. Something unknowable. A needle in a haystack. Something you won't ever find again. No matter how hard you look. Especially if you're looking hard.

Pasolini used the past to look at what that something else had been. That something that has no start and no stop and no finish. Derrida said: "What is happening is happening to age itself... What is coming... is happening to time but it does not happen in time."

What is time now but a perfect body double?

New time standing in for old time. Real time. You can't tell time so you can't tell its differences either. It's not that time is going to stand still, it's that it's not going to matter where it stands.

There's this scene in Robert Altman's depression-era drama *Thieves Like Us*, made in the '70s, in which three escaped convicts donning prison uniforms are given new clothes to change into. When they're given white shirts that are too small, they gripe:

"What are we, midgets?"

And when they're given overalls that are too big, they moan:

"What are we, giants?"

But somehow these three fugitives, who all have different bodies, fit into the clothes that are too small and the clothes that are too big, and they fit into both too small and too big perfectly. They fit into them as though they fit. Midgets and giants become spitting images of each other.

Everything means what it doesn't mean. You mean what you don't mean. You don't mean what you mean, or you did, or who knows—it doesn't even matter anymore.

Your emotions are like a green screen. Anything is possible. Everything fits. Goes there. No matter what you do or who you are.

No wrong move. No right move either.
You could go this way or that way.
You could be this person or that person.
You are.
You could live this way or that way.
You do.

— 2011

14

Solace

Does it still bother you? Does it still matter? Why does it still bother you? Why does it still matter? The most important thing to do now is to forget. To surrender and encourage. You should support one another. You should support him. You should learn from your experience together, then move on and love again. You should both be friends. There is nothing better than being friends. One day you will be good friends. You loved each other at the time. You meant what you said at the time. He meant what he said at the time. You can love a few different people at a time. You can be in love with someone and still want other people. You can be happy and in love with someone and still be with other people. You can have a soul mate, a true love, and still desire other people. It is impossible to love only one person.

You should call him up and ask him things. You should let him know that nothing's wrong. That nothing's lost. You should let him know how much he's taught you. You should listen to him say you've taught him nothing. Love is a lesson. Love is for learning lessons. We each have many lessons. We each have many soul mates. There are no soul mates. Nothing lasts forever. But eventually it might.

There will always be other people. There are always other people. There are so many people in the world. You should go out and look for them. There are too many people in the world, you will never have enough time to find them. You can meet anyone. You could find nothing. You can expect everything. You can expect nothing.

You should date. Are you dating? Are you dating anyone? Who are you dating? Why aren't dating anyone? It's time to date someone. Everything is timing. Everyone is timing. You can time things. You can time someone. You can time your life. You should try it. You would like it. You could learn to.

Are you having sex? Are you having sex with anyone? Who are you having sex with? Why aren't you having sex with anyone? Are you over him? Have you gotten over him? When will you get over him? Aren't you over him? What are you waiting for? You can't wait all day. You can't wait all year. You can't wait forever.

There is no such thing as love. Love is really lust. Love is really temporary. Love is really loss. Love is oppressive. Passion is oppressive. Passion is destructive. Passion is fleeting. Passion is temporary. Passion is only in the beginning. Passion is when you're cheating on someone. Passion is when you don't have permission. Passion is when you are young. Passion is when you were young. Passion is before you made decisions. Passion is the first time. Passion is before you got hurt. Love is only in the beginning. Love is before you know someone. Love is the opposite of desire. Love is unhealthy. Love makes you sick. Love makes you bleed. Love makes you too fat and too skinny. Too comfortable and too nervous. Love is exhausting. Love is consuming. Love makes you exhausting to be around. Love is in your sick mind. Love makes you feel like shit. Love is old-fashioned. Love is impossible. Love is criteria. Love is demanding. Love makes you demanding. Love is several. Love happens all the time. Love is happening all around you. Love is happening now. Love is easy. Love is unrealistic. Love is impossible. Love ends. Love doesn't exist.

You blame love for everything. You do everything in the name of love. Love is why you stayed. Love is why you left. Love is why

you're tired all the time. Love is why you're no longer fun to be around. Love is why you're always busy. Love makes you talk too much. Love is the reason you've stopped acting like a guy. Love is why you let him use you. How could you let yourself love him? How can you call that love?

Love means you call everything you have ever done love. Love means every time you hurt someone, you say that love is hurtful. Love is an excuse. Love is coexistence. Love is codependence. Love is the loss of your freedom. You're too young to love. You don't know what love means. You've never loved anyone in your life. You can't love now. You can love later. Now is not the time to love. You can love when you're ready. Love is freedom. Love is unconditional. Love means you can't want anything from the person you love. Love means you will gladly give away what you love. Love means you don't love, but you pretend you know how to. Love is something you give up on because someone gave up on you. Love means you don't even try. Love means after you've lost love once, you could lose again and you'd survive.

Love makes you jealous. Love makes you remember. Love makes you not care. Love makes you shit and have diarrhea and throw-up. Love makes you sleepless. Love makes you spleenless. Love makes you age prematurely. Love is why you eat so much. Love is why you've stopped eating. Love makes you pathetic. Love is disgusting. Love is inconvenient. Love makes you the same. Love means you can't see the difference. Love gets you nowhere. Love is a prison. Love is a waste of time. Love is precious. Love gets in your way. Love covers you with bruises. Love breaks your heart and then love leaves you broken. Love is what everyone says. Love is what no one means. Love is what you can't say. Love is what no one knows how to do. Love is what you forgot. Love is what you lost. Love is what you thought you had. Love is the word that you won't say. Love is the word that everyone says.

Love is the word that never gets you anywhere. Love is what you do when you fuck. Love is what you fucked up. Love is what never happened again. Love is what no one means. Love is what you will spend your whole life looking for. Love is what you already have. Love is what you will spend your whole life trying to mean.

And when it is over you should forget. When it is over you should forget and move on. When love is over you should forget and fall in love again. Except never acknowledge what you are doing as forgetting. Forgive and forget. Forgive and forget.

— 2009

I Give You My Word

"I give you my word, as I have nothing else to give you."
— Etel Adnan, *Premonition*

Speaking about the films of Harun Farocki at Artists Space in September 2015, Thomas Elsaesser stated, "Cinema has many histories. Not all of them belong to film." *Love Sounds*, a 24hr film I made in 2015, the same year as Elsaesser's talk, also has many histories, not all of which belong to cinema. Using film dialogue to think about the history of love in movies, *Love Sounds* is about what one medium does with another. *Love Sounds* is one version of history, one version of the essay, one version of autobiography, one version of love. Cinema is made acousmatic in order to consider the loss of a public discourse of love post-cinema. Language is the problem I return to over and over in my work in order to understand a century's relationship to love and emotion. But also: my own relationship to a new century that no longer talks about love. That no longer has the words or holds the words dear. In the same way that the face was a technology of cinema, cinema was a technology of relationship.

The Latin *sermonem* means common talk, learned talk, conversation, manner of speaking, discourse, literary style. In *Love Sounds*, I turn the cinematic voice into a sermon. The human voice, now muted by the internet's scattered and tone-deaf affects, was once the medium of love.

I've spent my life tracking and mourning language. It's why I started writing as a child. Not to tell stories, but to produce inventories of the stories we tell. We make lives out of language and we can never fully succeed at making our lives work because of language. Nothing anyone says is ever clear. An archive is a form of shelter. *Love Sounds* is a shelter that could only be made into a shelter by being made. I built what I needed to hear. What I ask the listener to listen to, I've already listened to, so the listening is doubled. I made the work to say something I didn't have the words to say. I was at a loss for words. Does this make it a dialogue? Does this make it an act of love?

When I was little I played "secretary." I pretended it was my job to answer the phone. I used my voice to resolve the conflicts that came in through the imaginary phone line. I invented the conflicts and the solutions to the conflicts. The fantasy phone calls I "received" were long and elaborate and required constant problem solving. I wanted to listen, to say things, to test everything out with words. I wanted to answer calls. To take messages. To write them down. One of the etymologies for archive is public records. But also, "beginning, origins, first place." The first place of *Love Sounds* were these childhood stagings. *Love Sounds* is also my childhood. My mother and father. Their love story is my origin story, my first place. One way to listen to love that works is to listen to love that doesn't. Because my mother and father's love works, because they never broke up, the question of an original split that never structured my life has structured my life. One first place of modernity is cinema, the last place for love. *Love Sounds* is an archive of our missteps. Of getting it wrong but still trying to get it right.

Growing up, I talked into a tape recorder. I didn't film things with a Super 8 or a video camera like other kids. I watched movies. Actually, I listened to them and remembered what people said. I never remember narratives. I don't really understand plot. I always remember words. What I feel about faces is

mostly tonal. Love is giving your word to someone. I made audio recordings by covering up the holes in cassettes with masking tape, then I layered my own voice over them. Braiding my voice with other voices. A video store clerk, from whom I rented movies as a child, taught me this trick. "You can reuse these," he said, holding one of his own tapes up to show me. "You don't need to buy blank cassettes." I was seven. I recorded over the Temptations, Boy George, an early orange-colored Madonna cassette I bought at a Belgrade train station while traveling from Russia to Italy on a three-day train trip with my parents. I was twelve and looked out the window almost the entire time. I listened to Black Sabbath and Supertramp. In New York, I talked for hours into a tape recorder in our laundry room with the lights off. Also in my bed at night. I performed skits. I performed monologues about the passing of time and the inevitability of death. I talked about what school was like, which I always described as a more positive experience than it actually was. I didn't say what was bad. I didn't talk about the way the kids at school treated me. I sang refrains from my favorite pop songs. Like Boy George's, "Do you really want to hurt me?/Do you really want to make me cry?" over and over. I impersonated people. I imitated their voices. I interviewed myself. Each cassette was a calendar in the form of audio fragments recorded and amassed over the period of a year or more. Two sides, A and B. Later, boyfriends made me mixtapes and recorded audio letters to me that they sent by mail. I saved the cassettes from my family's answering machines. The first boy I ever loved once received a phone call at my house, where a few friends were partying while my parents were upstate for the weekend. I remember all the lights were off. I remember it looked like no one was home. I remember everyone was spread out and standing still like statues. When the boy answered the phone on my mother's desk, which I found strange and rude, the answering machine kept recording. "Brian, I think we're being *re-re-re*-recorded," he

warned the caller nervously. His voice echoed and boomed through the entire house. I listened to this telephone scene for years, not having any photographs of him to look at—I was too shy to take any—or refer to for memory. His voice was my memory. So was his secrecy. So was that telephone call. Years before we became a couple, and years after we first met as children one summer, I got to know my first love by listening to him walk around his room in his 5th floor apartment in Soho, which was one floor above my best friend Nora's bedroom. I often went to her house just to study the sounds he made. To listen to his walk. I'd hear him come home, I'd hear him go to his room, I'd hear him practice his drums, I'd hear him fall into his bed. I could sometimes hear his muffled voice. I did not know who he was yet, but I could feel it. I could sense it.

The phone calls of friends and ex-boyfriends were also on those answering machine cassette ribbons, now warped. I liked the way you could pull a tape out of its player, find the ribbon stretched out and mangled, and wind it back in with a pencil. Fixing it. One summer I kept an audio diary for a boyfriend while he was in London and I was in New York. I never ended up posting the audio diaries back to England. In them, I can now hear what everyone else heard in my voice then whenever I would return to New York for short visits: that my New York accent had become Anglicized. As soon as I opened my mouth in NYC, people would immediately ask, "Where are you from?" I'd say, "Here." Now, years later, people tell me I sound like a quintessential New Yorker again. What does that sound like, I ask? I have been recording my sessions with Tarot readers and astrologers since the summer of 2000, building an archive from the things I want to know about my life but can't. The first recorded reading was in Prague, the second London. There were others in Italy, Greece, New York, Paris, Croatia. On a few occasions, I cried on tape, in front of the divinators, when they told me I couldn't have who or what I thought I wanted. Does that

mean I didn't believe in their ability to predict my future? Does that mean knowing your future doesn't help you bear the present? Every single reading gave me hope in the form of a voice I could play back and listen to over and over. It was the repetition of listening to cumulative readings on my ongoing question about love, not the predictions themselves, which almost never came true, that gave me insight into the future. Into what it was like to continue living with hope in spite of something not coming true.

Love Sounds is the last work in an Immaterial Trilogy. All three installments interface formally and thematically. Each project establishes a relation to epistemological and phenomenological surfaces—the screen, the face, the voice, the page, gender. Epistemology itself is a surface I rework and explore. In "Ever Since This World Began," an audio-visual essay from *Love Dog*, the second installment in the trilogy, I use a singer (Judy Garland) and a song ("The Man That Got Away") to consider the gendered phenomenology of the female voice by visualizing the aural. In my writing about faces, I look at the tonal affects—the things a face voices and a voice faces—of a face. In *Love Sounds*, I use a visual medium—cinema—to listen to the emotional history of a voice. During the silent movie era, the face was treated as voice. The screen face was treated as an audible geography. A book is no longer located on the page. Today's book is a curated space that interacts with and moves through many other spaces and forms. *Love Sounds* is one version of a book.

— 2016

III. PICTURE CYCLE

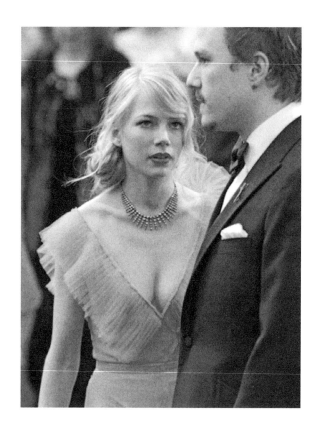

16

Picture Cycle

"What does it matter what you say about people?"
— *Touch of Evil*

"The world's a hell. What does it matter what happens in it?"
— *Shadow of a Doubt*

"Everybody says everything. What's the difference?"
— *Mikey and Nicky*

On January 25, 2004, Diane Keaton shows up on TV for the Golden Globe Awards and wins for Best Actress. We are told that excitement is in the air, and that Diane looks better than ever. I agree with the latter. Her nose is different, but she's stuck to her guns about wearing what she wants to wear. Wearing what others are not wearing. Gloves, hats, a shadow is always cast over her body. While everyone else is dripping with made-over flesh, Diane's body is nowhere to be seen. Diane wants us to look to her clothes, not to her body, and she's always been this way, she says. The other night, I YouTubed her and found her stuck in time on a 1974 appearance on *Johnny Carson*, draped in several layers of lilac like a window. Other Hollywood actresses use clothes to point to the body. Bras and low-cut dresses direct like arrows and guide the way road signs on the way to the Body do. In a *60 Minutes* interview, Leslie Stahl notes that Diane "works hard to hide herself." What came first the award or the amendment of the body? Can you have one without the other? If you

get one can you get another one without switching everything around for next time? Acting becomes a fully integrated state. Every single thing in your life and on your body is showbiz.

On TV, the sun limbos. It is seventy-six degrees in Los Angeles, but in New York it is five. The heat of the cameras and the televised power of yarn make the weather feel the same on both coasts. The awards ceremony begins while the volume of light is still turned up high. Diane is sheathed from head to toe in a white Edwardian-style dress jacket. It's long, with buttons from top to bottom. Like a bride, she is a clean slate, white like a dove. A blanket of snow the industry can piss a new script on: white pearls, white gloves, white shoes. Probably white bra and panties too. White like the snow Diane runs with Mel Gibson in in *Mrs. Soffel*, which sounds like *Soulful*. A week later, on *Oprah*, Diane, remarkably effusive, gushes about Mel. The way, take after take, he, a lone-wolf, climbed after her in the make-believe snow, or she after him, and then one of them collapsed into the other, and real-life lust spilled over into make-believe lust, melting Diane like the glaciers in Antarctica. In fact, Diane gushed romantically about everyone but Al Pacino and Woody Allen, both of whom she had worked with and dated, but neither of whom she's willing to talk about on *Oprah*. Put together by Oprah's producers, there is a list of men, with Mel Gibson and Jack Nicholson at the top. They are her favorites, she says. Diane crosses the other two men off, refusing to spill the beans on Al, who after two *Godfathers* and thirty-four years, makes her go silent.

In case I was seeing or hearing things on *Oprah*, I double-checked, looking at the Carson clip again, backpedaling thirty-four years, where I discover that Diane has always hated Al. Fresh off the set of *The Godfather: Part II*, and there she is clearly ticked off, her body under that lilac dress. What he'd done to her on camera, laid on thick within the hyperbole of cinematic chauvinism, seemed to leave a dent off-camera. Did the movie marriage lend itself to a non-movie romance, or did the movie

matrimony make any un-scripted desire or pleasure impossible? Diane couldn't encode her disgust and knowing how to act is about being able to equivalently hide and conjure what you don't really feel. But since this is before Reality TV, where TV and reality both become self-conscious classifications, "real life" is not the point, or else it is only the point when you're acting that too. Would an actor's repulsion ever make it on the air now or would it be caught in time and removed during the pre-interview?

On Carson, Diane says, "I just made *Sleeper* with Woody and *Godfather II* with 'those' guys,'" so bad they don't even get a name. Then, "I'm married to the same guy... Pacino," like she really had to be. She sighs, looks down. What is there to say that won't expose the stitching in the story and move the story off the screen? It's a marriage she regrets even on film. Diane says this as though she is still playing Kay. Or as though her/Kay's female entrapment by the male tribalism of the movie mafia is simply one of many female incarcerations.

The Godfather is a movie that kept going. That changed its mind and started over. Rewinding and backtracking from its initial version of "beginning" to incorporate things in the pre-quel it didn't the first time around. As a result, the two films caught Diane somewhere in-between her fictional relationship with Al and her real relationship with Al. In her glowing 1972 review of *The Godfather*, Pauline Kael notes, "The story moves back and forth between a hidden, nocturnal world and the sunshine that [the men] share with the women and children." While in *The Broad Picture*, Lynne Tillman asks, "Given life-in-patriarchy, is *The Godfather*, I wonder, as much a 'woman's picture' as a 'man's picture?'" What Kael, who famously had no interest in feminism, doesn't take into consideration is space in relation to gender. Space in film and space in life. The way one space carries over into the other all the time. Nor does Kael consider the gender of the viewer or the gender of time. The time assigned to "universal narratives" and collective gazes; a looking

that Kael argued elsewhere requires everyone to miraculously read at the same pace. When Johnny Carson asks Diane if it was as much fun working on the second *Godfather* as it was on the first, Diane can't hide the fact that it wasn't. "It was fine," she doesn't bother to assure. Bad acting? But she is acting, acting contained, and she wants us to dive down into the oceanic subtext to figure out what she really means. To read between the lines where there is no role, no character—just omission.

Men have problems with Al too. Even a big, hammy one like Robin Williams, who said that even though Al had worked briefly as a stand-up comic early on in his career, he did not initially find anything Robin said or did funny on the set of *Insomnia* (2002). But Al is method and Robin is improv, so maybe Al was just trying to preserve the mood of his character's hard, obstinate exhaustion. Something laughing would have ruined. According to the DVD special feature of *Insomnia*, Al and Robin had a talk, and word is, Al learned to laugh.

In *Something to Talk About* (1995), also known as *Game of Love, Grace Under Pressure*, and *Sisters*, and tag-lined as, "A story about husbands, wives, parents, children, and other natural disasters," Dennis Quaid plays what he plays best and plays it from life. Life becomes script and script makes life easier to play. Movies are one infrastructure where life gets treated as script. There are two possibilities: Quaid plays what's written on paper and does not stray from his lines. Or Quaid chooses parts that he knows how to play without having to explain how he's learned to play them. Real life becomes material that is easily reproduced and turned into fiction. Infused with an authenticity that is never spoken about: cold mornings on set, night sky, pre-dawn, Quaid spent too much time away from home, but with most of the year on film locations, what and where is home? Like those cameras that can capture the color of your aura, Quaid shows up on film after film as Quaid, except in the movies, where he is converted, becoming a better man for every woman but Meg Ryan.

Neither now nor then, did Diane shed a tear over *Annie Hall*. Saying, "What's the big deal? It's not like that was it for me." She's right, men don't cry over their roles, movies, or awards. They know there's more to come; that an award for a white actor opens up the world, so they become less grateful, more expectant over time. Men don't talk about one role for the rest of their lives. They live for the next one.

Tonight is Diane's big night—the academy is giving her away at the age of nearly sixty. Up at the podium, with the Golden Globe award for Best Actress in her hand, Diane is laughing as usual, shooing the prestigious award away with her famous smile and her self-deprecating jokes. She is saying, but not saying, "I don't deserve this. This is silly." Richard Gere, who starred with Diane in *Looking for Mr. Goodbar* in 1977 as a pushy and conceited hunk, makes it up to her by calling her name, presenting her with the award, and then escorting her off the stage, Buddha-like. His hair as white as her dress. White like the Himalayas he chants for.

Jack Nicholson is also nominated for Best Actor for *Something's Gotta Give* (2003), but doesn't win, so Diane spends her entire two minutes on stage making it up to him by handing him the award instead. Not literally, of course. Diane has always been nervous and self-effacing, so maybe in the world of character, this gesture, this gendered performance of deference, is also in character, which makes Diane an even better actress than I thought she was. Maybe this is yet another example of good acting, of collaboration; of roles overlapping, intertwining. But I wish she could have just reveled in the moment, as they say.

During her acceptance speech, Diane keeps saying the award isn't really hers, that it's Jack's, and although Jack doesn't technically win it, no matter what happens tonight, Diane wants everyone to know, in case they don't know already, that Harry Sanborn, the male lead and Diane's love-interest in *Something's Gotta Give*, and Jack—a real life fusion of on-screen

and off-screen—has won both of hers—Diane's and Erica's—hearts. And this perfect reciprocity of fact and fiction, reel and real, me and you, what's mine is yours, is a great night for showbiz. It just doesn't get any better than this, says Diane. It just can't.

In photographs of Heath Ledger and Michelle Williams, Michelle forgets the camera and looks at Heath instead. Whether she's looking at him instead of the camera *for* the camera, we don't know. But Heath rarely takes his eyes off the camera. He knows it's recording him in his new role as movie star and he never forgets that he is a man of roles. His body is work for the people who shoot it and people are shooting all the time. The camera is his lifeline. Michelle forgets what she is when she becomes his girlfriend. Each photo reveals a food chain. When they break-up, Sarah Horne writes a lament in *Radar Magazine*, calling the article "The Ballad of Heath & Michelle." "I could just imagine [Matilda's] parents stuffing the Smeg fridge with organic greens, growing tomato plants in their ample backyard, or baking their own bread—and thereby imagine my fellow and I doing the same." Horne's desire is a hand-me-down. It is activated by the desire Heath and Michelle are said to have for one another. In her mind, Horne tries to replicate the relationship she wants Heath and Michelle to have, not the relationship she wants for herself. She is immured in a desire that isn't hers. There is no her. Her is whatever they want next. Her comes from them, and them is never us.

The real subject of Horne's article is not avarice or lifestyle mimicry, but being as an amalgam of impersonated wants: desire as assemblage and desire based on the desire one imagines other people having. Individual desire goes out into the world of Hollywood bodies to look for a fantasy host to feed it. (Jean Rhys: "She had hypnotized herself into thinking, as they did, that her mind was part of their mind"). When a national paradigm of desire changes, shifts, or breaks, so does the desire

around and outside it: "Oh, well. No sense of living in the past—not with Jennifer Garner, Ben Affleck, and little Violet to crush on," writes Horne. Private desire responds to what it hears about official (visible) desire.

Confessions well up like images. For weeks after Heath Ledger's death, Michelle Williams avoids—runs away from—the predatory cameras that move after her and undulate through space and time. The cameras don't stop. They keep rolling. They have sophisticated spines like the red dragons in Chinese New Year parades. We feel the years go by in images. Changing movie faces are our feelings and emotions about our feelings and emotions. Michelle Williams ducks, disappears into fancy buildings, the way Heath disappeared into a fancy building, never to come out again. After their split, location—Heath's in particular—becomes a metaphor. A public obsession. Williams' Brooklyn townhouse is besieged, wrapped in a panorama of cameras and surrounded by people the way Heath's empty Manhattan bachelor pad is surrounded after word of his death gets out.

The romantic time-travel comedy *Kate & Leopold* (2001) reminds me of the red-carpet Oscar photos of Heath and Michelle—with Heath looking at the camera, into the future. Michelle looking at Heath—to the past. A ray of light from the flashbulbs blasts them forward through time, as though these faces, these red and black arrangements, were a deck of cards. I lose track of time, as if this is all there is: Hollywood, press, internet, awards, celebrity breakups and deaths. For the 19th century Leopold in *Kate & Leopold*, time travel into the early 21st Century is merely a way of getting the 21stth Century career-woman (Kate) to return to her (women's) 19th century domestic past. The movie is a fight over time, which of course is always gendered. History doesn't happen without people. Or rather, it doesn't happen, can't happen, without men.

While Kate can and must return to her past with Leopold in order to be truly happy, Leopold, a famous inventor whose

individual history is posterior (*later* in time), and therefore syn-
onymous with history, cannot. Leopold is marked by a history that
is intransigent because it belongs to an indispensable meta-nar-
rative (official history has always been about people who are
indispensable). A totalizing schema. The movie is therefore a
profoundly convoluted spin on, *Wherever my man goes, I go.* Or,
in Michelle Williams' case, *Whenever my man looks at the world,
I look at him.* Unlike Leopold, Kate (or in the case of Michelle
Williams, who looked into Ledger as though he were both her
past and her future; her entry into the world), whose history—
or future—is entirely bound up in Leopold's, can sacrifice her
place in the time-like curve, whereas Leopold cannot. In *Kate &
Leopold*, the motif of time travel and the theory of relativity is
applied to everything from language to parallel reality; specifically
space-time loops and word lines. Word lines, explains the Ency-
clopedia of Science, "are a general way of representing the course
of events, the use of which are not bound to any specific theory.
In general usage, a world line is the sequential path of personal
human events—with *time and place* as dimensions—that mark
the history of a person." Another term for word line is closed time-
like curves that form closed loops in space-time, "allowing
objects to *return to their own past.*"

When Heath Ledger dies of a drug overdose on January 22,
2008, I am running up New York City's Broome Street to cele-
brate the Chinese New Year with Goretti, my older Malaysian
friend and student, at the Guan Gong Temple on Elridge Street.
I don't want to be late for the ceremony. While Ledger lies dead
above the Nanette Lapore clothing boutique at 421 Broome, I
pause to catch my breath by his door. It's cold. I don't know that
Ledger had been living there by himself, in an enormous loft, a
"bachelor pad," that a film studio was paying for and that
reportedly cost $22,000 a month to rent. In my head, I still have
the picture Sarah Horne has drawn of Ledger and Michelle
Williams in their Brooklyn Shangri–la.

At the Guan Gong temple, Goretti instructs me to address all the Buddhist deities in the room with wishes and prayers. She also tells me to ask for "whatever I want" as long as it isn't something "unnecessary." "Don't waste a wish. Even in death," she warns tersely.

In Michelangelo Antonioni's color trilogy (*Blow-Up*, *The Passenger*, and *Zabriskie Point*), identity, doubling, and death all go hand in hand. The body of someone else is always a kind of glamour—an excuse not to be in one's own body—and the glamour comes in the form of a death wish, both literal and figurative. In *The Passenger*, whose tagline is, "I used to be someone else, but I traded myself in," color marks breaks in time, ties with time; the chameleonic body in and out of time. In the 1975 film, David Locke (Jack Nicholson), a war correspondent in the Sahara, meets an English arms dealer, David Robertson, who dies suddenly. Locke, who is fed up with his own life, decides to steal Robertson's identity. Becoming someone dead, the melancholic Locke thinks, will allow him to stop living. The body in *The Passenger* is a kind of tabloid. A death story that lets us forget ourselves by holding memoriam for someone else. The plot of *The Passenger* is foreshadowed five years earlier in Antonioni's *Zabriskie Point* (also set in the desert), where Mark tells Daria, "Once I changed my color, but it didn't work, so I changed back." In Antonioni's color trilogy, color marks the passing of time. Color is history.

Instead of being the ultimate obstruction, death in celebrity culture is a passageway. When it comes to the famous, death is a tunnel into someone else's life.[1] After he dies, hundreds of people stand in front of Ledger's building all night long. Holding vigil, talking to reporters, crying. Ledger's building becomes a surrogate body and fans leave things at his door, the same way

1. The idea of the tunnel as identity portal is humorously depicted in *Being John Malkovich*, 1999.

that people lay their prayers and flowers at the feet of the gilded Buddhist statues at Guan Gong. "Don't waste a wish, Even in death." On the news, I watch people who'd never met Ledger rush to buy him flowers, leave notes, hang drawings. The equivalent of a backstage pass, they gain access through death, entering a private world that had belonged to Ledger. Housed him and excluded them. Now they are where he has been. Now they are instead of him. Interior becomes exterior. Out becomes in. Death, access rather than finish. His body becomes their fame. Time is camera, camera is world. The link between inside and outside. Onscreen and offscreen. Something he was said to have but didn't really have. Something he had and didn't have. Something only a camera can say or make about someone. The beloved is always the ultimate place to store oneself and also the most difficult to go in and out of. What happens on film is not even close to what really happens.

Reports start to come out about the inside of Ledger's body. The outside we saw did not match the inside we didn't see. Fans treat Ledger's body as if it were their own. They want to know what was inside of it. The media vacillates between interior/ exterior truisms; the images of Ledger living and acting versus the un-filmable, surreptitious contents of his body. One Fox spy witness treats Ledger's autopsy like unseen footage. "They'll find everything," he warns, which translates to, "They'll *see* everything." And, later, Fox follows up with: "When they do the autopsy it will all come out." Others say Ledger's death means the coveted reel is lost forever and now we'll never know who or what was inside.

In the film-essay *Los Angeles Plays Itself* (2004), Thom Andersen examines the way Hollywood has fictionalized the real Los Angeles, observing, "In a fiction film, a real space becomes fictional… If we can appreciate documentaries for their dramatic qualities, perhaps we can appreciate fiction films for their documentary revelations." The idea on display, like Andersen's

assertion that Los Angeles has been forced "more often than not, [to play] some other city," is that some part of Ledger hadn't been playing itself and that some parts onscreen were more him than someone else. In *The Dark Knight* (2008), Ledger's Joker declares, "Wait till they get a load of me." Does this mean that the Joker is the real Ledger couldn't help being? Was his Joker the real in the fiction—the real mixed in with the fake—or, to go back to Andersen's point about Los Angeles, a real person becoming fictional? In a 2009 interview with *Wired.com* about *The Imaginarium of Doctor Parnassus* (2009), Ledger's last film, Terry Gilliam states that he "loved Heath on [*The Brothers*] *Grimm*" because "he was so funny all the time." Ledger was apparently even funnier on *Parnassus* because, Gilliam notes, he "had evolved as the Joker." Gilliam claims that Ledger seemed "liberated" by playing the Joker, which, allowed him to "se[t] up the foundation for what he was going to do on the other side of the mirror... he was becoming everything, anything he wanted. The one thing I would have given anything for," Gilliam laments, "would have been to see what Heath was going to do on the other side. But he never got there." This is an interesting choice of words, given that "the other side" is a popular euphemism for death, and because Ledger did die, did cross over. Was a mirror and in a mirror

In *The Imaginarium of Doctor Parnassus*, Ledger's character first appears as a figure from the Tarot, The Hanged Man. Film critic Ray Pride notes that "Tony is a Trickster, a fancy-pants and escapee from the higher reaches of society (as well an actor with only weeks to live, we know)." Gilliam's solution "to a missing leading man," writes Pride, "was simple and works unexpectedly well: the scenes that had not yet been shot all took place behind the mirror of Dr. Parnassus' Imaginarium, so the writer-director divided the three scenes (tarot readers usually require a person to divide a tarot deck into three sections) between Ledger's colleagues, Johnny Depp, Jude Law, and

Colin Farrell. Each actor wears their own fitting of the costume that Ledger wore." The Italian film director, Pier Pasolini, took a similar *Goldilocks and The Three Bears* "just right" approach (which involved morphing its original heroine—an "ugly" and "antagonistic" old woman—into "a pretty little girl") to *The Gospel According to Saint Matthew* (1964). Pasolini reportedly chose Matthew because "John was too mystical, Mark too vulgar, and Luke too sentimental." Pride, too, creates distinctions between the Ledger representations. "[Colin] Farrell... is the least of the Tonys" the way that Matthew, according to Pasolini, is the least of the gospels. Gilliam believes that because Ledger's character in *Parnassus* is so "liquid and light" (recalling *Terminator 2: Judgment Day*'s shape-shifting liquid android assassin, T1000, who is made of "mimetic poly-alloy"); because he was "becoming everything and anything he wanted," anyone could and did become Ledger; could step in to take his place: "It allowed Johnny, Colin, and Jude," says Gilliam, "to move in and be different faces and do different things," which makes it fitting that Ledger, rather than his character Tony, was replaced in *Parnassus*. Sharing the same homosocial body, and the same male body of representation, allows multiple men to share one role; to take each other's place, resulting in a "just right" hybridization. Mirror is copy, and liquefying to the point of shape-shifting, to the point of dissolution and ruin, is not only in the mythos of Ledger's Joker, but in its stylization: the smudging, corruption, and cultural assimilation of makeup. The liquid of identity stepping in for you.

The actor is also the clown with the painted grin. In the 1965 movie *Inside Daisy Clover*, Natalie Wood's rising star Daisy Clover, sings, "The clowns don't smile. That's just a painted grin." The painted grin conjures two iconic faces: Betty Davis' over-rouged cheeks and crooked red mouth in *Whatever Happened to Baby Jane?* (1962), and the always open-mouthed '80s teenage heartthrob Corey Haim, who died in 2010. Both Jane

and Haim were washed-up child stars. In *Whatever Happened to Baby Jane?*, child-actor Jane wears the crimson horror of her Grand Guignol face much the same way that Leather Face wears a human-flesh quilt in *Texas Chainsaw Massacre* (1974)—his own horrific red mouth poking through. Jane's painted-on face and Haim's commissioned smirk is a way to embalm time.

In a *Daily News* article about Haim's death, Soraya Roberts notes that, "Signs of decline were etched on the doomed star's face." On the cancelled Reality TV series, *The Two Coreys* (2007), Haim has the overcast hue of mold. Or worse, a dead body. A kind of Hollywood living-dead, Haim was the dingy shade of something long spoiled. A Dorian Gray. "Sitting down with the actor, the first thing I noticed was his skin," Roberts notes. "What was once flawless with a sprinkling of freckles was now corroded, creased and discolored. He looked to be in his 40s, rather than his mid-30s. His lips had taken on the same hue as his skin, making him look even more unhealthy… The worst part was Haim's smile. His trademark lopsided grin had been stripped of any joy. Now, whenever his mouth turned up, it seemed Joker-esque."

As an adolescent, Haim barely captured my attention—I didn't see *Lucas* (1986) until this year. Yet, his death affected me more than the death of actors whose work I do admire and whose faces I did grow up loving. For days, I felt sick to my stomach whenever I saw pictures of Haim, or thought of his deathly color foreshadowing his death.

The Dark Knight director, Christopher Nolan, says he wanted to take a more realistic approach to his version of Batman, so Ledger's Joker grin contains a realistic touch. Less makeup than scar, more makeup mixed with scar, or scar masquerading as makeup, the real is mixed in with the fake. The Joker has always been the one with the painted grin—the painted grin that doesn't come off. The Joker's Grand Guignol mouth is the world askew, unsalvageable. Similarly, at the funhouse, the mouth is

how you enter the world and is big enough to fit your entire body, leading Hal Hartley's heroine, Fay Grim (on a quest to find her fugitive ex-husband, Henry Fool) to tell a Turkish Baazar shop owner, "There's always this character—the one with the big mouth." Ledger's Joker, Baby Jane's smudged face, Leatherface's red lips, and Haim's septic skin and cocked mouth, are all faces of ruin and commercial atrophy. They are also physiognomies of a death that only disaster capitalism can produce. "Some men," Pennyworth tells Bruce Wayne in *The Dark Knight*, "just want to watch the world burn."[2] Though it would be more accurate to say that all four faces are the world-already-on-fire. For, while Haim's permanent teen-idol smirk signifies ultimate commercial and pedophiliac accessibility, the Joker's brutally hacked-into mouth-on-mouth in *The Dark Knight* signifies its devastating geopolitical cost. Today's Batman is only relevant for what he *can't* do, for a world he *can't* save. A world (there is no world, there are only corporate networks now) in which vigilante heroes are both powerless and obsolete.

As I scanned the magazine rack at Barnes & Noble the other day, my eye ran across the image I've been seeing in transit all week. The caption "A List Nip/Tuck" presides over a picture of the old and the new Scarlett Johansson. The old Scarlett is rattier, less composed, not as blonde. Then a yellow blonde, now a

2. It is interesting to compare the Joker's bank robberies in *The Dark Knight* (2008) with the Ex Presidents' bank robberies in Kathryn Bigelow's *Point Break* (1991). In the former, nihilism—the desire to see the world burn—is the impetus for criminal acts. In the latter, the crimes are anti-establishment, in line with an alternative ethos of living. In *Point Break*, the L.A. surfers are also bank robbers who wear the face-masks of former US presidents Ronald Reagan, Richard Nixon, Lyndon B. Johnson, and Jimmy Carter, rebelling against American politics. In *Birth. Movies. Death.*, Priscilla Page writes: "Their heist performances are like bad comedy routines: 'Please don't forget to vote!' Reagan reminds everyone during a holdup. Before exiting the bank, Nixon declares, 'I am not a crook!'... *Point Break* has something unsubtle to say about Ronald Reagan, and it smartly uses a pulpy story to do it. The film and its characters are suspicious of the entire system."

snow-white Kim Novak blonde. But the biggest change of all is her nose. Noses are all over the place these days, emblems of a morphological order restored. The face is a war zone. Walking home, I wonder what all these Befores & Afters really signify when none of it alters how we see things and what we do about the things we see. In "Nikons and Icons," David Levi Strauss writes, "Robert Hariman and John Louis Lucaites rightly point to the larger problem identified by Peter Sloterdijk that modernity has entered into a terminal phase of 'enlightened self-consciousness' whereby all forms of power have been unmasked with *no change in behavior*." This recalls Brecht's, "As crimes pile up, they become invisible," Jacques Derrida's, "In this century, monstrous crimes ('unforgiveable' then) have not only been committed—which is perhaps itself not so new—but have become visible, known, recounted, named, archived by a 'universal conscience' better informed than ever," and Mikhail Bulgakov's "Maestro Woland is a great master of the technique of tricks, as we shall see from the most interesting part, namely, the exposure of this technique and since we are all unanimously both for technique and for its unmasking, we shall ask Mr. Woland." In *The Master and Margarita*, Bulgakov's great 1967 Russian novel, Mr. Woland is the Devil who shows up in 1930s Moscow. Like the four faces, all four writers point to a new paradigm of criminality: the exposure of (and public outcry over) crimes in place of actual justice.

In the post-cinematic age, vulgarity, excess, and corruption move from off-camera to on-camera. Delighting in the technique of exposure, we no longer fear that something must be hidden in order for it to succeed. That hiding has any cultural or monetary value. That money might be lost, careers ruined; that secrets must be kept rather than sold. Backstage takes center stage. What is ugly seeps through to the surface, a palimpsest of post-cinematic culture. The line between what you see and what you don't becomes the pivot of content.

In exchange for studying what each fraudulent cell looks like under a merciless commodified lens, viewers enable late-capitalism to run more smoothly by calling in with their votes, as is the case with Reality TV. From the inside, secrecy appears eradicated, as though secrets comprise the totality of injustice rather than just one part. Justice is reduced to a vantage point. We see and we see and we see ad infinitum.

Two years ago, on Centre Street in New York, a block north of Broome Street where Ledger died, an ad from Samsung takes up a perfect corner and announces: "There's more to director Joe Wright's extraordinary film *Atonement* than meets the screen." Recording a radical shift in being, the eye/I is now totally eclipsed by screen, leaving us and our eyes, completely out of the picture. Instead of eye/I to screen, and screen to eye/I, two screens make eyes at each other, like the artist Douglas Gordon's famous screen double of *Taxi Driver*. As a metaphor for seeing, the ad evokes a technocratic orgy; a discourse of vision so bleak even the *Blade Runner* replicants had the heart to fear it.

— 2009

17

Devil Entendre

[RATTLE RATTLE]

"Let us not believe that the Devil belongs solely to the past."
— *Haxan*

Taibele and her demon

The 1967 British political drama, *The Comedians*, proclaims that "All horror is real." That is: men that are not labeled or perceived as horrific. The 1960s—with its normal, boy next-door monsters, like Norman Bates and Bobby Thompson—was also the beginning of psychological horror: the horror we live with every day.

In her book, *Seducing the Demon*, Erica Jong writes about the demon's creatively deceptive appearance: "The job of the writer is to seduce the demons of creativity and make up stories. Often you go to bed with a man who claims to be a demon and later

you find out he's just an everyday slob." Analyzing Bashevis Singer's story "Taibele and Her Demon," Jong notes, "Taibele doesn't want to acknowledge that her lover is merely human… [A man] pretending to be a demon visits by night a pretty young woman… At first the demon terrified her with his ugliness, but then she falls in love with him—as much for his vivid stories of hell and heaven as for his demonic lovemaking." Among other things, Singer's story, writes Jong, is about Taibele's need to believe that the man she willingly engages in non-traditional sex with is a demon "so that she thinks she has no choice but to submit to him." Singer's story is also about the illicit narratives we assign to horrors that are ordinary.

In *Rosemary's Baby*, the Devil is simultaneously Rosemary's husband, Guy (who sells his soul to the Devil in exchange for acting fame), and the Devil himself, who swaps bodies with Guy, who rapes Rosemary in order to impregnate her with the Devil's spawn. In the case of *Rosemary's Baby*, the Devil is also a bad marriage—a supernatural moniker used to simultaneously describe and avoid describing the conditions of "normal" female entrapment and sexual abuse. Perhaps there is no Devil. Perhaps the Devil is only a bad husband. In the film, the horror is predicated on what happens to a woman when she has no way out, which is real.

In "Taibele and Her Demon," Singer describes Tailbele's demon lover: "Sometimes his breath smelled of onion, sometimes of garlic… His body felt like the body of her husband, bony and hairy, with an Adam's apple and a navel… His feet were not goose feet, but human with nails and frost blisters." Singer's monster sounds a lot like the demon that sexually assaults Rosemary while she is drugged, a crossbreed of inhuman-husband and human-Devil. Could it be that Rosemary (along with Carla Moran in *The Entity* (1982), who is brutally raped over and over by an invisible incubus), a consummate good Catholic girl, does not want to admit to having—let alone *liking*—rough sex with Guy? Is "demon" a name we give to otherwise "normal" husbands, who occasionally like to exercise

sexual dominion over their wives? "It was kinda fun in a necrophile sort of way," Guy sheepishly jokes to Rosemary, who complains about scratches all over her body the morning after the rape. "You could have waited" Rosemary replies, shocked but compliant.

In her reading of Singer's story, Jong suggests that the Devil is how we absolve the hubris and shame of our desires. While Guy is seduced into power by his Devil-worshipping neighbors, the Castavets, Rosemary, a bourgeois woman proximately aligned with second-wave feminism, is seduced into motherhood. In her essay, "The Trauma of Infancy in Roman Polanski's *Rosemary's Baby*," Virginia Wright Wexman states that Rosemary resolves her sexual anxieties and fears by "conjur[ing] up an image of power and violence that is both erotic and punitive: a diabolical rapist."

> Guy pretends Rosemary doesn't know he is raping her.
> Rosemary pretends Guy is a demon.
> Guy pretends neither Rosemary nor the baby were ever harmed.
> Rosemary pretends her husband—the "talented Actor"—is more than average. Which is the horror.

Angel of death

The Rabbis found the angel of death mentioned in Psalms lxxxix. 45 (A. V. 48), where the Targum translates: "There is no man who lives and, seeing the angel of death, can deliver his soul from his hand." When Llewelyn Moss wakes up at the hospital after a nearly fatal brush with Anton Chigurh (aka "Sugar") in *No Country for Old Men* (2007), Carson Wells, who visits him, asks, "You've seen him and you're not dead?" Moss is what is known in the horror genre as the Final Girl. The Devil is also referred to as the Angel of Death, which derives from the Bible. It has been argued that sometimes the Grim Reaper is actually able to induce death, leading to tales that he can be bribed, tricked, or outwitted, like when "Sugar," a modern-day Grim Reaper, cruelly orders his victims to

flip a quarter in order to "outwit" their doomed fate. Yet, as *The Usual Suspects* (1995) demonstrates, almost no one lives after seeing the Devil, and Moss doesn't ultimately live either. Though not much is made of his dying or his procedural efforts to stay alive, and usually not much is made of people's deaths in general. So why should death count more on screen? Because actors are involved.[1]

What purpose do actors really serve, both on and off the screen? Isn't fame always simultaneously a pact (a binding contract with a system) and a form of unwanted possession (fans flood and invade the lives, biographies, and bodies of actors)? Fame is always represented dualistically—a Faustian pact that is half-blessing, half-curse. Part angel, part demon. The demon is the second half of the success story. The (bad) note you end on. When it comes to fame, instead of an unwanted someone or something possessing you, the "body" is more generally a host for an amorphous monster known simply as Culture. "Celebrity demands a certain type of hypocrisy from all performers," writes Margo Jefferson in *On Michael Jackson*. "The persona can't possibly square with the private life." In *Rosemary's Baby*, the Devil appeals to Guy, a desperate, out of work New York actor, played by John Cassavetes, who, having good looks and charm on his side, fools by vocation—taking on the job of duping, seducing, and demonic recruiting. When Rosemary and Guy first view their new apartment at the "Black" Bramford, the realtor informs the newlyweds that the building is "popular with actors"—a lineage the real-life Dakota building, most famously the residence of the murdered John Lennon, shares. The realtor tells Guy and Rosemary that the great industrial evil of late modernity, World War II, filled the empty Bramford up again. Begging the question: What kind of evil lived there before?

In the sin-inspired *Se7en* (1995), Gwenyth Paltrow saw the Devil too, or its late 20th Century avatar, in the form of Kevin

1. The mark of a Coen Brother's film is always rigmarole. See *Burn After Reading*, 2008.

Spacey, who plays the Devil-as-apocrypha in *The Usual Suspects*. Paltrow, like Salome inverted, ends up with her head FedEx'd to the Nevada desert, a tragic delivery scheduled for her husband, played by real-life boyfriend Brad Pitt. The desert is also where *No Country for Old Men* takes place. In *The Usual Suspects*, the Devil does live to talk about the Devil, but only because he's talking about himself—ad-libbing—hence the name *Verbal*. Unlike "Sugar" in *No Country*, Javier Bardem isn't humanized or turned into a romantic figure like John Cusack's mercenary, contract-killing Angel of Death in *Grosse Point Blank* and *War, Inc.*, where the Devil/death often comes for people in the form of a politically-motivated assignment. In a 1989 interview about *Say Anything*, Cusack stated that he liked Lloyd Dobler because he wasn't a "charm monster." Charm is how actors acquire the monstrosity of fame.

In *The Usual Suspects*, the Devil is verbal and requires translation and interpretation. When the Hungarian Arkosh Kovash famously outed the Devil—"Soze"—it was in a language most American audiences couldn't understand. Verbal concocts and narrates a Devil that is colloquial. Verbal is the Devil *as* vernacular, as babble. As slob, as myth. Weak and all-powerful, Verbal cobbles together and improvises a Devil out of fragments: newspaper clippings, random words, the bottom of a coffee cup, racist lore, hearsay. Not coincidentally then, the first person to bring up the Devil is the person playing him. "Who is Keyser Soze?" Verbal asks, feigning terror. The question, along with the name, unleashes the Devil and activates a fiendish yarn. In Tim Burton's satanic romp *Beetlejuice* (1988), the name "Beetlejuice," also known as Beetlegeist, must be uttered aloud three times in order to release the Devil back into the world. The fairytale Rumpelstiltskin is also a fable about names and misnomers. The everyman and nobody, philosopher Michel de Certeau explains in *The Practice of Everyday Life*, "Plays out on the stage the very definition of literature as a world and of the world as literature. Rather than merely being represented in it, the ordinary man performs—acts—the text itself."

Names and monikers

Rumpelstiltskin, like Soze, is chameleonic and part German when it comes to his *nom de guerres*. Each country took turns renaming him. He was Tom Tit Tot in England and Päronskaft (meaning "pear stalk") in Sweden. The German name Rumpelstilzchen translates to "little rattle stilt" (A stilt is a post or pole that provides support for a structure, and in this case, the Devil is the ultimate rig). A Rumpelstilt or Rumpelstilz was the name of a type of goblin (also called a pophart or poppart) who makes noises by rattling posts and rapping on planks. The meaning is similar to rumpelgeist ("rattle ghost") or poltergeist, a mischievous spirit who clatters and moves household objects. Other related concepts are mummarts or boggarts and hobs—mischievous household spirits that disguise themselves. At the beginning of *The Exorcist* (1973), Regan's mother, the actress Chris MacNeil, misidentifies the Devil for rats scratching in the attic. The screen caption for this scene reads, "Rattle. Rattle." Dracula's surrogate bodies also include rodents and bats. By initially presenting itself as mischievous and playful (via a Ouija Board), not menacing (via rape in *Rosemary's Baby* and *The Entity*), the Devil in *The Exorcist* adopts the cartoonish and kid-friendly, pedophiliac-sounding alias, "Captain Howdy" in order to lay the groundwork for the possession of pre-pubescent Regan's body. Regan's story recalls Rosemary's story.[2]

Rumpelstiltskin is the leitmotif running through all devils. Goblins, on the other hand, were known for stealing unattended babies, not unattended female bodies—the thing that Rumpelstilitskin and the Devil in *Rosemary's Baby* are after—and switching them with changelings. The changeling story is at the heart of both *Rosemary's Baby* and *The Omen* (1976). The

2. Today's equivalent is the online male sex predator posing as a "lonely" and "sensitive" teen.

so-called product of the post-Vietnam American family, twelve-year old Regan's body is left unattended while she plays with her Ouija board in the basement. The Devil is alone with her. *The Exorcist* makes a point of equating the sexual theft of Regan's pubescent body with the fact that she is a child of divorce:

> A child of the '70s
> a child of a single
> Hollywood-actress mother, who is always filming on set.
> A girl with an
> absent
> angry
> father.
> In a
> home that is unlocatable
> permeable
> ruined.
> With the door left open, the Devil walks right in.

The Shock Doctrine

Fairytales also conceal the dark side of governments. In *The Shock Doctrine*, Naomi Klein locates this ancient form of ghoulish plundering in George W. Bush's *habeas corpus*. Using the metaphor of shock as scare tactic after 9/11, the Bush Administration's cronies kidnapped "Arab-looking" men for being "enemy combatants" and held them captive in secret prisons beyond the rule of law. Shock was employed as a political maneuver to lull the rest of the country into acquiescence, creating what Klein calls "the shadow state of the Blackwaters and the Halliburtons." "History shows us that building a secret prison opens up a Pandora's box in Hell," writes Naomi Wolf in *The End of America*. Philip Zimbardo describes this process of illegal detainment and torture as the Lucifer Effect in his eponymous book. Klein

defines a shock doctrine as "The gap between event and information or event and analysis." "We go into shock," she explains in an interview, "when something huge happens that we can't process into a story or a narrative. Information, analysis, and narrative are the tools of shock resistance. We can still be frightened and hurt when the next shock comes, but the disorientation and regression—which is where we lose our wits and our rights—happens when we lose our bearings, when we lose our story, and when we allow ourselves to become childlike." One could argue that *Rosemary's Baby* is in fact an allegory about what happens to women when they are jolted by patriarchal institutions—marriage; the responsibilities of motherhood—and, regressing into infancy and infantalization, lose themselves and their lives—their "wits, their rights." Mother becomes baby. Woman becomes child.

When Joan of Arc refuses to concede that her visions come from the Devil—not God—in Carl Dreyer's *The Passion of Joan of Arc* (1928), she makes an important distinction: The Devil is not rooted in the individual, who disrupts the harmony of the social order, but in the collective that corrupts and possesses the individual. The social order itself is a Devil that systemically obliterates the individual who chooses to resist. The female changeling, sexual subjugation, and reproductive anxiety were all popular themes in late 1960s and 1970s cinema—Truffaut's *Fahrenheit 451*, Tarkovsky's *Solaris*, and Donald Cammell's *The Demon Seed*, all depict the horror of body theft.

It is Rosemary, a pre-second-wave feminist—not her supposed demonic baby—who becomes the changeling, an alien to herself. The Bramford's deceased tenant, Miss Gardenia, foreshadows Rosemary's imminent possession. When Rosemary and Guy first view Gardenia's apartment at The Bramford, Rosemary notices what appears to be a handwritten note on Gardenia's writing desk. The truncated memo reads:

"I can no longer associate myself..."

The realtor informs the Woodhouses that Gardenia had been a female pioneer—"the first woman lawyer in New York."

The Stepford Wives (1975), also written by Ira Levin, inverts the action-of-doom in *Rosemary's Baby*. Both Rosemary and Joanna are married to the wrong men. Joanna Eberhart isn't like her husband. Guy isn't like Rosemary. While Joanna, a photographer, leaves New York City for the suburb of Stepford, where her husband gets a new job, Rosemary Woodhouse leaves the suburbs for New York in pursuit of her husband's acting career. Both women are done-in by the Faustian deals their mediocre husbands make at the expense of their wives in order to advance in the world. Their willingness to do so, to ransom their wives in exchange for success, is the de facto evil of both films.

At the end of *No Country for Old Men*, Sheriff Bell rhapsodizes about the nature of violence, describing devils as the political reality of nations. As a sheriff, Bell knows firsthand he can't do anything about the problem of systemic evil. "This country's hard on people," Bell explains. "You can't stop what's coming." Society is the true Devil in *No Country for Old Men*. Sheriff Bell describes "Sugar" as "an indiscriminate killer... A

complete mystery," while the actor Javier Bardem has stated that "Sugar" is a symbol for a new kind of drug-related, gang warfare. "Sugar"'s accent sounds Mexican and the movie largely concerns the border between America and Mexico as an artery for drug trafficking. But what does it mean for Bardem, a Latin man, to play that symbol; to traffic racial and cultural meaning in the film while pretending not to? To kick it up like dust in the allegorical desert? Ethnicity is turned into the invisibility and illegibility of monsters—a racial cop-out on the part of the Coen Brothers.

Devils are often not known by sight. When Verbal Kint relays the source of Soze's vengeful rage to Chazz Palminteri's Detective Dave Kujan, "Soze" is merely a cut-up of racialized myths and stereotypes; a mix of Old World and New World. Faceless, he's shown engulfed in a blaze of fire and wild hair.[3] When Verbal is finally unveiled as the Devil, the big reveal is in the form of a faxed sketch. The Devil is sourced from verbal description. The Devil you see is not necessarily the Devil who speaks, and vice versa.

The Usual Suspects flips Erica Jong's demonic portrait on its head. The Devil doesn't hoodwink you by being a handsome actor like Guy Woodhouse in *Rosemary's Baby*. Rather, the demon seduces—*passes* for demon—by playing a crippled, indistinguishable "slob," like Verbal Kint, or "Verb," as Detective Kujan calls him. Verb being the part of speech that literally makes him "The man with the plan." Verb, like the tense, is both action and state of being, as well as the thing that propels narrative. Verbal weaves the tale of the Devil using the humdrum and unremarkable—the Nobody. "The greatest trick the Devil ever pulled was convincing the world he didn't exist," Verbal tells

3. To kill one enemy—in Soze's case, the Hungarians—you have to, as the Joker points out in *The Dark Knight*, "Burn down the world," which is precisely what Soze does at the start of *The Usual Suspects*, when he blows up the cargo ship. The fabled Soze can also be seen doing just this during the narrative of Soze setting the "world" on fire.

Kujan. In the 1931 film *Dracula*, Van Helsing tells John Harker that the "strength of the vampire is that people will not believe in him." As the Devil in *Se7en*, Spacey also utilizes a plain-Jane moniker, "John Doe."

In *A History of Violence* (2005), the Devil is the murderous and flamboyant gangster, Joey Cusack—the man the ultra-ordinary Tom Stall used to be. In the film, Stall relocates to a small American town and reinvents himself as a gentle Nobody in an effort to leave his violent mobster past behind. He switches his body with someone else's body, the way bodies and identities are swapped in sci-fi and horror. Ordinariness is figured as a stage-identity. Stall's rejection of violence (his non-violent body-double; his refusals to fight, even though he can) recalls the *Superman* sequel (1980), in which Superman forfeits his super-powers in order to live an ordinary life with Louis Lane. In *A History of Violence*, violence returns as a specter that haunts Tom Stall, who is brutally beaten and shot at throughout the film. Stall's body has failed to leave the history of masculine violence behind. In the documentary *The American Nightmare* (2000), *History of Violence*'s director David Cronenberg, states: "You don't get body without society and you don't get society without body."

One of the anagrammed words the name Keyser Soze produces is Zero. A Nothing, a non-entity. "And like that," Verbal concludes, "he was gone," blowing the iconic apocryphal monster he's concocted into thin air. "Nobody knew [Soze]," Verbal, a corporate mouthpiece for a non-existent Devil, tells Kujan, "or saw anybody who worked directly for him." Similarly, Spacey's Jon Doe has little or nothing to do with the schematic crimes that have been committed in *Se7en*. The Devil's arrest is simply perfunctory lip service to the conventions of the who-dunit genre. When we finally do see Doe/Devil, he has no fingerprints. Detectives are forced to release him. Without fingerprints, which he's abraded with a razor blade, Doe cannot be identified and does not exist.

Denying any conscious ethno-characterization, director Joel Coen describes "Sugar" as "unplaceable ethnically and nationally," while Javier Bardem, on the other hand, is. Coen says "Sugar" is Hungarian, like Soze's fabled enemy, only he doesn't sound like it. He characterizes "Sugar" ethnically, but only to get out of doing so. Thus, covering a real identity with a fake identity, or as Certueau puts it, by using "a name that betrays the absence of a name." Soze is a fictitious monster invented by the American Verbal Kint, and nations, especially non-American ones, are both coined and othered by other nations. Verbal invents a racialized Devil and tells Kujan that Soze "was supposed to be Turkish. Some say his father was German." Bardem notes "Sugar"'s power is that "he doesn't need to be explained," and he isn't. "Sugar" is an unexplained and unexplainable presence. Black feminist theorist bell hooks has made a similar argument about the "unexplained" use of James Earl Jones' "black" voice to symbolize the dark Father-as-Devil in the *Star Wars* trilogy, asking, "Who decides what voice will constitute the villainous voice?" As famously meticulous directors who actively participated in assigning specific attributes to him, are the Coens espousing a view of movie-making they don't practice by reducing "Sugar" to the indefinable and unidentifiable? Furthermore, are they hiding behind the demon/denial that pretends that movies are pure magic—not conscious manipulation?

Rogue vs System

Unlike the complicated hell of life, movie hell offers avenues of escape. So-called straight genre horror films tend to be more optimistic than ambiguous post-war horror: there is usually an end to suffering, an antidote to hell. A way to kill the monster and restore order. When it comes to the real-world system, most devils do not work alone. Nor are they mohawked, vigilante rogues, like *Taxi Driver*'s Travis Bickle. Or aberrant sharks, like

Jaws. Real devils are both systemic and symptomatic and therefore do not need to "break" into the world (a system or body) because they are already and always inside the world. While Chief Brody's "fatigue" (in *Jaws 2*), and offscreen death (from a heart attack in *Jaws 4*), are chalked up to the psychic shocks and blows of an anomalous, indefatigable shark, in reality, Brody is defeated and destroyed by a horror that is overwhelmingly structural. That is, utterly consistent with—rather than extraneous to—reality. The corrupt town politics of Amity are what finally defeat Brody. The shark signifies the *order*—not the *disorder*—of things. The very fact that the shark recurs and remains (comes back again and again in sequels) is symptomatic of its total entrenchment. It is not, as the film would have us believe, an exception to the rule. It is the norm. As the film critic Andrew Britton points out in his 1979 essay on *Jaws*, the real (systemic) devil still exists in Amity:

> The concentration on the hunt seems designed to distract us from the real problem, which is not the shark at all, but the city council. The personal catharsis for the hero (and, by identification, for the audience), by which he is simultaneously purged of his guilt and cured of his life-long dread of the sea, conveniently ignores the fact that nothing has been done about Mayor Vaughn. *Jaws* is a monster movie in which the hero kills the wrong monster.

As James Baldwin notes in his essay, "Where the Grapes of Wrath Are Stored," *The Exorcist*, like *Jaws*, sidesteps the true evil at the heart of film, which is not a bodily or crude devil, but the corrupt bourgeois class the world has built for itself. The otherworldly in *Rosemary's Baby*, *Jaws*, and *The Exorcist* is simply a distraction from the horror of the real world. The bodies of young girls, Baldwin points out, are and have always been, easy targets.

While Bardem claims that "Sugar" "shows that violence doesn't have an explanation most of the time, or any roots," in *The Usual Suspects* the Devil is in part the descendent of cultural mythologies about race and national identity. That is, the way language scapegoats and spreads devils around à la George W. Bush and the open-ended narrative of Devil-as-terrorism. But there are also more literal and targetable devil forms like Osama bin Laden and Saddam Hussein. In his foreword to *The Politics of Friendship*, Jacques Derrida writes:

> We are not referring to those crimes called political crimes, those assassinations with political motivation, which litter History with so many corpses. Rather—a second hypothesis—a thinking of *that* crime in which, allowing for the difference of a repression, the political being of politics, the concept of politics in its most powerful tradition is constituted (the 'real possibility' of the enemy being killed, in which… Carl Schmitt identifies politics as such, and which he would desperately wish to distinguish from crime as well as from murder). Unless—and here is a third hypothesis—we must think the crime *against* the possibility of politics, against man *qua* political animal, the crime of stopping to examine politics, *[arraisonner la politique]*, reducing it to something else and preventing it from being what it should be.

For Derrida, crime is the political structure we refuse to examine. If "Sugar" is anything, if devils are anything, they are structural. The natural byproducts of late modernity and the global exchange of capital. They are also, as Naomi Klein points out, the kind of information that, if analyzed, can send vital signals that save our lives when we've been confiscated, switched with someone else, and held against our will. If that is the case, rather than genre fantasies, devils are the purest form of reality.

— 2010

18

The Rights of Nerves

"I transform 'Work' in its analytic meaning (the Work of Mourning, the Dream-Work) into the real 'Work'-of writing."
— Roland Barthes, *Mourning Diary*

"It's the Demon of Fear. I'm actually scared of everything."
— Ingmar Bergman, *Bergman Island*

PART I

As a writer I often feel like I am in trouble. This is something a writer should never say or admit to feeling. Not if they want to continue to write and not if they want others to think of them as writers who know how to write. Writing produces constant dread and anxiety: the feeling that I have to write, but can't. That I

don't know how or never will again. This is how writing starts. This means that writing is not simply what I do, it is also what I cannot do and might never do again.

In the documentary *Bergman Island* (2006), Ingmar Bergman makes a list of his demons and then reviews each one on camera. Bergman admitted to having many fears, but the one fear he said he never had was the "Demon of Nothingness," which is "Quite simply when the creativity of [your] imagination abandons [you]. That things get totally silent, totally empty. And there's nothing there."

Bergman Island ends with Bergman describing a fear that he claims to have never had, to have never even known, and which his huge body of work (63 films) corroborates to some extent (the way that a corpus of work always corroborates the ability rather than the inability to work), but which nevertheless burrowed into his life in other ways: his films, which featured characters, often artists—both men and women—grappling with the fear of Nothingness. In Bergman's films, characters wrestle with being abandoned and betrayed not by their imaginations—for fears produce their own fantastic fiction—but by the inability to creatively hone, represent, and endure those imaginations.

In *Bergman Island* Bergman also talks about the Nothingness of death. The way he thought about and was "touched" by death every single day of his life. Then one day, while under anesthesia for an operation, he realized that because death is nothing ("a light that goes out"), it did not need to be feared. The love that Bergman felt for his last wife, Ingrid von Rosen, to whom he was married (after many other marriages) for twenty-four years until she died, forced him to once again reevaluate death and whether or not death effaces Nothingness. Bergman loved Ingrid, wanted to feel her presence after her death; wanted to be reunited with

her, and therefore couldn't allow himself, he says, to see death as an end to life, for that would have meant an end to Ingrid too.

I watched *Bergman Island* and Bergman's 1968 gothic horror, *Hour of The Wolf*, at the same time. I considered them companion pieces. I was heartbroken after a breakup and struggling with my writing. The two films confirmed how difficult and elusive creative work is. What motivates one person to work, resulting in hyper productivity, is the very thing that makes working impossible (paralyzing) for others. While some people work in order to avoid thinking about what is behind their working— that is, in order to not think about what is *not* working; what doesn't get recovered and compensated for by work—others work as an attempt to fix, evade, or control what is not working. For some, work works. For others, work fails to work.

Bergman Island reveals that while Bergman (who died a year after the documentary was released) managed to kick the fear of Nothingness, as far as death was concerned, he continued to harbor the rest of his demons. Because fears free-associate and mesh— induce and house other fears; the way one fear can unveil and morph into another—the fears that plagued Bergman throughout his entire life could have easily mutated into the catchall fear of Nothingness, with respect to his creativity. Yet rather than not work because he was afraid, or reject fear as a source of inspiration, Bergman often made films about fear and in the face of fear. Made fear the subject and his subjects afraid. He did not ghettoize fear. Nor did he restrict it to the genre of horror.

If you pay attention to Bergman's list of demons in *Bergman Island*, you'll find a Bergman film for every single of one of his fears. You'll find a film in every demon and a demon in every film. For Bergman, the process of and reason for making a film was partly about what it means to be creative without mythologizing or

romanticizing creativity, or even proposing it as an outlet or anti-
dote to the anxiety work simultaneously alleviates and produces.
I don't think Bergman believed creativity was capable of softening
the blows of fear and doubt. He focused instead on what it
means to give up the idea of mastery and control in order to
explore something more grave—debilitation. Many of Bergman's
characters make themselves sick.

In *Wittgenstein* (1993), Derek Jarman establishes a similar trajec-
tory regarding the trauma of knowing. Of what it means to know
and the ways in which knowing can disable as well as enable one
to live. In Jarman's film, the search for knowledge does not miti-
gate the trauma of knowing. For Wittgenstein, "knowledge" results
in one epistemological and ontological crash after another. The
Austrian philosopher slides between different multiplicities and
temporalities. Wittgenstein is simultaneously weak and sick, child
and adult, Austrian and English (the slippages in accent; the slip-
pages in everything), active and passive, hopeful and despairing,
brilliant and stupid, gentle and tyrannical. Both *Wittgenstein* and
Blue (1993) take potentiality and finitude as their philosophic
start-up positions. Wittgenstein is a trans-subjective subject,
appearing in the film as the child-philosopher because it is the
child who has view of the future. What Wittgenstein—the-child—
knows, he has always known. And also, could not have known yet
and might never know. Uncertainty and doubt belong to the adult
Wittgenstein. It is Wittgenstein-the-man who writes (in the
Tractatus), "What's more important about philosophy is all the
things philosophy can't articulate. Can't say."

Despite Bergman's assertion that his creativity never failed him,
never fell silent, Bergman made *Hour of The Wolf*, in which
Johan, an artist, is unable to paint, and *Persona* (1966), in which
the stage actress, Elisabet Vogler, stops speaking. It isn't clear,
however, which fear blocks Johan and Elisabet, or if the fears in

these two films can even be classified. For both Alma and Johan one fear leads to another and creativity exposes one to a topology of fears that threaten it.

For Bergman, fear doesn't always need a direct object. As he illustrates with his catalogue of demons in *Bergman Island*, fear simply requires a direct stake or address—the naming of that which is unnamable. Like Alma (Elisabet's nurse), who speaks and doubles for Elisabet in *Persona*, Alma (Johan's wife) in *Hour of The Wolf*, suffers the blows of Johan's unspeakable fears. Johan's fear is the source of Alma's fear. She fears for his fears, fears for herself, and is afraid of him because of it. Thus, it is the terrified Alma who, on their way back from the party at the castle, tells Johan: "I'm nearly sick with fear… I can see that something terrible is happening. Just because it can't be called anything."

PART II

In *Hour of the Wolf*—both the film itself as well as its characters—are plunged into the phantasmagoria of the hour of the wolf: "The hour between night and dawn. The hour when most people die. The hour when the sleepless are haunted by their deepest fear. When ghosts and demons are most powerful." The hour of the wolf is the Void (in *Repetition*, Kierkegaard describes this time in the early morning as: "That hour when the day battles with the night, when even during the summer a cold chill runs through nature.") you fall into in the "Night of the World" because for Bergman, Night (death, doubt) is the very core of subjectivity. To quote Hegel, from his Jena Lectures:

> The human being is this night, this empty nothing, that contains everything in its simplicity—an unending wealth of many presentations, images, of which none happens to occur

to him—or which are not present. This night, the inner of nature, that exists here—pure self—in phantasmagorical presentations, is night all around it, here shoots a bloody head—there another white shape, suddenly here before it, and just so disappears. One catches sight of this night when one looks human beings in the eye—into a night that becomes awful, it suspends the night of the world here in an opposition. In this night being has returned.

Hegel's "Night of the World" is also the horror genre. We catch sight of the Night's abyss in Janet Leigh's postmortem eye in Hitchcock's *Psycho*. The female eye/I is also a screen for the male violence that victimizes it. The frustrated painter Johan has much in common with the creative neurosis and male hysteria of the writer Jack Torrance in *The Shining* (1980), where Night (horror and insanity) descends in the form of patriarchal winter—the Dark Night of the Soul. Stanley Kubrick admitted to the enormous influence Bergman had on his work, and in many ways *Hour of the Wolf* (along with Bergman's *The Silence* (1963) and *The Passion of Anna* (1969) is a blueprint for *The Shining*). The haunted Gothic castle, where Johan and Alma attend a dinner party, and that Johan later revisits alone in the throes of his mental breakdown, shares the gothic tropes and psychosexual furies that flood the Overlook Hotel.

Marooned together for the winter in a snowbound hotel (a seasonal winter that can be characterized as the figurative *hour of the wolf*), Jack and Wendy are doubles of Johan and Alma, who are stranded together on a remote Swedish island. Both Alma and Wendy are captives of male violence and creative madness. Like Jack's possession at the Overlook Hotel, and Johan's violent breakdown in *Hour of the Wolf*, one of Bergman's demons was his temper. In *The Shining*, bad-tempered Jack gives up on his ability write productively, instead writing automatically. The trance

state belongs both to art and horror. Marked by a fatalist count-down of the calendar, we see and hear Jack furiously typing—page in typewriter, a stack of pages piling up on his desk, the days of the week accumulating and appearing on screen. This is what every writer hopes for: Jack is possessed by writing. Later, through Wendy, we see the big reveal of Jack's manuscript—the film's monster.

What is terrifying about the discovery of Jack Torrance's mani-festo, "All work and no play makes Jack a dull boy" is the infantilized male tautology it exposes. *The Shining* unmasks the mourning and horror that work simultaneously conceals and supplants, leaving only the raw and unassimilable impetus (the unusable outtakes and drafts) of creative work. It is rather like Bergman's list of demons without the extensive filmography to referee and valorize them. Jack's haunted manuscript is:

1. Writing as failed work.
2. Work that fails to look like work.
3. Work that has failed to be turned into art.
4. Drafts that have failed to become final.
5. Life that fails to be saved by art.
6. Mourning that has failed to be sublimated into work.

The Torrance family moves to the Overlook so that Jack can:

1. Write because Jack cannot write under normal circum-stances; in his normal environment.
2. Jack cannot work a normal job.
3. Jack is an alcoholic and an abusive father.

In *Civilization and its Discontents*, Freud cites Theodore Fontane on the necessity of auxiliary constructions. Palliative measures are principally neurotic and enable us to bear the unbearable,

paralleling the overriding program of the pleasure principle. Fontane outlines three primary measures of escape: "Powerful deflections, which cause us to make light of our misery; substitutive satisfactions, which diminish it; and intoxicating substances, which makes us insensitive to it." As a writer and alcoholic, Jack indulges in the second and third auxiliary, rotating between the two; swapping, splitting, and doubling the deflections at various times. When he can't write, he drinks. When he drinks, it's not clear if he is able to write. Though an "Illusion in contrast with reality" that is not accessible to everyone (Freud in "The Relation of the Poet to Daydreaming": 'We laymen have always wondered greatly how that strange being, the poet, comes by his material."), Freud notes, art can be categorized as an effective substitutive satisfaction because of the presence of fantasy in our mental life. Dream-like shots of Jack typing away are revealed as the fantasy of writing a fantasy book. The fantasy of writing-work going well, which is every writer's fantasy. The illusion of productivity is itself a fantasy. Jack is merely pretending that he can write because he can no longer cope with not being able to. Psychotic mania in the form of possession takes hold as the ultimate intoxicant. The key to happiness, Freud explains, lies not simply in the right substitutes, but in finding the substitutes that work *for* us. When art no longer works because it cannot give Jack's phantasies body, deflections like sex and alcohol turn into hallucinations and ghosts. Jack's manic possession becomes his best fiction. It is Jack at his most creative, uncensored, and inspired.

Jack's manuscript reveals the demon underneath all creative work. The demon that is possessing Jack and that Bergman refers to as the demon of Nothingness: "The Demon of Nothingness, which is quite simply when the creativity of [your] imagination abandons [you]. That things get totally silent, totally empty. And there's nothing there." Jack's text is a horrific testament to the

Nothing behind his work; the nothing (tedium and dullness) that cannot be sublimated or transformed through work or into work despite the hundreds of pages of fastidious organization and re-formalization of Nothingness. All of his work ("all work and no play"), we learn, has been in vain. But so, too, has Wendy's silent and gendered suffering. Jack has "worked" for nothing while Wendy (along with Alma and countless other wives of male artists) has stood by that hostile Nothingness (her man) for nothing. Wendy will now suffer the wrath of her husband's idle work (work for nothing).

PART III

Jack's manuscript is a de facto record of the futility of a woman's work when that work is investing in one's husband's failed artistic pursuits at the expense of one's own livelihood and survival. If Jack's work has been for nothing, then so has Wendy's, whose incalculable work has been being the wife of a difficult male artist. For what has Wendy—an abused wife and mother[1]— suffered if not the artistic turmoil and false "genius" of a psychotic husband—the writer Jack Torrance, who has been given the "perfect refuge" to write, yet still cannot write?[2]

1. Based on the documentary, *Making The Shining*, that Vivian Kubrick, Kubrick's teenage daughter, made on set, Wendy was also the abused actress, Shelley Duvall. In 2016, Duvall told Dr. Phil that working with director Stanley Kubrick became so stressful that it was unbearable. "I was really in and out of ill health because the stress of [*The Shining* role] was so great," says Duvall in *The Complete Kubrick*, 2000. Jack Nicholson says that Kubrick forced Duvall to film the now-famous baseball bat scene over 127 times.
2. It is Wendy who actually takes care of Overlook Hotel. Similarly, in Krzysztof Kieslowski's *Blue* (1993), Julie is suspected of writing her composer husband's famous symphonies.

Jack's manuscript in *The Shining* is also an aesthetic double of the often violent—physical and psychic—consequences of male creativity. The regressed and unreliable Father merges with the regressed and repressed text in which the father is infantilized as Jack, "The dull boy," who has lost all paternal credibility and authority. More precisely, Jack's infantilization is rearranged and ordered "in a new way that pleases him better" (Freud). Freud writes that, "Play is taken seriously" by the child and, "Every child at play behaves like an imaginative writer... The writer does the same as the child at play; he creates a world of fantasy which he takes very seriously." In contrast, Wendy experiences the horror of creative misogyny—a taxonomy in its own right—that wives have historically endured. The impotent excesses of Jack's text are expressed through the amount of times he duplicates the phrase, "All work and no play makes Jack a dull boy." One of the many examples of doubling and repetition in *The Shining* is commensurate with the amount of time Jack has spent doing (writing) Nothing. The compulsion to repeat here is synonymous with failure and is literally expressed through formal word play. When he is not playing the game handball, writing is a game that Jack plays (seriously) because he cannot write. In *The Shining*, writing is a substitute for: failed writer, failed husband, failed father.

As Freud, Derrida, and others have pointed out, when we work we are in mourning, therefore the work of mourning indicates that what motivates us to work is also the very thing that prohibits us from working. Bergman feared his creativity because he knew that creativity is a Pharmakon that can backfire at any moment. In *The Shining*, Jack's creativity ceases to work *for* him. Like Ingmar Bergman, Jack Torrance is afflicted with the Demon of Nothingness. Yet unlike Bergman, he has nothing to show for his creative possession. In fact, it is because of his *a priori* possession by Nothingness, narcissism,

and neurotic fear that Jack, much like Guy Woodhouse's struggling actor in *Rosemary's Baby*, is susceptible to other possessions and moral detours.

PART IV

At the beginning of his lecture "Fear and Anxiety," Freud remarks: "It is certain that the problem of fear is the meeting point of many important questions, an enigma whose complete solution would cast a flood of light upon psychic life." "Fear and Anxiety" (and later "Anxiety and Instinctual Life," his follow-up essay) distinguishes fear (which needs an object) from anxiety (which is free-floating; without an object), as well as real fear from neurotic fear (*nervus vague*). Freud points out that "neurotic anxiety," as opposed to "realistic anxiety," is expectant. It is fear in advance, just as melancholia is mourning in advance—fear without preparedness; fear without fight or flight reflex; fear that leads to paralysis. With melancholia, one expects to lose something, one internalizes future losses. With neurotic anxiety, one anxiously anticipates fear. Both melancholics and neurotics imagine and await the worst.

Neurotic fear has historically been assigned to women. More specifically to being female. Real fear belongs to men because men have actual (not imaginary) things to fear. Only men are actually threatened; only men can and do take action. Only men have a legitimate (real) relationship with the outside world. It is only in children, Freud argues, that neurotic fear is potentially experienced as real ("Infantile fear has very little to do with real fear, but is closely related to the neurotic fear of adults."). The question of real and imaginary, inside and outside, is central here. Freud's definition of fear is itself gendered and neurotic: fear is purely psychoanalytic (within), not ideological (outside).

While fear may need an object, for women men can be the object of fear. Freud writes that with neurotic (not real) fear, inner danger is treated "as though it came from without." Correlatively, women's fear of men is often treated as though it were neurotic (unfounded) rather than real. Real threats are not treated as real. This is one reason belief and the line between real and imaginary in horror is a trope allocated to the so-called false and overactive imagination of women. To react or act is to always *over*react. For women and people of color to react to psychic and physical threat is to mistakenly treat what is inside as outside, and vice versa. Horror is largely concerned with proving that what is perceived as imaginary (danger) is in fact real (danger). This proof is essential to genre and plot alike, for when one is alone with what one fears, or alone in fearing, it is not acknowledged as reality. With neurotic anxiety, the fear that is sometimes "exaggerated out of all proportion" ("Anxiety and Instinctual Life") is instead, in the horror genre, danger seen too late. Freud's division of neurotic anxiety and realistic fear imposes a discrepancy not only on the right to be afraid, but in *who* has a right to be afraid of *what*. While Freud notes that the neurotic is our "best source of knowledge," despite experience, most women do not "suffer" from enough expectant anxiety when it comes to their fear of men. For fear of men, especially cis white ones, is treated as neurotic (invented). The wrong fear to have if you want to be/feel "right." It is Wendy and Danny who experience fear from the threat of Jack's *neurotic* violence (he can't write, he can't father, he can't take care of the Overlook) turned real (he tries to kill his family because he cannot find successful substitutes). Men are the external world and the horror genre is predicated on the contract between women doubting their fears and the world doubting women.

PART V

Hauntings are always encrypted in writing. Success haunts work. Failure especially haunts success. Success is mostly a reflexive (exterior) phenomenon that is marked by avarice. No one *feels* successful, they only appear that way to others, and that is one reason why we work—to appear to be living a certain way. Derrida would call this the work of mourning ("One does not survive without mourning"). Walter Benjamin (in his essay on Karl Kraus: "He found that [the nerves] were just as worthy an object of impassioned defense as were property, house and home, party, and constitution. He became an advocate of nerves."), the rights of nerves. The impetus, the energy, the pursuit comes from nerves: nerves as a call to escape or beat nerves; nerves as a way to prove your nerves wrong, especially during the moments when your nerves feel so much greater than anything else in your psychic arsenal. When we work, we are in mourning about the life we cannot live and the living we don't know how to do and so put in(to) work. One solution is to record the failure in writing.

In films like *Hour of The Wolf* and *Wittgenstein*, fear and madness directly correlate to the trauma and problem of knowing. With what can happen when you know. With the fears that knowledge prompts and presents. The hopeless dream of wanting to know—of knowing—is synonymous with the "hopeless dream to be." In a letter to his wife, Lady Ottoline Morrell, Bertrand Russell, Wittgenstein's teacher and mentor at Cambridge writes: "We both have the same feeling that one must understand or die." For Jarman and Wittgenstein, who rejected the bright illuminations of the Enlightenment, the quest for knowledge makes epistemological delineations impossible because knowing is about being in the dark and culling from that darkness, as well as wanting or trying to be in the light. While night is associated

with fear for Dr. Isak Borg in *Wild Strawberries* (1957), and Johan in *Hour of the Wolf*, ghosts and daydreaming artists in Bergman's films almost always appear in bright sun (In *Mourning Diary*, Roland Barthes writes solemnly about "that South-West sunlight, which has accompanied [his] life." In "The Relation of the Poet to Daydreaming," Freud asks, "Shall we dare really to compare an imaginative writer with one who dreams in broad daylight?"). Night is not restricted to the time of day or to the logos of death. In *Bergman Island*, Bergman appraises his list of demons with the filmmaker Marie Nyrerod in a room flooded with light, telling her: "I've never experienced bright light as anything friendly, but as something threatening. My ghosts, my demons, phantoms and spirits, never appear at night. They often appear in bright daylight."

Bergman's anxieties, fears, and horrors in broad daylight recall Nietzsche on the beginning of terror in religion in *Beyond Good and Evil*: "Later, when the rabble gained the upper hand in Greece, *fear* became rampant in religion, too—and the ground was prepared for Christianity." Along with his assertion that "our most profound solitude" ("most midnightly, most middaily solitude") collapses and conjoins day and night (Nietzsche also refers to the "night owls of work even in broad daylight."). Correspondingly, the beginning of terror introduces not just an epistemology of horror, but inverts the *time* of horror, as well as when one is safe from it, which is never. In *Hour of The Wolf*, the horrors of the day come to roost at night. In *The Shining*, most of the horror occurs in the morning and afternoon. The white snow is a daylight menace that engulfs the Overlook Hotel.[3]

3. In *Maxims and Reflections*, Goethe writes: "Snow is fictitious cleanliness." There is also Yeats' line: "In the cold snows of a dream," which can be applied to my reading of *The Shining*.

Derek Jarman, who was losing his sight while making *Blue* due to HIV, describes a similarly menacing light as "atomic bright photos... with yellow infection bubbling at the corner." In *Reveries of the Solitary Walker*, Rousseau writes about a "horrible darkness," which he refers to as an "uncertain road" through which he "could make out nothing but sinister apparitions;" a nonliteral darkness that is not only a form of doubt, but is also like the dogging, sickly brightness that Marcel Proust writes about. It is the same sickness and light, or light as sickness, that Bergman describes and floods his films with, even the early black and white ones—hiding the dark in the light. The way that day can be switched for night, and vice versa, so both day and night, darkness and light, are mirror images of each other. In *Wittgenstein* and *Hour of The Wolf*, Night, or "Night of the World," becomes mise en scène.

At one point in Jarman's film, Wittgenstein drops out of Cambridge to write *Notes on Logic* and flees to an island in Norway "at the end of the world," where he builds a small house like Bergman did on Fårö, and Johan and Alma do in *Hour of the Wolf*. Afterwards, Bertrand Russell tells his hairdresser: "I told [Ludwig] it would be dark in Norway. And he said he hated daylight. I told him it would be lonely. He said he prostituted his mind talking to intelligent people. I said he was mad. He said, 'God preserve him from sanity." This series of inversions echo Bergman's day/night reversals.

Hour of The Wolf is a testament to the work Bergman was able to do in the face of daylight fear, and because of fear, but that swallows Johan whole. Work enabled Bergman to if not face his fears, bear his fears, while fear made living impossible for Johan, who vanishes without a trace into the hour of the wolf—a place from which no one can return. In *The Shining*, Jack freezes to death in a maze of daytime snow.

About *Persona*, Bergman stated: "At some time or other, I said that *Persona* saved my life—that is no exaggeration. If I had not found the strength to make the film, I would probably have been all washed up." In *Hour of The Wolf*, Johan writes the following in his diary, which could easily be Bergman's diary:

Friday night I wake up at 2 a.m. from a very deep sleep. I don't know where I am. Suddenly feel infected. Merciless anxiety. How can I protect myself against the terror suffocating me? Dear God, don't let me lose my mind. May I make it through. May I gain strength and joy.

— 2016

19

On Robert Bresson

"What you take into your hands, you take into your heart."
— *Witness*, 1985

1. It took me a long time to appreciate Robert Bresson's films. Not long in the sense that I had to see his films repeatedly before I was able to appreciate them. Long as in I watched a lot of other movies and directors before I ever even came to Bresson. This is just as well, for I had to go through other films to prepare for Bresson's films. I also suspected that Bresson might be overrated, and whenever I suspect someone or something is overrated, I respond with resistance. I have resisted a lot of things I later came to love. Sometimes one has to avoid answers before answers can become answers.

2. *Pickpocket* was the first Bresson film I saw. I watched it perfunctorily. Because I had to. It was part of my cinema history education, the one I was giving myself while writing *LACONIA: 1,200 Tweets on Film*. It was the year I watched 1,000 films. While watching *Pickpocket* I was more or less a bored pupil. This is not how I typically watch things. What I am referring to here has more to do with a temporary blindness to what I would later come to see as undeniably perceptible. But sometimes blindness is necessary. It's not just what you see, as Wim Wenders explained about Pina Bausch and the documentary he would eventually come to make about her (a documentary that took 20 years; a documentary he did not want to make), but when you see.

3. I remember reading an interview at Saint Mark's Bookshop in New York as a teenager. In it, the writer Dennis Cooper said that Bresson was his favorite filmmaker and called the director's work his first communion. This has always stayed with me. I think that interview was with the writer Robert Glück, but Cooper has also said this to many different people, in many different interviews. As Bresson writes in his aphoristic film manifesto, *Notes on the Cinematographer*, "Images and sounds like people who make an acquaintance on a journey and afterwards cannot separate." At 17, I had the feeling that Cooper liking Bresson might be important for me. This feeling was not a case of idolatry, or an anxiety of influence, but a kind of clue I had stumbled upon for the future (Another Bresson aphorism in *Notes on the Cinematographer*, "I unconsciously prepared myself," comes to mind here). In some ways Cooper saying he loved Bresson over and over was the thing that interested me most about Cooper and eventually led me to Bresson. As both an obsessive and cinephile, repetition and timing (even when my timing feels off) is one of the ways I learn to understand something.

4. Because I was so struck by how much Cooper loved Bresson, I kept trying to love him too. I kept Cooper's love in the back of my mind as a revelation I might come to have in my own time. Four years ago, I posted the following about Bresson and Cooper on my blog, *Love Dog*, and called it "Agnus Dei," which means "Lamb of God" in Latin. The Lamb of God is used in liturgies and as a form of contemplative prayer. Contemplation being something you do alone, and movies being something we historically watched with others.

Agnus Dei

December 1, 2012

When I was a teenager, I used to read about Dennis Cooper loving Robert Bresson and I didn't understand. Now I am an adult and I do.

Dennis Cooper, "First Communion":

> In the early '80s, a friend invited me to a screening of Robert Bresson's *The Devil, Probably*, on the condition that, no matter what, I not say a word about it afterward. He claimed that Bresson's films had such a profound, consuming effect on him that he couldn't bear even the slightest outside interference until their immediate spell wore off, which he warned me might take hours. He was not normally a melodramatic, overly sensitive, or pretentious person, so I just thought he was being weird—until the house lights went down. All around us, moviegoers yawned or laughed derisively; some even fled the theater. But, watching the film, I experienced an emotion more intense than any I'd ever have guessed art could produce. The critic Andrew Sarris, writing on Bresson's work, once famously characterized this reaction as a convulsion of one's entire being, which rings true to me. Ever since, I've imposed basically the same condition on those rare friends whom I trust enough to sit beside during the screening of a Bresson film, and I'm not otherwise a particularly melodramatic, sensitive, or pretentious person.

5. I am now the same way about Bresson too. This means I am protective of work that I like, which means I don't especially want to share it, or even talk about it too much, apart from in my writing sometimes, and that doesn't always come easily

either. Nor have I ever especially liked going to the movies with other people. I have had only a handful of movie companions in my life and I chose all of them carefully. When the Film Forum in New York City held a retrospective on Bresson in the winter of 2012, I went with a male acquaintance only because he insisted on paying for as many Bresson films as I wanted to see. The experience those screenings left on me remained mostly private. I didn't want to see all of Bresson's films with someone else. I wanted to see them alone. I only saw *A Man Escaped* (1956) (also called *The Wind Bloweth Where it Listeth*), along with the film of Bresson's I was most struck by at the time, *Lancelot du lac* (1974), with my friend. *Lancelot* was a movie I had been writing about in *Love Dog* at the time and watching on YouTube for weeks whenever I could find it (it is frequently taken down). The film contains one of the most powerful marriages of image and sound in film history, particularly in the opening credits.

6. 2012 was the year I watched all of Bresson's films. After I saw *A Man Escaped* at Film Forum, I came home and wrote about the idea of timing, preparation, and emotional endurance by stringing together lines from the film in the book I was writing at the time, *Love Dog*.

At Each Touch, I Risk My Life

January 23, 2012

"In this world of cement and iron."
"Your door. I'll try again."
"To fight. To fight the wall. The door."
"The door just had to open. I had no plan for afterwards."

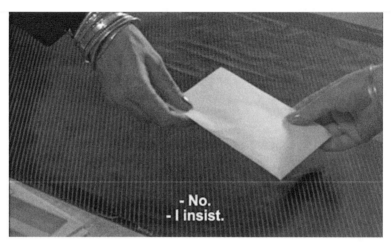

L'Argent, 1983

7. In a Bresson film, hands are key. To Bresson, hands mean what faces mean to directors like Carl Dreyer and Ingmar Bergman. And what the body means to Tsai Ming-liang and Claire Denis. If in Levinasian terms, ethics begin with the face, which pleads, *Do not kill me*, hands do or do not do the killing. In Bresson, hands are mise en scène, often taking up the entire frame, in close-up. The hand is the instrument of ethical/unethical relation: What we do with our hands.

The hand finalizes and seals a deed. Commits one to an act. Sets one on a course. Hands are cause and effect. They send out distress signals. Recall Gena Rowlands's flickering hand in *A Woman Under the Influence*: a little white flag, an SOS. Upon waking, Rowlands shows her hand before she opens her eyes. Hands are give and take. Hold and let go. Hands tell, think, and show. They are: how we touch, who we touch, what we touch, how we are touched. Love and hate. Why else would Robert Mitchum's hands in *Night of The Hunter* and Robert De Niro's hands in *Cape Fear* feature the four-letter word pair? Not to mention Lars Von Trier's hands—the word "Fuck" splayed across his knuckles.

In Bresson, without the catalyzing and notational (from Latin *notātiō*: a marking; from *notāre*: to note) hand, there is no life, no consciousness—no destiny either.

The hand epitomizes human-ness, as Heidegger points out. We choose to be human as well as inhuman with our hands. With our hands, we mark the moments we are one or the other, and both. In *What is Called Thinking?*, Heidegger writes that the hands not only distinguish us as humans different from other species, they are craft, which "literally means the strength and skill in our hands." If, as Heidegger asserts, "The hand is in danger" because it is what makes us human and therefore, vulnerable, this is never more true than in a Bresson film. Over and over, Bresson uses hands to signal various kinds of precarity and distress. Complicity and guilt. If the hand is in danger, so too is our human-ness. The Zen Buddhist monk Thich Nhat Hanh puts it this way: "Love is action and the symbol of action is the hand. When you enter a Tibetan or Vietnamese monastery, you can see a Bodhisattva with one thousand arms. It means the Bodhisattva has one thousand ways of loving and seeing." Similarly, Rowlands' playing hand in *A Woman Under the Influence*, opening and closing, is the state of her heart, which is in a state of emergency.

A Woman Under the Influence, 1974

A Woman Under the Influence, 1974

8. There are also all the idioms about hands:

> Don't bite the hand that feeds you
> Falling into the wrong hands
> Trade hands
> Take it off your hands
> Blood on my hands
> Wash my hands of it
> Playing into one's hands
> Showing your hand
> To take someone's life in one's hands
> My hands are tied
> My hands are clean
> Putty in my hands
> In the palm of your hand
> Don't overplay your hand
> I'm in your hands
> You're in good hands
> Keep your fingers crossed

9. Bresson quoting Cezanne's "At each touch I risk my life" in *Notes on the Cinematographer* equally translates to, *At each touch, I risk yours*. In *L'Argent*, Lucien's hand bursts open onscreen occupying the entire frame. A signifier of innocence, Lucien's open palm symbolizes the unfolding of tragic events (his palm is his misfortune) and the admission of guilt at the same time. A kind of harbinger, the hand shows what will happen.

And they strike you.

L'Argent, 1983

At the end of *L'Argent*, which has always felt to me like the moment where Michael Haneke's films begin, Lucien's hand returns and strikes again, resulting in a final, murderous blow/denouement that is echoed and revisited by Haneke in *Caché* nearly forty years later. Both Bresson (through hand shots) and Haneke (through unexpected violent blows) allow, as Renoir put it, "The unforeseen to come into the shot."

L'Argent, 1983

Caché, 2005

L'Argent, 1983

10. After watching *Au hazard Balthazar* (1966) for the first time, I wrote about the immolation of Balthazar's tail and Marie's iden- tification with the ill-treated donkey.[1] Both Marie and Balthazar suffer at the hands of a sadistic boy named Gérard.

Precarious Life

June 21, 2012

1. Women and animals, as Bresson shows us, endure similar subjugations.

You could love it like this:

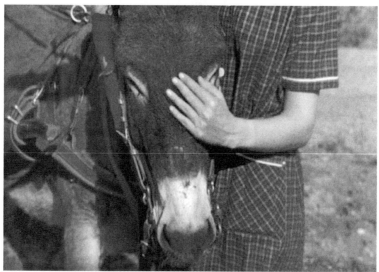

Au hazard Balthazar, 1966

Or you could hurt it like this:

Au hazard Balthazar, 1966

For Bresson, these two options—to love or to injure—are not only at the center of *Balthazar* but at the heart of existence. How we treat (touch) something. How something touches us. How we put our hands on something. On others. How things pass through our hands. Over the course of his life, Balthazar sacrificially passes through an endless economy of love and cruelty. "The donkey would pass from master to master and each of these masters would represent a human vice," Bresson explains in an interview in 1966. Animal in *Balthazar* is ultimate precarity but also ultimate spirit. Balthazar is not only everything that has been historically wounded—subject to malice, exploitation, domination—but everything and everyone that has been made an object of cruelty: Women, the poor, people of color, gay people, animals. Balthazar is literally the Lamb of God. In his book on Bresson, *Neither God nor Master*, Brian Price observes, "The animal (or criminal or slave) is capable of making us tremble."

11. In *A Man Escaped*, the imprisoned Fontaine's deliberate and painstaking hands are all over everything. They are his choices, his decisions, the painstaking time spent on things. Most of all, Fontaine's hands represent the time and thought it takes for him to set himself free.

Bresson's careful compositions of Fontaine's hands recur in other films like *Pickpocket*, *Au hazard Balthzar*, and *L'Argent*. Bresson repeats these hand arrangements over and over in his filmography. In *Cinema 2: Time-Image*, writing about what he refers to as "traditional sensory-motor situations" in cinema, Gilles Deleuze points out:

> It is Bresson, in a quite a different way, who makes touch an object
> of view in itself. Bresson's visual space is fragmented and discon
> nected, but its parts have, step by step, a manual continuity. The
> hand, then, takes on a role in the image which goes infinitely

beyond the sensory-motor demands of the action, which takes the places of the face itself for the purpose of affects, and which, in the area of perception, becomes the mode of construction of a space which is adequate to the decisions of the spirit.

12. I finally arrived at Bresson just as I was starting to make homes out of certain forms in my own work. Like Bresson, I use form to work through form, which is how I work through ideas. Form is a house for thinking. For grief. I found one home in the ascetic modulations of the aphorism, both textual and visual. One such variation and modernization of the aphorism is the screenshot. I have called some of the work I do screen-shot criticism. I wrote *LACONIA*, a book of 21st century aphorisms on film, before I had read *Notes on the Cinematographer*, and after only seeing one or two films by Bresson. For this I am grateful. As a presence, he was both there and not there yet. He was the work and the form ahead. I think of form as a way into and through a medium. Form as discovery. In an essay in *Love Dog* called "Reunion," where I discuss Wim Wenders' aforementioned documentary, *Pina*, I chose to frame creative work and the forms it comes to take, prophetically: "Work is destiny; destinal. It never happens straight… There is the work you make and the work that makes you. The work through which you become—a human being, an artist, a thinker."

In *Notes on the Cinematographer*, Bresson refers to this kind of formal precision and restraint in a number of ways, "Passionate for the appropriate," "A matter of kind, not quantity," and "To know thoroughly what business that sound (or that image) has there." In the years ahead, I would come to make a body of work about sound precisely to understand not just what business a sound has *there*—in cinema—but what sound tells us about every other structural business that has shaped the world and given the world shape. Bresson uses sound as something separate from image. When swords pierce through the clunky, armored

bodies of medieval knights in *Lancelot du lac*'s vividly green forests, the death cries are almost disembodied sighs of pain and cartoonish relief. The voices are the bodies. The sounds a body makes, and the voices a body has, do not come directly from the bodies onscreen, nor from the diegetic narrative. They are something extra. The warring bodies in *Lancelot* is a body across time; a body functioning in a historicized setting; a body when struck and pierced; a body when touched by a hand; a body inside armor, a body inside time. Bresson himself wrote that, "While music flattens a surface, makes it into an image, sound lends space, relief." In Bresson, Freud's "the work of mourning" becomes the work of *working out a form*. As Susan Sontag points out in her 1964 essay, "Spiritual Style in The Films of Robert Bresson," form—the *right* form; the right form for a particular problem, situation or idea; the right form for a particular artist— *is* Bresson's subject and substance (The jury is still out on whether this can simply be called style, as style is both affected and deeply personal). It is what Bresson means by "passionate for the appropriate." In order for an artist or their work to be passionate, passion needs the appropriate form—not the other way around. Passion makes form, it does not defy or dissolve it. As we see in *A Man Escaped*, careful calibration of form in Bresson is also a way through suffering and injustice. *Working out* a form—indeed, working *anything* out—is one of the ways in which style becomes both "spiritual" (and political) in Bresson's work.

Sontag:

> Why Bresson is not only a much greater, but also a more interesting director than, say, Buñuel, is that he has worked out a form that perfectly expresses and accompanies what he wants to say. In fact, it is what he wants to say… And the form of Bresson's films is designed (like Ozu's) to discipline the emotions at the same time that it arouses them.

Lancelot du lac, 1974

Indeed, gradually *working out* a form of escape is how Fontaine succeeds in escaping from prison in *A Man Escaped*. Escape—a spiritual trial—is a form that Fontaine masters over time, resulting in both corporal and spiritual release. Fontaine's hands stand for method, deliberation, duration, and endurance. In Bresson's procedural *The Trial of Joan of Arc*, the form is a *resistance* to form, which is the trial (or *process*, as it is called in French) itself. Joan's discipline, as Sontag puts it, is to not submit to the form (system) of male coercion that is inflicted upon her by the church. Her form is restraint, resistance, internal fortitude, spiritual conviction—how she does and does not proceed during her trial. While Carl Dreyer's film about Joan of Arc puts passion and emotion (Joan's suffering, Joan's sacrifice, Joan's crying face) at the center, Bresson, whose screenplay is drawn from the minutes of Joan's actual trial, makes the form of the trial the focus. Another notable difference between the two versions of Joan of Arc is the part of the body that is filmed and underscored. For Bresson it is Joan's hands, for Dreyer the trial is famously in Maria Falconetti's exquisitely performative face (Bresson hated Dreyer's film). The

trials of Joan, Fontaine, Mouchette, and Balthazar—to name a few—and the internal/external forms of suffering and transcendence that Bresson assigns to each of his films, is what I think Deleuze means by "decisions of spirit."

The Trial of Joan of Arc, 1962

— 2014

20

Everything Better Than Plot

1.

A movie is not plot. A movie is, to quote Albert Serra, "every-thing I love better than plot." I am embarrassed to say that much of the time I can't follow certain plotlines. At a recent multiplex screening of *Solo*, the latest *Star Wars* spin-off, I had little sense of what was going on, due in part to my lack of knowledge of the *Star Wars* story. Instead of plot, I focused on Alden Ehrenreich, trying to remember where I had seen him before, as if we'd met beyond the screen. After searching on my computer at home, I discovered I knew him from Francis Ford Coppola's 2009 film *Tetro*. Ehrenreich—whose face I had not seen since, and had for-gotten, but in that way cinema never really lets you forget—had been cast to make us both remember and forget Harrison Ford. I thought about Solo's famous "charisma," which Ehrenreich was hired to recreate—failing, according to critics. But Ford's charisma is hardly his strong suit. His string of 1980s movies with foreign directors were the roles I grew up with on TV: *Blade Runner*, *Witness*, *The Mosquito Coast*, *Frantic*. Movies it seemed Ford was hiding out in after the enormous success of the *Star Wars* and *Indiana Jones* franchises. In *The Mosquito Coast*, eighties heart-throb River Phoenix plays Ford's oldest prodigal son, the same year as *Stand By Me*. Seven years before he would OD outside the Viper Room. Five years before he played a narcoleptic passing out all over America in *My Own Private Idaho*. And three years before starring in *Indiana Jones* himself as a teenage Jones. He played Ford.

After Ford and River, I began to think about the representation of age. In the 1970s and 1980s, lead actors were usually in their thirties and forties—grown-ups. Teenagers had their own subcategory. Their own films to star in. Post-eighties childhood bridged the gap between teenager and adult. Without the latch-key kid prematurely forced to act like an adult in an adult world, youth could not reign. Having adults in lead roles taught moviegoers to admire—or at least accept—age and maturity. To respect and identify with the lives of people—not simply their glamour or youth. To be beautiful and compelling did not necessarily mean you had to be young or brand-new. To be young was not necessarily a number, which is why my childhood screen crushes often centered around weary, grown-up men like Ford in *Witness*, Dustin Hoffman in *Kramer vs. Kramer*, and Jeff Bridges in *Against All Odds*. At the time, it never occurred to me that a man or woman in their forties was too old to watch. Too old to be human or hopeful. I realize this was a unique conceit for a now youth-obsessed age.

2.

If a movie is not plot what is a movie? What is the everything better than plot Serra refers to? A movie is sounds, trees, colors, faces, human voices, buildings and streets—particularly as gentrification de-faces and wipes out cities, landscapes and histories, while celluloid's innate mono no aware-ness automatically preserves them. A movie is how it is discussed, how it is desired, when it is watched. A movie is offscreen. A movie is about how long an onscreen kiss lasts. Whether the attraction was real. How a director treats the actors offcamera. How a male actor treats a female co-star. The way a face changes. The way a body changes. The way it ages. The way it isn't allowed to age. The way you can hear a voice getting older through the years. A movie is an actor before they died and an actor after they die. A movie is how old you are when you see it. A movie is destiny. A movie is always a ghost.

3.

Everything better than plot is also a question. In Serra's films, it is a leitmotif. One question is whether cinema should do what life does or what life doesn't do: cut. The cut, unlike life, is concerned with the length of a shot. Too long and too slow and we move closer to life, which is unwatchable. The average length of a shot in a Hollywood action movie is two seconds. If life is plotless and requires living, mainstream cinema, the great escape, offers entertainment (relief from life) and plot. Movies cut the time out of life. Onscreen things count. Too much time and a movie stops being a movie.

BIRTH

4.

There is little face in *Birdsong*. Faces, Serra says, were more prevalent in his earlier movies, before he moved on to landscape film. In *Birdsong*, there are backs and profiles. Long shots and long takes. The body no more relevant than a mountain. *Birdsong*'s "plot" (explained to the camera by an angel, thirteen minutes in) is a reimagining of the story of the Three Kings, who appear in the second chapter of the Gospel of Matthew. In Serra's version of the nativity story, the Three Kings (the Gospel never mentions the number of Magi) set off *in medias res* (Matthew reports they came "from the east") to meet the newborn Jesus. The film, with its unspecified locations and barren atmosphere, a word Serra frequently uses to describe his work, predates Christianity. Without the scaffolding of religious ideology and the narrative of Christianity, the meaning of their mission—both diegetically (*Birdsong*) and not (the Bible)—is concealed.

Entirely concerned with the immediate logistics of their expedition, the three men never mention Jesus. From afar, amidst

assorted landscapes that defy geographical continuity, the kings trudge along languorously and aimlessly, with countless stops and lags in between. At times, all three appear in the frame, miles away, going nowhere. Sometimes we can hear what they are saying. Other times we can't hear them at all. We hear wind, water, trees. We watch them sit, swim, sleep and walk. If traditional cinema eavesdrops, making us privy to the up-close and private—the privacy of a look, of a relationship, of a conversation, of thoughts, of camera placement itself—Serra's films do not bend to the tenets of psychological realism.

Next is a river. Then an ocean.
No narrative, no people, no plot.
Nothing happens.

Except this is wrong.

There is the sound of different kinds of water. Or the different kinds of sound that different kinds of water make. More precisely, the sound of a river from far away, the sound of ocean waves from up close. Not just waves, but waves that a certain kind of weather might produce. To see these three male figures standing in these landscapes tells us something about what it means to have lived then. To have moved from place to place. The energy it took—and the time. In the absence of narrative—and in Serra's version, a guiding star to orient them—there are simply sceneries. The term "slow cinema" here reflects more than contemplation—it suggests the time to think about what we are seeing and hearing without the rush of cuts setting the pace. Movement is painfully slow in *Birdsong*. Distance is not tracked, progress is not made. The Three Kings appear in places that are never named. Landscapes overpower and obstruct. They set the tone and the pace of the epic walkabout. The layout and sonority of cinematography. Mountains necessitate "painful efforts" that result in a great deal of humorous deliberation (at times, the Three Kings act like the Three Stooges). The three men are always hesitant to move, action is frequently delayed, making them almost Hamletian. "If we go on top of them, and water falls," one Wise Man says to another about the formidable

clouds ahead, "we will fall too." For Serra, cinematic speed—the protracted length of shots, but also how long it takes to do something—is the materiality of unscalable space. Serra's films are concerned with the approximation and characterization of historical speed, offering a cinematographic analogy for that moment through the lens of the fragmented present.

5.

Faith is both a long shot and a long take. Serra recorded over 110 hours of digital film for *Birdsong*. It took him another four months to edit. The work of editing was not in cutting images (he claims he only cut one) but in deciding on the length of each shot. Serra, a digital filmmaker who works without a monitor, never looks at rushes during production. Similarly to his Three Kings, Serra uncovers the vast, mysterious landscape of his films in real time, convinced that what he needs the viewer to see will be there "later, when there is nothing else to do. This is important because it's a question of faith—faith in the film … If you are looking at a monitor, you do not really *feel* the film. You see an image, but you do not feel the film." Faith is devotional labor, temporally felt and experienced, and *Birdsong* locates the spectator inside the spiritual plot of the film's real-time distance and duration. To watch the Three Kings de-glamorized and disoriented by landscape is to share some of the physical and spiritual effort at the center of the film. Faith in the walk replaces the familiar *modus operandi* of Christianity and the narrative action of destination.

6.

Post-cinema is not only a shift in technology, it is a shift in what we do with time. As lived time disperses offscreen, directors like Serra force it back into cinema, dragging it out onscreen. Do we want cinema to omit or do we simply want it to frame and direct

our attention, forcing us, as Serra does, to listen to and watch what we otherwise don't hear or see? The few close-ups in *Birdsong* are partial and askew. Serra approaches the close-up almost like a long shot. When he moves the camera towards a face, he withholds it. Filming sideways, showing only parts of a face. The point is not what the three men are thinking, feeling—doing. The point is the environment and the pathos of the walk itself. Serra's emphasis on duration is faithful to the Three Kings story given that the Gospel does not clearly specify the interval between the birth and the visit.

Asking whether there is magic (the magic of spectator identification) without close-ups is tantamount to asking if there is cinema without plot. Without close-ups or plot, where do we put our attention and for how long? How do we get pleasure? How do we know what to feel and who to feel for? Cinema with this much time becomes immersion rather than identification. In *Birdsong*'s longest shot, Serra uses space to open up the cinematic frame wider and wider. The farther his actors (all non-professionals) go, the farther away the camera stays. As the Three Kings walk toward the horizon, then further beyond, action and dialogue dissolve. The psychology is almost counterintuitive. Are we supposed to keep looking? How long will this go on? Without cutting, Serra holds the "empty" shot for eleven minutes. He lets the time pass, uncompressed. The Three Kings vanish from the screen for almost a minute. Absence becomes presence. The distance accumulated in the shot becomes "the magic."

7.

When the Three Wise Men suddenly arrive, seemingly by chance, no one is expecting them. There is no King Herod. Serra's nativity scene is anti-climactic. Joseph simply asks Mary, "Who are they?" Mary is breastfeeding baby Jesus, and doesn't even answer. Without saying a word, all three men prostrate themselves

at the limit of language, remaining silent in worship for nearly four minutes. At this moment, the movie's first and only instance of music on the soundtrack, a Catalan folk song, the birdsong of the film's title, rises up for us to listen to. Sound becomes an event. For Serra, there are no wise words to describe the significance of this happening. Nothing sayable. Music stands for silence. They didn't come this far to talk. Cinema is also respite.

DEATH

8.

Story of My Death is also a slow film due to the absence of biographical plot about its central historical figure. Early on, Casanova, the film's protagonist, informs that his memoirs will not be gossip. When asked to explain what he writes about, he simply declares, "What I do is think." Casanova's version of the autobiography consists of everything but the self. The memoirs shall "Tell of the cities of Europe. The falling of empires. The new science. A little astronomy, a great deal of reality and facts. Facts." A self is a conduit for a century—what Casanova means by "experimental." Sampling women, books, travel, food, shit, wine; Casanova's autobiographical "self" is a voracious tasting machine.

The last time Casanova's memoirs were brought to the screen was by Fellini in his titular 1976 film. In it, Fellini formulates a mostly unfavorable position on the *man*. Serra, on the other hand, insists on inventing his Casanova, characterizing the Enlightenment rather than the author. Only one dialogue from Casanova's memoirs was actually used. Nor does Serra explicitly reveal Casanova or Dracula's—the film's other protagonist—identities in the film. Casanova is named once in the movie; Dracula's name only appears in the end credits.

Before his death, and after he completed his "Trilogy of Life," Pasolini remarked, "Without death, life has no meaning." *Story of My Death* draws on Pasolini's "Trilogy of Life." *Salò* was purportedly the first instalment in Pasolini's "Trilogy of Death," and the last film he made before he was murdered, leaving the series unfinished. In Serra's *Story of My Death*, a real historical figure, Casanova, meets a literary one, Dracula. Dracula, the living dead, will end Casanova's life, closing the door on the Enlightenment: bridging life and death, fiction and nonfiction, pleasure and destruction.

Serra was initially approached by a Romanian producer to make a genre film about Dracula. But neither Dracula nor horror interested Serra. However, a comparative study of Dracula and Casanova as epistemological counterparts—two different portraits of desire and pleasure—did. Serra's aversion to genre movies or historical exactness results in hermeneutics over genre, where biography emerges as phenomenology. If genre is an enclosure for the transmission of ideas and styles, a century is a formal enclosure for how these two figures—real and imagined—approach their overlapping narratives of desire. Dracula, who literally has no mirror image, is a mirror image of Casanova. Both are infamous male seducers. In Serra's portrayal, Casanova's relationship to pleasure, sensuality, and women is infantile and doctrinaire, while Dracula's is irrational and violent. Dracula is therefore the more historically and sexually turbulent discourse.

9.

During his Transylvania trip, Casanova asks his manservant Pompeu, whose face we can't see, if he likes the "half-light" that befalls them. Pompeu, now his main interlocutor, answers "not much," but Casanova surrenders to its melancholy. "It's like undergarments," he proclaims, resorting to discourse. ("What I do is

think"). Romanticism, the birth of the repressed (it's here that Freud appears, as does cinema) is the psychosexual undergarment that lies beneath the "civilized" dress of rationalism. Just as Dracula lies beneath the century that is Casanova. While Casanova is familiar with a calculated narrative of the bottom—*he's tried it all*—Dracula's chaotic vision heralds something else, something total—beyond discourse and pleasure: the unconscious.

The road is getting troublesome.

Here, History shall not be broken once more?

When Casanova leaves Switzerland (the sublime geography of Continental philosophy) to venture through the Carpathian Mountains, history breaks. Casanova begins to ponder the death that unknowingly awaits him at the end of the film. A conversation with Pompeu ensues. Just as the climb in *Birdsong* is mystic rather than epic, this geographical passage is both historical and

metaphysical, tracing the increasingly "troublesome" discursive path from rationalism to Romanticism.

> From domestic, interior shots to wild exterior landscape.
> From day to night.
> From Casanova to Dracula.
> From the living to the living dead.
> From fact to fiction.
> From shit to blood.
> Dracula is the unknowable "beyond" that Casanova's anti-Christian rationalism rejects.
> It is also how a century dies.

10.

Death comes for knowledge last. Knowledge is too inebriated for something as sober and non-discursive as death. Serra notes a difference between the two epochal seducers. One listens for input, one imposes it. One loves to celebrate, the other merely pretends to. Dracula's polyamory in the face of Victorian hypocrisy is a cover for power lust. His castle of women recalls Charles Manson's family in 1960s LA. Serra's somber Dracula is a beguiling, manipulative rogue who will reappear throughout history again and again. And who will, like many weak husbands, male predators, and cult leaders—the Devil in *Rosemary's Baby*, *The Exorcist*—force women to do his dirty work for him. Dracula's gloomy sonority is the film's only non-diegetic musical score. As *Story of My Death* nears its end, and Dracula's power intensifies, Dracula's sway turns to sound, emanating from deep within the earth, the audio equivalent of *Birdsong*'s 11-minute long shot. Dracula's "sound" is immersive. It moves just as glacially and cryptically, down to the roots of Serra's mise en scène. Willful, bottomless—what it might sound like to hear seafloor spread. All Dracula has to do now is put his hands on the

world as though he were a DJ spinning a record everyone can't help but dance to. Knowledge is drugged. Knowledge is helpless. Worse, it's corruptible. Sound is for what is to come. And what is to come is always unsayable. Serra says: "Sound gives you a sensation of what's happening." In the film, the score comes after all the women have been bitten and taken over by sensation—what they think is pleasure. The *beyond* that Dracula refers to and represents is the return of the repressed. When Dracula invites the still unbitten Carmen to live at his castle across the river, she admits she's never been "to the other side." A river separates and conjoins two centuries. Getting to the *other side* will entail certain decisive actions, like torturing and killing her father, obeying Dracula's paternal laws instead. What lies beneath life, what makes life worth living, as Pasolini observed, is communion with death, but not at the expense of life, knowledge, and love. Unlike the playful, flamboyant Casanova, the Dracula paradigm is tyrannical and oppressive. Dracula is a man who won't take no for an answer. Casanova, an infantile blowhard, collects carnal and corporeal data, building a freewheeling record of enjoyment and connoisseurship. Dracula's charm monster leverages pleasure in order to dominate. Serra's final scene offers not just an image of a new century but a new allegory of male power.

— 2018

On Sophia Coppola's *Marie Antoinette*

I hear she's frigid.

"Here I am, again."
— *Orlando*, 1992

1. History is one long going away party.

2. The modern soundtrack tells us: Problems are both old and modern. Only the clothes and the jewelry are new.

3. Decadence is a sign of crisis. Wealth is how you adorn (cover up and decorate) disaster. What you lack immaterially, you create using more material. Too much is never enough because too much is the result of not knowing or feeling what is there in the first place.

4. Spending is the cost of ruin. "I want you to deal with your problems by becoming rich." Who steals from who?—*The Wolf of Wall Street*. See also Coppola's *The Bling Ring*.

5. *Marie Antoinette* is concerned with how to perform not-seeing. More precisely, not showing that you see, which is why Coppola dramatizes gossip. Gossip in the film is not about true or untrue. Actual or invented. It is not about source. Gossip is the thwarting of a kind of epistemology. Everything is knowable and known—not the other way around. What is at stake is immunity. What is at stake is how to handle the shame of knowing. Of being found out.

6. Before it meant rumor or idle talk, gossip, was *godsibb* in Old English, which meant "'sponsor, godparent,' from God + sibb 'relative' (see sibling). Extended in Middle English to "any familiar acquaintance" (mid-14c.), especially to woman friends invited to attend a birth." In other words, gossip is something you know is being said (about you and others), but which you have a customary or contractual stake in not knowing you know. It is the equivalent of being a woman.

Gossip is part of you, familiar, familial, very near (proximate) and even dear because what happens or doesn't happen around us is intimately related.

Gossip is what you know is happening. In the film, the constant murmur of mendacity is audible. The person being gossiped about is always immersed in the travel and treble of the rumor.

7. "There are no secrets," an older friend once told me when, like Marie, I complained about all the pretending. Everyone always knows (feels) what is being hidden, he said.

8. The art and etiquette of appearance and appearing. But also: appearing as not-showing. And: not-showing as pretending not to see or know. As in: it is okay to say what one is not supposed to say and hear what one is not supposed to hear as long as one does not show that one sees and hears. That one is being seen and heard. It is about-face, saving-face. The denial of what is out in the open. Hiding in the open. Invisibility as something you can see; something always in view. We would never have had history, injustice, or culture without visible covers and shrouds.

9. In one of the film's key scenes, Marie Antoinette, unable to produce an heir due to her unconsummated marriage to King Louis the XVI of France, treads through the long corridors of the Versailles palace; through a tunnel of clamoring whispers, holding in her shame. She knows that everyone knows she is ashamed, and everyone knows that she knows they are shaming her. Yet she waits to get *behind closed doors* before allowing herself to wail. Everyone can hear her loud weeping on the other side of the wall: a thin veil. As long as Marie abides by the veneer and affectation of privacy, she is free to publicly unravel. This is yet another instance of gossip. A woman is not simply behind closed doors. A woman herself is a behind closed doors. A woman must pretend that she does not know that she is being seen and heard and laughed at. A woman must be the right thing at the right time in the right places.

In Sally Potter's *Orlando* (1992), based on Virginia Woolf's 1928 sci-fi novel, the future is a gender-bending wormhole. Orlando is sentenced to gender organization at a certain time and place— the 17th century. To escape, Orlando enters a labyrinth as though it were a time-travel machine, and gender jumps to another time and place, the 19th century. A labyrinth is also what saves Wendy and Danny from the byzantine monster of fatherhood in *The Shining*. The labyrinth is how patriarchy is outwitted.

10. History is full of party scenes. Getting wasted. Watching the sun come up. The beginning and end of love affairs. Behind the scenes, the weeping wall, the tall, wild grass behind the palaces. Nothing has ever not-happened. It didn't start happening, it has always been happening.

11. Prematurely gray hair (gray before your time; time that came early) is the original and coveted history of Beautiful. Life got old so fast, and so did beauty. To be as ornamentally old and color-less as your ancient wealth, ancient history, ancient life, ancient body. Like the statues.

12. Coppola always humanizes and sentimentalizes the elite. The people do not have their noses pressed up against the glass of that world. More like: the glass keeps the people entirely out of view, out of the film, with nothing on the other side of it. There are no outsiders in Coppola's films, only insiders.

— 2015

22

Love Story

Time is impossible. It's hard to get our heads around it. But I think about time all the time. I want time these days like a person wants a person. I want New York City too. The bygone one. The one you only see in old movies now. Especially movies from the 1970s, where a city was a central character. A run-down character. Full of trash, cars painted primary colors. Heat.

I want actors before the screen aged them, even though everyone is always aging, screen or no screen. Even me. Hence this thing about time. This thing about screens. Wanting time on and off other people, as well as myself, as though time were a fancy dress to put on, to take off.

Movies make me cry. Right now, good ones and bad ones. Everything makes me cry right now. People crying makes me cry. People I don't like, crying, makes me like them. Like when Jean-Claude Van Damme recently started crying in an interview, saying that he had "fucked up his life." That made me cry.

When the tire blows out in Brian di Palma's *Blow Out*, a nation ruptures, expires, and Jack Terry, a microcosm of that nation, goes careening. Everything and everyone and every city and every time. And every love. The mysterious loves that blow out like the car tire in the film. After that everything turns into noir. You investigate. Rewind. Rescind. Reconstruct. You know something. Then you don't. You have something. Then you don't.

I think my ex thinks—as Donald Barthelme notes in "Me and Miss Mandible"—"I am sorry to be the cause of her disillusionment, but I know that she will recover." How do men know this? The boyfriends that cause disillusionment are like leap years. They don't come every year. You lose a decade. You lose hope. It takes a special kind of man to disillusion you.

The '70s were about disillusionment too. You watched everything break down, then you faced it, asked questions, and decided whether you wanted to go on. Disillusionment in the '70s was the equivalent of mortality. Do you want the world to go on? Do you want to go on in the world?

In *Taxi Driver*, Travis Bickle, the disillusioned man par excellence, writes: "Loneliness has followed me my whole life, everywhere: in bars, in cars, sidewalks, stores. Everywhere." Bickle said this in the '70s.

What if the stores, the bars, the streets, the people became so new, so polished that everything—places, streets, people—became even lonelier than they were when they were poor, messy, broken, empty. Because empty doesn't always mean empty. Before the '70s, the city was a set, a fantasy. Fiction. The fiction covered up the facts. In the '70s, people had jobs and a social class.

I look at everything thinking: I didn't know it. Thinking: I could have. Thinking: I did. Thinking: I won't. I feel the way Travis feels, only Travis is psychotic, and a man, and I don't know what I am. But this is a diary too.

If time—a time—has a mood, I am not in the mood for this one. After he made *Velvet Goldmine*, the filmmaker Todd Haynes said that the '70s were the last truly progressive decade. The last decade to show its seams.

Film—the screen—used to be a lot quieter. Like there were breaths between the frames. A horizon. Digital means no breath. Digital means seamless. Means the image never ends.

There is the way the '70s screen did things.

Did water

Did cities

Did bodies

Did people's faces like they weren't just something you picked up at a doctor's office. Even did a shark, still on the cusp of real and unreal. Machine and imagination. When they couldn't get the fake to run smoothly in *Jaws*, they simply used our conscious and unconscious dread about what's underneath the surface of the water, which is real.

In the '70s, Hollywood actors often wore simple clothes to the Oscars (scarf, hat, casual jacket, rumpled blouse) that people wear on their way to the store for milk. An actor could be mistaken for being a person.

The '70s did dissolution, which the decade admitted to. That falling apart is not glossy and a city doesn't always look pretty or expensive while you do it.

Trust was a '70s issue—we stopped trusting: police, politicians, government, media, capitalism. Trust had to be earned, rebuilt, replaced with something new. The '70s were both an end and a beginning. Then the '80s came and got rid of things like endings. Things like new beginnings.

"Is it safe?" the infamous Nazi war criminal Szell asks Dustin Hoffman repeatedly in *Marathon Man* just before he drills into Hoffman's unanestheticized tooth. "No," Hoffman finally succumbs (realizes), "It's not safe."

When Jill Clayburg died in 2010, film critic Ty Burr wrote an article about her and called her a '70s actress. "It was the '70s," Burr wrote, "and we didn't trust glamour gods just then."

And computers weren't skin. The skin of skin. The skin of an image. The skin of life.

— 2010

23

Lost Highway

On the subway, all fifty of us had on our headphones like idiots trying to block out the world, or put music to it, since the world on TV and in the movies always has music. I remembered listening to The Stills while driving cross-country with you. Our first stop: North Carolina to see your sisters. On the way there, we stopped in a Target parking lot, turned the popped trunk into a café awning, and made our own soy lattes with the aero-latte frother I had bought on a flight to London.

On the trip the road was polarized: half-horror, half-romance. We thought we were going to get killed half the time, which was romantic because dying with someone always is, and we were going to die together, die trying not to die, and I even started praying in the dark just in case. The trucks on I-90 were so big and fast, silver bullets shooting through the werewolf highway, *Duel*-like, except real men were driving them and we had nothing to ward them off with. No cinematic formula. We just pulled over and stopped the little red car we were in, a tiny bloodstain moving across the big picture of the road. The woman at the gas station said, "Be careful. This stretch is known for its bullies," the way that life is a stretch known for its bullies, and everyone but my mother, laughed at us for being scared when we told them what happened. Remember when we used to tell people how we felt? Remember when we weren't all just narrating for everyone at the exact same time? I often asked you that. The memory of trusting people, confiding in them.

I was so terrified that I left you alone by falling asleep for half an hour and when I woke up the road was all ours, like at the end of a movie where two characters get to live, or a post-apocalyptic space that's yours but ruined. Yours because it's ruined. In sleep, in love, we dozed in and out of each other, in and out of the world, lanes crisscrossing, like the characters in *Lost Highway*, except I wasn't the dark playing off the light, or the dark playing off the blonde (you). And for the last forty minutes, after the coast was clear, when all the bullies were finally gone, we cruised along the asphalt and held hands under the music. The astral road was stripped of cars, lit up and silver, like that path in the Redwood forests of *E.T.*, or the moon over Elliott's levitating bike, and it was just us, a punk-rock version of Adam and Eve, us against everything, us there first, or last. Except I didn't come from you or any garden.

What's that movie where the road is interior? A personality. A light switch. It was like that.

It wasn't just your run-of-the-mill love story. It was movie love. Love you could film. Love you remember seeing somewhere. Love you remember seeing all your life. Love that changes you or that you change. Love that could mean something to the people looking at it. Big and rare and photogenic.

I kept you awake by squeezing you every now and again because I don't drive. You said you needed my help, and more than once I saved you from crashing. And now, now that you're gone, I would replace you if I could, but I've never even seen a face I think I could even remotely know. I never see a single face.

In the movie *Julia*, Lillian Hellman tells her life-long best-friend, Julia: "You still look like nobody else," which is the best compliment I've ever heard. Lillian means that whatever Julia is on the

inside is what makes her matchless on the outside. Someone you can't lose in someone else or double with an opposite or split into parts or dream up again.

Listening to too much music is like being underwater or having cotton in your ears. It's a lot of pressure on what you're feeling. The music weighs in. When it comes to feelings, listening to music is the equivalent of framing a picture. Framing a face. You can have your picture feelings up on the wall without a frame, but it doesn't look as put together. It doesn't look as good. It doesn't stay there. With music, you can hang your feelings up and look at them, and so can other people.

— 2011

Acknowledgments

An earlier version of "Famous Tombs: Love in the '90s" was originally published in *Berfrois* as "Johnny & Winona (Die with Me)" in December 2012. A longer version was published in *The White Review*, February 2013.

"I Touch Myself" was originally published on *Ryeberg.com* in 2010 and in *Vertbreae Journal*, Issue One, 2011.

A shorter version of "Ever Since This World Began" was originally published in *Love Dog*, Penny-Ante Editions, 2013.

"All An Act" was originally published in *Indiewire's Press Play*, 2011 and *Boing Boing*, 2011.

"The Authentic Self" was originally published in *Indiewire's Press Play*, March, 2014.

"The Rights of Nerves" was published in *The White Review*, September 2016, and also *Animal Shelter*, Issue 5, 2018. An earlier version of "The Rights of Nerves" was originally published as "In the Time of Fear" in *Fandor*, 2011.

"Time for Nothing," a radio monologue, was commissioned for Performa: 11, the New Visual Art Performance Biennial, 2011.

"Solace" was published in *Specter Magazine*, October, 2011 and *Unsaid Magazine*, Volume 7. N1, 2014.

"I Give You My Word" was originally published as "Love Sounds" in *The Third Rail*, Issue 6, 2016.

"Behind the Scenes" was originally published in the anthology *Life As We Show It: Writing on Film*, co-edited by Masha Tupitsyn and Brian Pera, City Lights, 2009.

An earlier version of "Devil Entendre" was originally published as "A Mash-Up of Devils" in *The Rumpus*, July 2009.

"A Sentimental Education" was originally published in *Berfrois*, January 2013.

An earlier version of "Mixed Signals" was originally published as a video-essay, titled "Prettier in Pink," on *Ryeberg.com*, July 2011.

"Mike Zuckerberg and David Bowie Play with Time" was originally published as a video-essay on *Ryeberg.com* in 2010.

An earlier version of "Picture Cycle," originally titled "Screen to Screen," was published in *Animal Shelter* Issue 1, 2008 and *The Enemy*, 2014.

"On Bresson" was published in *Necessary Fiction* in January, 2014.

"Everything Better Than Plot" was published in *Fireflies*, Issue 6: Alain Guiraudie/Albert Serra, October, 2018.

"On Sophia Coppola's *Marie Antoinette*" was published in *Entropy*, July, 2015.

"Lost Highway" was published in *Ryberg.com*, 2010 and *Faggot Dinosaur*, 2012.

An earlier version of "Analog Days" was originally published as "Reel Men" in *The Coming Envelope*, Issue 7, Summer 2013.

ABOUT THE AUTHOR

Masha Tupitsyn is a writer, critic, and multi-media artist. She is the author of *Like Someone In Love: An Addendum to Love Dog*, *Love Dog*, LACONIA: *1,200 Tweets on Film*, *Beauty Talk & Monsters*, and co-editor of the anthology *Life As We Show It: Writing on Film*. In 2015, she completed the 24-hour film *Love Sounds*, an audio-essay and history of love in English-speaking cinema, which concluded an immaterial trilogy. The film has been exhibited and screened in the United States, Canada, Europe, and Australia. In 2017, she completed the first installment, the 1970s, of her ongoing essay-film, DECADES. The second installment, the 1980s, was completed in 2018. DECADES composes a history of cinematic sound and score for each 20th century decade. Her writing has appeared in numerous journals and anthologies. She teaches film, literature, and gender studies at The New School.